EXPEDITION NAGA

Diaries from the Hills in Northeast India
1921–1937 • 2002–2006

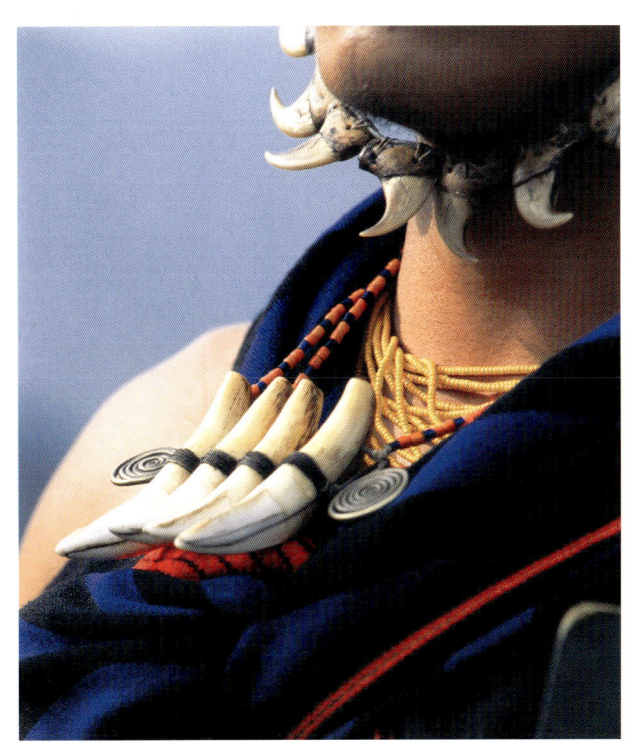

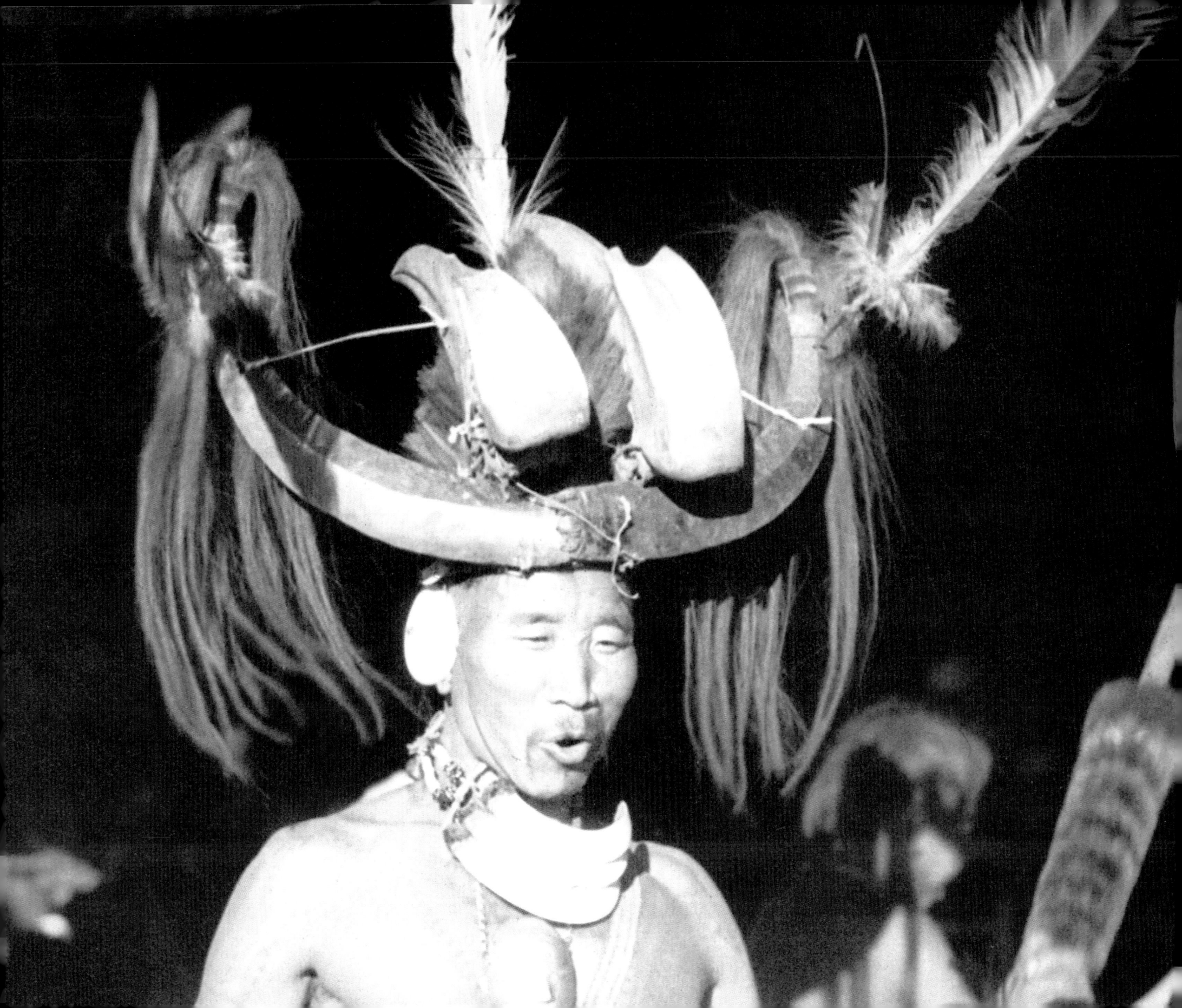

EXPEDITION NAGA

DIARIES FROM THE HILLS IN NORTHEAST INDIA
1921–1937 • 2002–2006

Peter van Ham & Jamie Saul

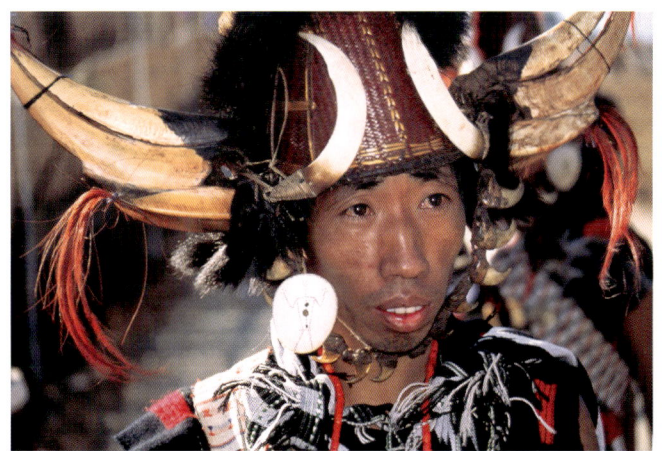

With a foreword by
Alan Macfarlane

Contents

Foreword: At Hutton's Desk – Alan Macfarlane 6
Preface: The Sources, the Travels, the Book 10
Introduction: Curfew at Tobu – a Night in the Naga Hills 12

Part One: The Longleng Diaries – Peter van Ham

Among the People of the Clouds 24
Headhunting Season 34
Clan Feuds and Screaming Morungs 54
Retaliation and Healing 62
Headhunting Heroes 74
Naked and at One with the Universe 82
The Chicken Knows the Future 96

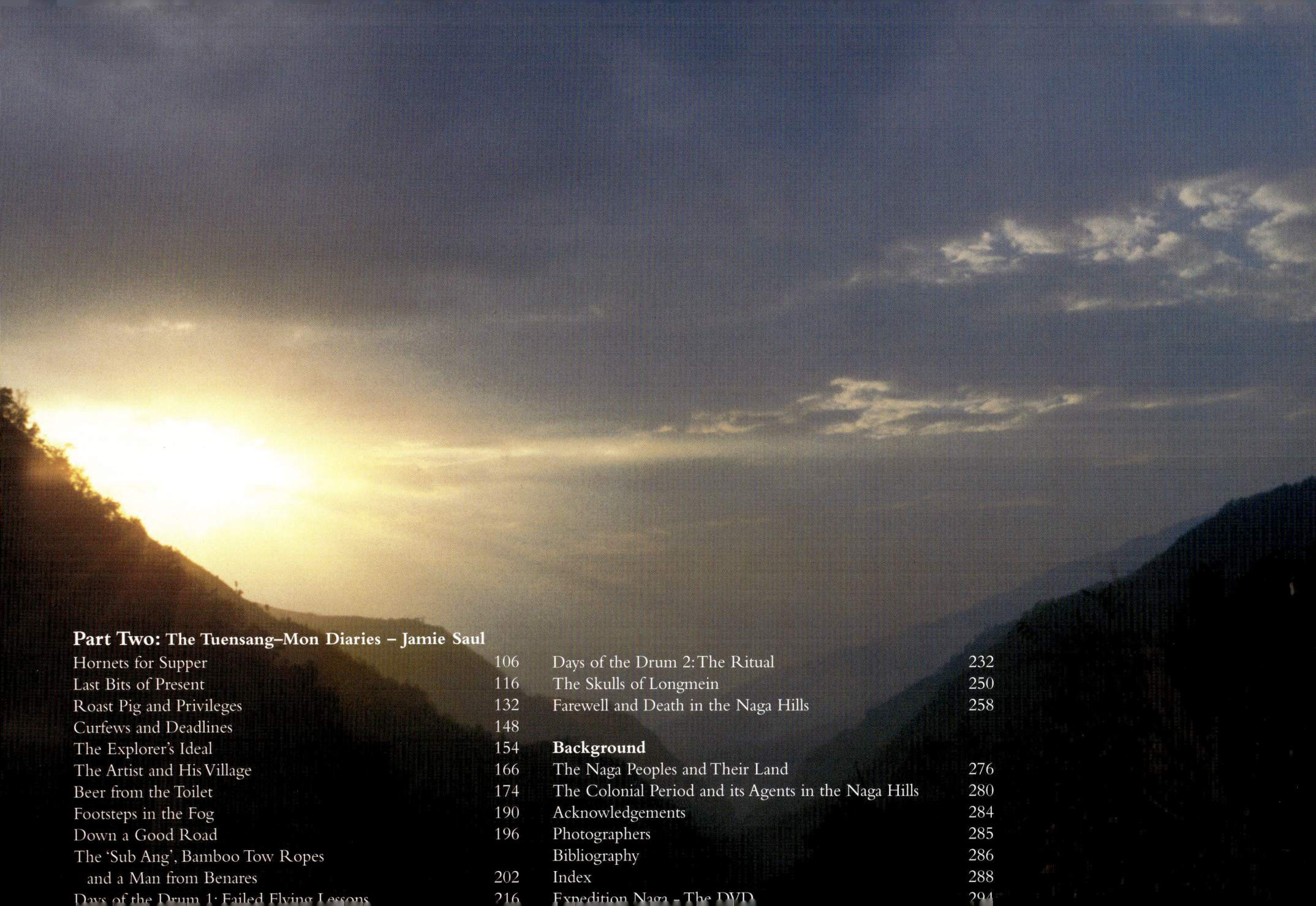

Part Two: The Tuensang–Mon Diaries – Jamie Saul

Hornets for Supper	106	Days of the Drum 2: The Ritual	232
Last Bits of Present	116	The Skulls of Longmein	250
Roast Pig and Privileges	132	Farewell and Death in the Naga Hills	258
Curfews and Deadlines	148		
The Explorer's Ideal	154	**Background**	
The Artist and His Village	166	The Naga Peoples and Their Land	276
Beer from the Toilet	174	The Colonial Period and its Agents in the Naga Hills	280
Footsteps in the Fog	190	Acknowledgements	284
Down a Good Road	196	Photographers	285
The 'Sub Ang', Bamboo Tow Ropes and a Man from Benares	202	Bibliography	286
		Index	288
Days of the Drum 1: Failed Flying Lessons	216	Expedition Naga – The DVD	294

FOREWORD
At Hutton's Desk

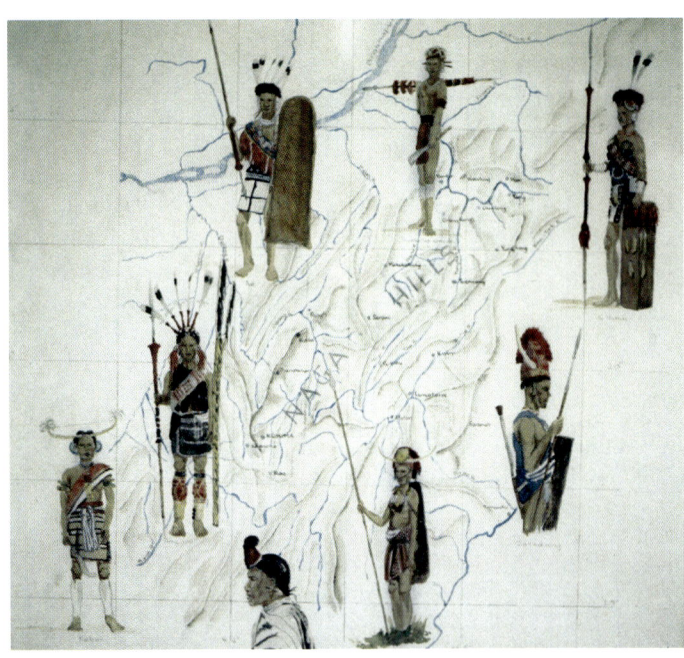

Half title page: Tiger teeth and claws adorn a Khiamniungan warrior at Tuensang.

Frontispiece and title page: Continuity of dress among the Naga: a Konyak warrior of Wakching wears a helmet with two hornbill beaks in 1937 (CFH/MA/SPNH) and a Makuri man from the Burmese side of the Naga Hills using the beaks as horns sixty-five years later. (SK)

Contents page: Sunset over the dense forests enroute to Mt. Saramati.

Above: An illustrative watercolour map of the Naga Hills showing some of the major Naga groups. Drawn by Jamie Saul at the request of J.H. Hutton for a re-release of J.P. Mills' "The Ao Nagas" in the late 1960s, unfortunately the painting never got published. (MA/SPNH)

Opposite: A Konyak carving said to depict J.H. Hutton, as indicated by the pipe and the sheet of paper the figure is holding. (PRM) (MA/SPNH)

It is a pleasure and an honour to introduce *Expedition Naga – Diaries from the Hills in Northeast India* by Peter van Ham and Jamie Saul. One particular interest in this fascinating account of various visits to the Naga Hills on the Assam-Burma border is the way in which it weaves back and forth from the tours that the Deputy Commissioner for the Naga Hills, J.H. Hutton, made through the unadministered areas as early as 1921 and then again in 1923, followed by his successor, J.P. Mills, along with Christoph von Fürer-Haimendorf in 1936, and those made by the authors between 2002 and 2005. In fact there is a deep symmetry to be found in these encounters with the Naga, which are some eighty-five years apart.

Hutton had been in the Naga Hills from 1912 to 1929 and, as a synthesis of his researches, published his two classic monographs, the *Sema Nagas* and the *Angami Nagas*, in 1921. The following years he toured in the remote, unadministered areas in the north of the Naga Hills where the Konyak and others lived, and wrote an ethnographically extraordinarily rich account in the form of a travel diary. Eighty years later, after a visit to Arunachal Pradesh and Nagaland in 2002 and consecutive visits to the Burmese Naga Hills, Jamie Saul synthesized his immense knowledge of the Naga on the Burmese side of the border into *The Naga of Burma* (2005). Meanwhile, Peter van Ham and Aglaja Stirn had travelled through the southern slopes of Nagaland in the 1990s and then in 1998 to the Tirap District of Arunachal Pradesh. They went on to visit various restricted areas in 2002 and the following year published their magnificent set of Naga photographs, along with a deep and knowledgeable text, in *The Hidden World of the Naga* (2003). Van Ham and Stirn continued their research in the remoter parts of the state in 2004, which Hutton had also visited. Then, Saul and van Ham made another expedition in 2005 to the remotest interiors that Hutton had traversed – the Konyak northeast. The result of all this is an ethnographically intense and yet highly readable and adventurous account in the form of a travel diary presented in this book.

The journeys to the northern Naga Hills were special. In the earliest, Hutton was only the second or third European to visit most of the villages, and the first in some cases. These were dangerous and arduous trips, which he vividly described. In the most recent exploration, only very special permission allowed the enthusiastic, observant and knowledgeable van Ham and Saul to retrace Hutton's footsteps, as well as those made in 1936 by Hutton's successor, J.P. Mills, and the young Austrian anthropologist Christoph von Fürer-Haimendorf. It is astonishing to think that the world observed by those early explorers is still so fully alive, despite eighty years of missionary and other infiltration – for example, that headhunting rituals take place, that log drums are being pulled, that

the ill are treated with the spiritual aid of tigers, and that young men sleep in the bachelors' dormitories. The reasons for this are sensibly explained by the authors and have to do with a revival of traditional culture as a result of only partial integration into mainstream Indian society. Yet the world observed in this book may change soon if new motorways are built through Burma to Assam. In the meantime we should be grateful to the authors for their enthusiastic adventure to capture a unique world existing on the margins between two rapidly modernising countries, India and China.

As I sit typing this at Hutton's black, roll-top, wooden desk in my home in England on my 65th birthday, I realize something of the continuity and connection which is represented through my own life and experiences that links back to Hutton and before. There is the desk itself, which I bought from one of his colleagues during the time Hutton held the second William Wyse Professor at Cambridge University (1937-1950). Hutton's formative years were influenced by an anthropology which lay its main emphasis on collecting as many 'facts' about other cultures as possible, on as wide a range of topics as possible. The results were the two classic ethnographies mentioned above – classics also in the sense of this kind of ethnography – which were both published some sixteen years before Hutton moved to Cambridge. He methodically and in great detail compiled information of an invaluable and lasting kind on the social, economic and ritual life and history of the two southern Naga groups, the Angami and Sema. Hutton had not been fully trained as an anthropologist, although his two books show that he was fully conversant with the theories and methods of the time. It was not until he was into his fifties that he became an academic-teaching anthropologist and it seems the more abstract theoretical approaches do not appear to have interested him greatly. Due to the changes in theoretical paradigms in social anthropology towards structural functionalist approaches Hutton, shortly before his retirement, was perceived as a rather dry and out-dated lecturer by those I have interviewed who were taught by him.[1]

More widely, however, Hutton provided the inspiration for a talented group of ethnographers, including J.P. Mills, Haimendorf, Henry Balfour, Ursula Graham Bower and W.G. Archer, who between them gathered one of the most thorough accounts of a tribal people that has ever been made. They also collected objects for museums. Hutton alone collected 2,783 artefacts from the Naga Hills for the Pitt Rivers Museum in Oxford, while many others went to the Cambridge University Museum of Archaeology and Anthropology, which my colleagues and I used for a temporary exhibition on the Naga in the early 1990s. They took thousands of photographs, most of them available on the Naga website[2] and now archived by the Society for the Preservation and Promotion of Naga Heritage (SPNH). Between them they wrote more than ten monographs on the Naga.

The world they documented was worthy of their effort. The Naga have long had an extremely rich material and symbolic culture, with huge variations within a relatively small area. Their culture was one that had intrigued me as soon as I was conscious, for as a little boy, just as the last great British anthropologist, W.G. Archer, was surveying the art of Nagaland, and Verrier Elwin was documenting the myths and customs of Northeast India, I was a young child living on the edge of

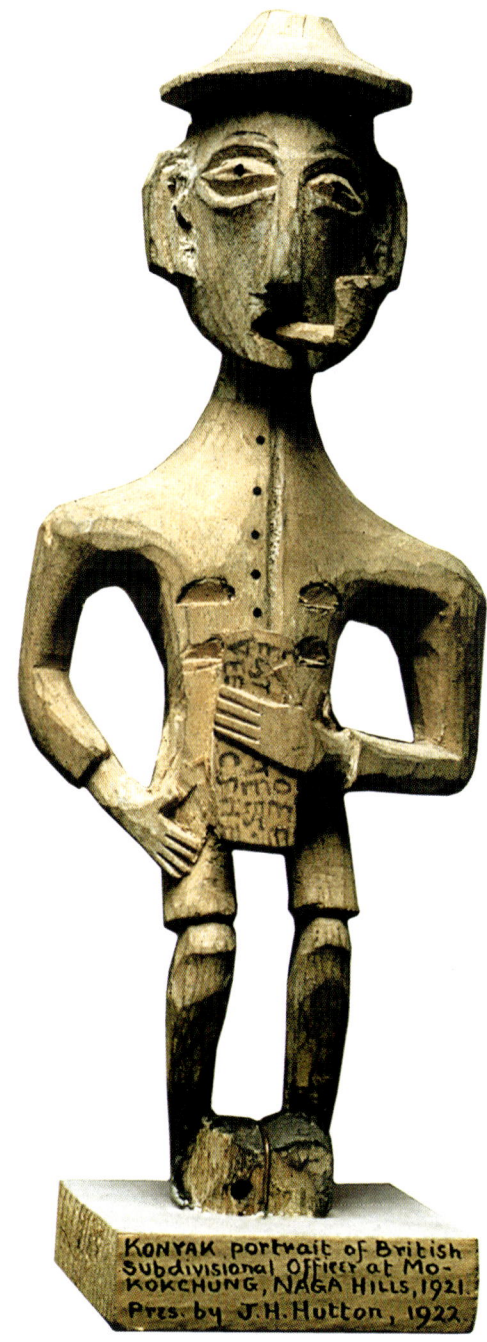

1. See especially the interviews of John Barnes, G.I. Jones and Jack Goody at www.alanmacfarlane.com/ancestors/index.html
2. www.alanmacfarlane.com/FILES/nagas.html

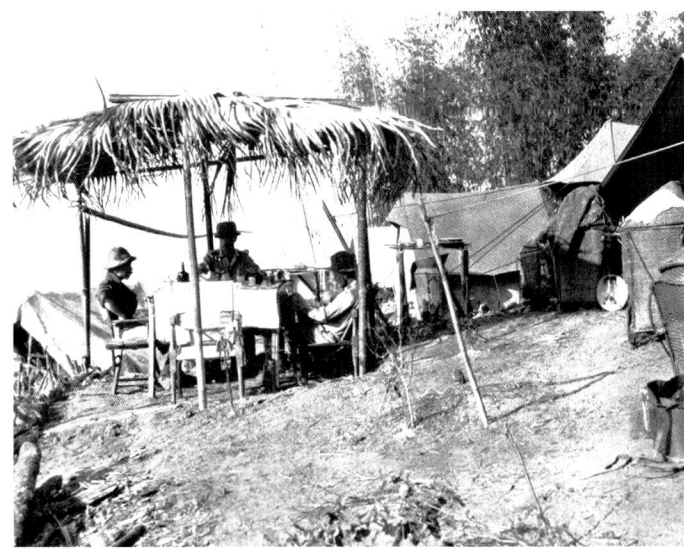

Top: J. H. Hutton (left) at a 'temporary desk', photographed at camp during a punitive expedition in the hills of present Mon district in 1927 by Suydam Cutting. (VH)

Above: The veranda of "Hutton's Bungalow", the sub-divisional office at Mokokchung, in the 1920s. (JHH/MA/SPNH)

the Naga Hills. I remember playing with the colourful spears and *daos*, which on two more boyhood visits further intrigued me, and later led me into the discipline of social anthropology.

In 1967 I decided to try to work just south of the Naga Hills and Haimendorf was appointed as my supervisor. He was another superb documenter of the Naga and his work is an important anticipation to that of van Ham and Saul. I interviewed Haimendorf and asked him about his Naga fieldwork and photographs, and I was later able to make one visit to the Naga Hills in 2001. I learnt to admire the energy and creative skills of the Naga, though I have never had the privilege of travelling in the northern Naga regions which feature in this book. The fairly urbanized Angami area my wife and I visited in 2001 contained some remnants of the proud past but I was absolutely unprepared for van Ham and Saul's magnificent photographs, and for their vivid accounts of logdragging and life in the *morungs* and villages that appear in this book.

So I return to Hutton's desk and feel the wood, and realize how it was to a certain extent Hutton's work that ultimately made me an anthropologist. His work is often the only historical source for the Naga themselves, and I have been visited by Naga whose whole history is unrecorded except for a precious paragraph in Hutton. This has helped create the foundations for a detailed history of the highly intelligent and gifted Naga of today, whether they are part of the diaspora – doctors, teachers and businessmen – who have emigrated all over the world, or still practising their rituals and beating the log drums in the remote forests of the eastern Himalayas. Hutton's work still inspires others. Thus, his influence hovers over the meticulous work synthesized in *The Naga of Burma* by the late and much lamented Jamie Saul, a friend and correspondent whom we treasured for nearly twenty years, a man who lovingly pursued all things Naga, and to whom this volume is dedicated as a last tribute.

I am linked to Hutton in another way too. My own Department of Social Anthropology at Cambridge, as well as the School of Oriental and African Studies (SOAS) in London and the Pitt Rivers Museum at Oxford, all owe a great deal to Hutton and the Naga. Indeed, the first William Wyse Professor at Cambridge was another Naga expert, T.C. Hodson. But it was Hutton who took the Department through the difficult years of the Second World War and beyond, from 1937 to 1950. He hoped and lobbied to be succeeded by Haimendorf, but in the event Meyer Fortes was elected instead. Haimendorf went to SOAS, University of London, as Professor and Head of Department, and was later joined by J.P. Mills as a Reader. Haimendorf was a very gifted administrator and built up the Department of Anthropology at SOAS to become the largest in Britain. Meanwhile, the collaboration between the Director of the Pitt Rivers Museum in Oxford, Henry Balfour, who had also visited the Naga Hills, and Hutton, resulted in the Naga collection becoming by far the largest tribal collection in the museum, as well as being extremely well documented, and was later complemented by materials from Ursula Graham Bower and others. So, indeed, it was Hutton who was behind a veritable 'Naga phase' in British social anthropology.

Today there may even be a revival of the apparently buried diffusionist ideas of Hutton, which

may already be perceived in his 1923 diaries and surface especially in a very intriguing article on 'The Mixed Culture of the Naga Tribes' (1965), which shows, along with his general and insightful book on *Caste*, that Hutton was not just a local ethnographer but had developed general ideas in relation to sacrifice, magic and headhunting, and had tried to place the Naga in the much wider frame of cultural resemblances as far as the west coast of Africa. His work as Census Commissioner and organiser of the highly important Census of India of 1931 also made him aware of the tribal diversity of that massive continent, to which he could relate his microcosm. Now that we not only have better tools for the study of long-term diffusion and also greater knowledge of how far peoples have travelled, Hutton's ideas are becoming interesting again.

The eighty-five years between Hutton's tours of 1921 and the present-day ones described in this book span a major period of the understanding and documentation of non-Western peoples through intensive observation. Hutton, as a Deputy Commissioner, belonged to the tradition of partially external observers, yet there was clearly a sense of mutual admiration between himself and the Naga, and on the basis of this he managed to gather a huge amount of knowledge. Haimendorf then undertook the new style of participant-observation fieldwork, spending thirteen months among the Konyak, and showed through his photographs and writing an intensely engaged ethnography of the new kind. Now, with van Ham and Saul, we can revisit those mist-shrouded mountains where the various peoples ended their wandering to become the fierce warriors who fascinate us as the Naga today, and we can use this book to vividly compare the remains of the past with the changes that have taken place in the region.

It says a great deal for the Naga that they should be able to intrigue, win the affection of, and engage so strongly with a succession of British, Austrian and German outsiders whose education and world-view has always been so alien from theirs. The brilliant evocations of life in the Naga hills in Haimendorf's *Naked Nagas* and the present *Expedition Naga* of van Ham and Saul show how very close these authors have come to their subjects. Not only is Naga history and culture documented by these observers, but so are ideas about totally different worlds, which, historically speaking, were brought to us for the first time in the great period when anthropology was challenging the imperialist arrogance of the West; ideas which are now, in a world that is facing the effects of globalisation more and more, particularly important. Amidst all the rapidly shrinking diversity in the world, it is wonderful to see that the Naga have retained so much of their cultural heritage. This present book is therefore full of hope that, despite an appalling period of civil war and the marauding activities of outsiders, so much of value remains and will hopefully continue to remain for a long time to come.

The wheel has come round, and my life is a small spoke in the middle of it.

Alan Macfarlane
Professor of Anthropological Sciences, Department of Social Anthropology
Fellow of King's College, Cambridge University. December 2006

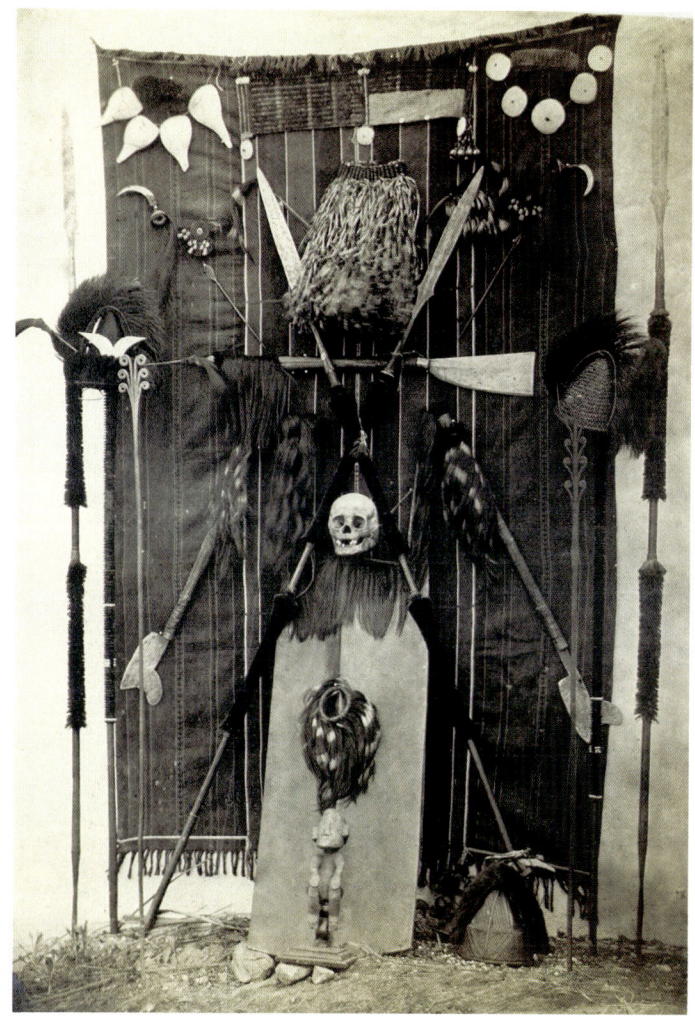

Above: Artefacts collected from the Naga Hills displayed and recorded in the early twentieth century. Images like this date back to the last quarter of the nineteenth century, indicating the fascination with Naga culture shared by all the early explorers. (Unknown photographer, MA/SPNH)

Top: The original cover of Hutton's 1923 diaries. (VH)

Above right: Cover of the second reprint of Hutton's diaries. (VH)

Above left: Cover of the first edition of Christoph von Fürer-Haimendorf's The Naked Nagas, 1939. (VH)

Opposite page
Above: Indian soldiers in body armour and equipped with half-automatic guns shopping at Kohima bazaar.

Below: Jamie Saul on his last tour in the Burmese Naga Hills in spring 2006. (Neil Ryan/SPNH)

PREFACE
The Sources, the Travels, the Book

J. H. Hutton's *'Diaries of two tours in the unadministered area east of the Naga Hills'* appeared for the first time in 1924 as Volume XI, No. 1 of the *Memoirs of the Asiatic Society of Bengal*. In book form they were first published in 1986 as *Report on Naga Hills* and were reprinted in 1990 as *Naga Manners and Customs* – in both cases as facsimile editions and only in India. On the one hand, this speaks of the eminence of Hutton's records; on the other hand, it indicates the scarcity of material about the region described in Hutton's diaries. Since then, few articles and even fewer books have dealt with this geographical and cultural region in detail. One of these is J. P. Mills' *The Pangsha Letters*, a collection of personal letters written to his soon-to-be wife Pamela in England in November 1936 during a punitive expedition against the village of Pangsha. They were discovered only in 1980 by Professor Alan Macfarlane of Cambridge University and edited by Geraldine Hobson, J.P. Mills' daughter, in 1995 for a limited edition of the Pitt Rivers Museum in Oxford. Furthermore, there is the work of Christoph von Fürer-Haimendorf and, in particular, his book *The Naked Nagas* (1939), an ethnographically rich travel account which made the Naga known to the world.

The main reason for the scarcity of material on the area can be attributed to political circumstances such as proximity to the Burma border and strong military presence due to activities of various underground factions striving for independence from India, which have rendered the region inaccessible to researchers for fifty-five years. The restrictions were eased only in 2002 by the central Indian Government and the state of Nagaland, when controlled access, confined mainly to administrative centres, was allowed to limited groups of tourists. Most of the area visited by Hutton, Mills and Haimendorf in the works described above lay outside these regions. Thus, the opportunity of accessing the interiors of Nagaland and the possibility of moving about there relatively freely, which thanks to the State Government's consent we were permitted to do, can be considered a rare privilege.

Our goal in travelling to Nagaland was to compare Hutton's and Mills' diaries and Haimendorf's book with the present situation and to determine which of the customs and traditions they described were still current in the areas they visited. Of course, we are aware of the historicity of these documents – their colonial style, the views of the people presented in them and the historical paradigms which underlie them. Many of the research concepts and ideas may appear outdated and politically incorrect, but these are the only sources in existence and, as such, they are precious, besides being comprehensive and intense. And it was these historic descriptions that brought our attention to the extraordinary cultural characteristics of these regions. Therefore, we place the historic descriptions without comment next to our own contemporary ones, and any explanations or reservations about the sources may be found in the Background.

By and large we followed the same routes as the three authors. While our observations were not always made in the same places as those mentioned in the historic sources, often we found similar things in other places. Sometimes, however, we include documentation on places that were mentioned by them but could not be visited. Other places they travelled to we had to leave out of our itinerary due to time restrictions. Also, we had to make a choice of descriptions due to restrictions of space in the present oeuvre. But places we could not describe in detail appear in the photographs and the respective captions. In this regard, a research and documentation journey done on behalf of this project by Günter Gessinger and Bea Bartusek, both members of our Society for the Preservation and Promotion of Naga Heritage (SPNH), helped tremendously. They ventured to places in Mon and Tuensang districts which we could not access and their valuable work is included here, especially in pictures and captions.

We describe our experiences not only geographically and chronologically but we also assign them to certain themes in the hope of revealing the richness of this cultural region.

We dedicate this work to all the people who contributed to it and, in historical terms, to future generations who may be interested in the aspects of culture and tradition we found in 2005. We hope that this book will offer the interested reader a glimpse of one of the most fascinating areas of Nagaland and will contribute to an awareness of the precious and special cultural customs still prevailing there – as well as creating a sense of awe about how comparatively little has changed in the region over the last eighty-two years. We hope especially that this consciousness will extend to the Western world, but also to the many young Naga we met on our journey, who are just beginning to open up to their own history and culture.

<div style="text-align: right;">Peter van Ham & Jamie Saul
Frankfurt and Johannesburg, March 2006</div>

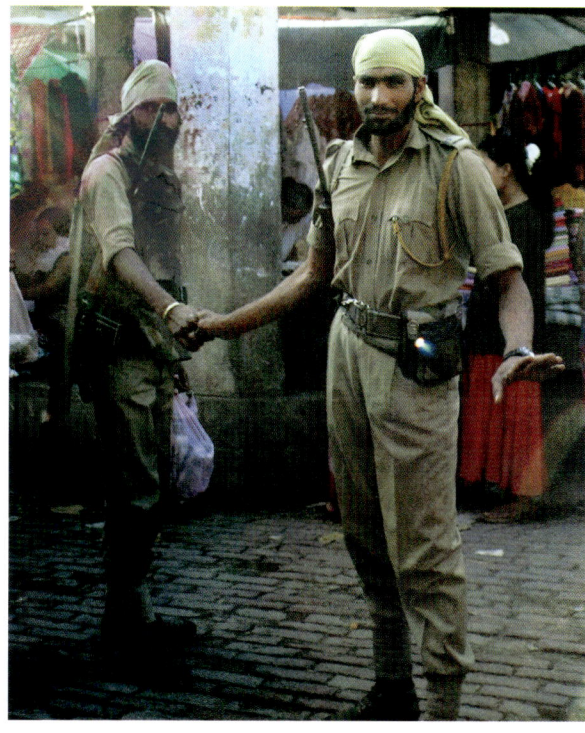

Postscript

It causes me great personal pain to add these lines. Shortly after Jamie had sent his chapters, as well as his additions and corrections to the texts already written, and had set out on a field-trip, this time to the Naga on the Burmese side of the border, our fruitful collaboration came to an end. With the terrible news of his sudden death, I lost a man who in four years had become the best friend I have ever had – a soul mate, whom I had the privilege of meeting in person only once, but for one of the most intense times of my life. With him the world has lost not only one of the very few true scholars, but a loveable human being and a philanthropist par excellence. This gap may never be filled. Thus, at least I would like to broaden this introduction and on my behalf dedicate this work to the man himself – Jamie D. Saul. You will never be forgotten.

<div style="text-align: right;">Peter van Ham, Frankfurt, November 2006</div>

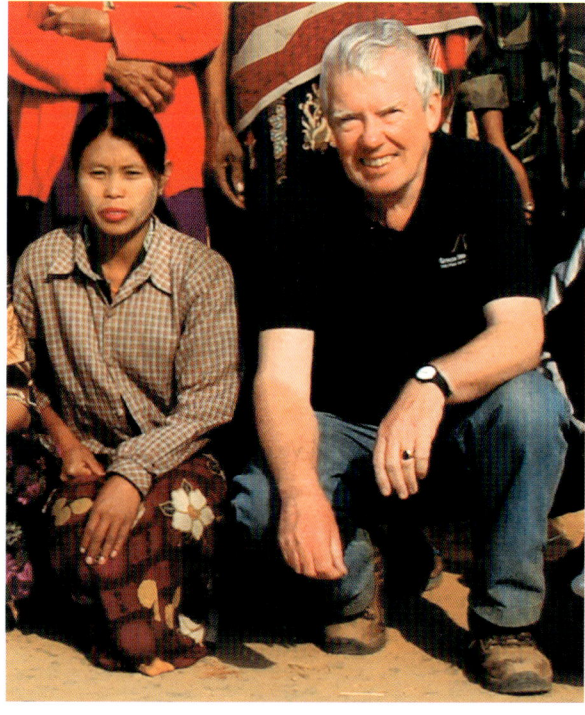

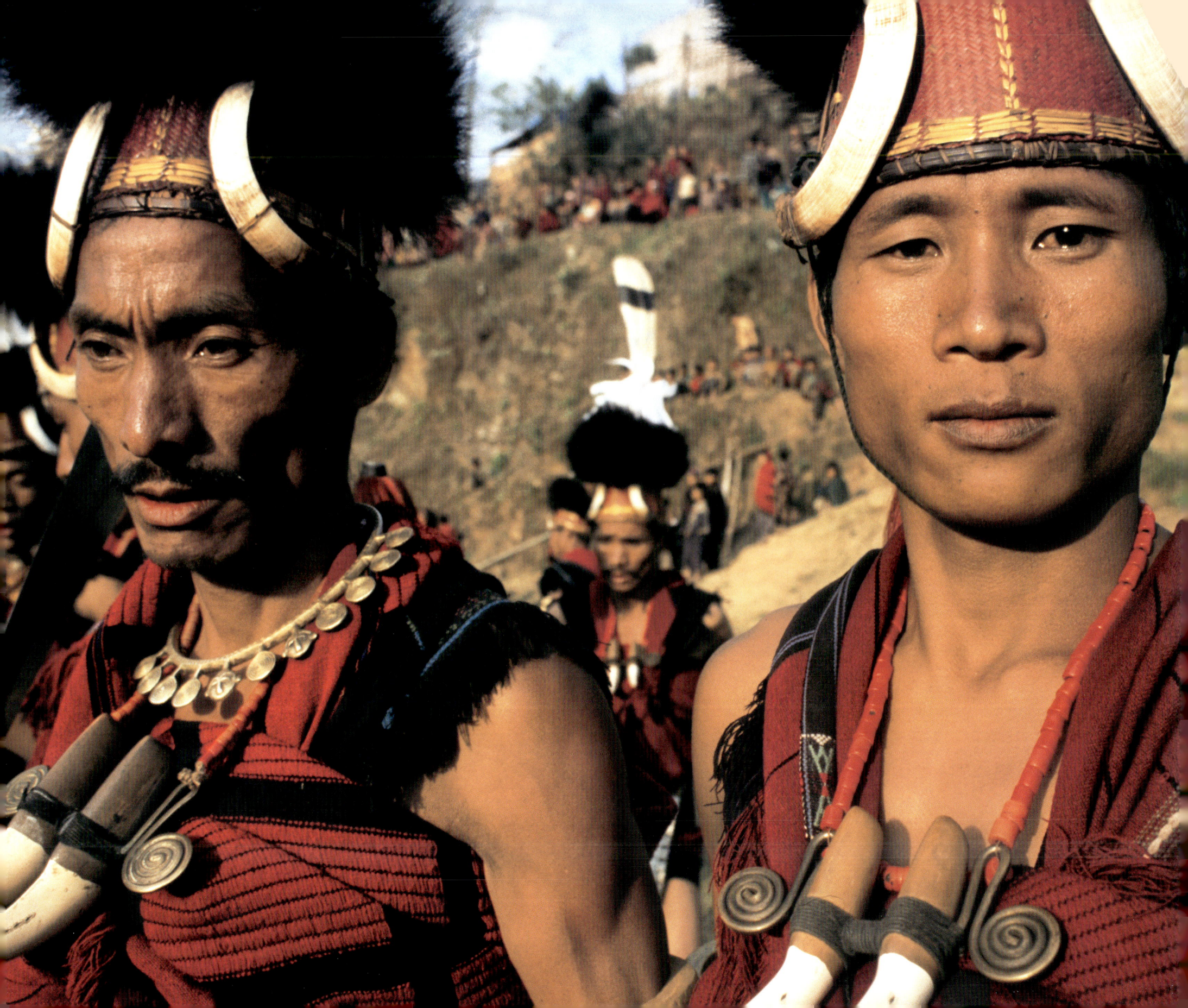

INTRODUCTION
Curfew in Tobu – A Night in the Naga Hills

When the way of life of a certain people is seriously endangered, as can happen in every society, then the way back is not far. Then people may easily resort to something very primordial. The fear of enemies makes them think: 'Let's finish them off before they do.' Thus, in dangerous times it does not take much to return to customs such as headhunting.[3]

It is stuffy in our shack, the electricity has gone off once again and I stare into darkness. Jamie, returning from the toilet, brings out from the rickety bedside locker a half-burnt candle in a candlestick smudged with wax and soot. The plastic couch creaks as he takes his seat. My underarms stick to it as I get my emergency rations of gummi bears[4] and cereal bars from the backpack and pass them around. Jamie refuses and instead takes a gulp from his bottle of Scottish Malt and sighs. 'Bloody fools,' he murmurs into his three-day beard, 'do they really have to deposit the diesel canisters in the toilet?' (See Curfews and Deadlines, pages 148-153.)

It is 19 October 2005 and we are spending a second night confined to the small Inspection Bungalow of Tobu, not exactly caged but only on condition that we do not leave our quarters after dark. And darkness falls early in the Naga Hills – at approximately 6 o'clock. We have arrived right in the middle of an old clan feud that for centuries has been smouldering between two Naga groups – the Chang and the Konyak. And Tobu, amidst the steep hills of Mon, is the centre of this old quarrel. As is the case with so many feuds in the world, this one concerns land. The Konyak accuse the Chang of ruthlessly expanding their territory and stealing their limited cultivable land. They say that Konyak women, who were sowing crops in the fields, had been insulted by the Chang and chased away. There have been rapes and killings, it is said. There have also been talks, but negotiations and threats have not worked. What's the alternative? A headhunt! It's as simple as that.

Just how simple, Jamie and I have experienced again and again in the last few years of research expeditions here in Nagaland. I witnessed three ritual headhunts myself, and both of us have had countless discussions with the old headhunters. All these experiences have made us feel how exceedingly proud the Naga people are of their cultural heritage – and indeed headhunting is a *cultural* heritage because it lies at the centre of all Naga culture, from architecture, carving and weaving to their class system. And even today, when headhunting is prohibited by law, it is still present – in the attitude of the people, in the clothes they wear, the carvings they make, the rituals they celebrate. This, to my mind, is quite special and, as far as I know, unique in the world. It engenders a strange thrill, a feeling somewhere between disgust and fascination, which is difficult to put into words. This is even more

Above: Fürer-Haimendorf's 1937 photograph of Mauwang, the Konyak chief of Longkhai, (CFH/MA/SPNH); and (opposite) Yimchungrü warriors of Sangpurre taken in 2002. The notoriety of the Naga as fierce headhunters still surrounds them.

3. Alan Macfarlane – Interview for *aspekte*, ZDF German TV, 3.9.02.
4. German wine gums.

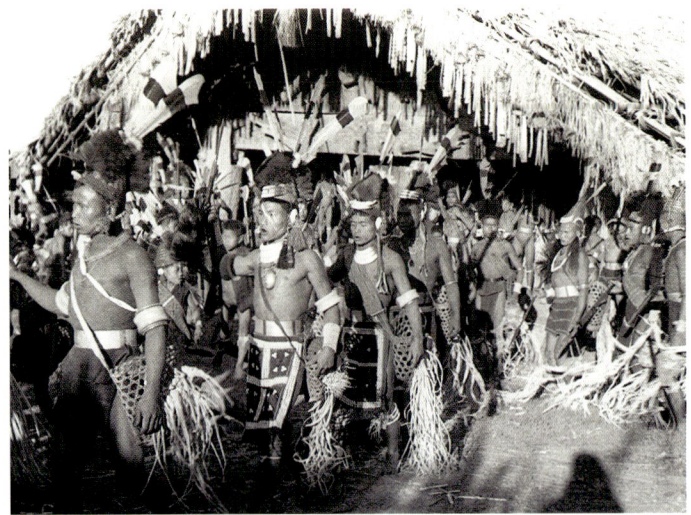

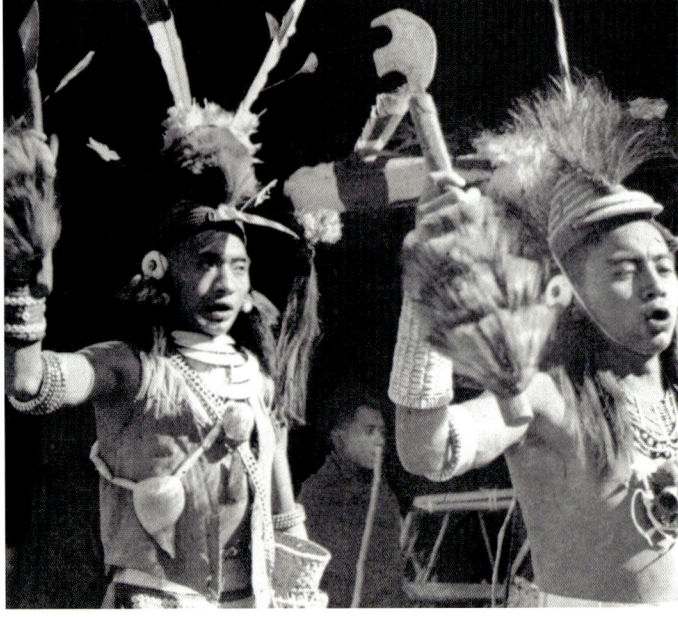

Phom warriors of Yongnyah during the spring festivities in 2002 (opposite) and Konyak of Wakching (top) and Tanhai (above) celebrating the reception of an enemy head in the 1930s (CFH/MA/SPNH). To our amazement, the impressive, war-like rituals among the Naga groups of the Longleng, Tuensang and Mon districts, which we witnessed in 2002 to 2006, were much the same as Fürer-Haimendorf had experienced in 1936/37.

5. Hutton 1924, 4, footnote 4.

difficult to reconcile due to the many contradictory impressions one gets as an outsider, especially as these headhunters offer unbelievable hospitality and genuine cordiality. Naga society is still inward-looking, concerned primarily with clans and the hierarchy between them, while at the same time trying to cope with modernity and new values, many of which are alien. Missionaries and administrators have instilled in the people the worthlessness of their traditional ways of life, insisting they are savages, even animals, possibly in order to exploit them as well as to form them according to their own liking. But forced compliance tends to work only until resistance arises, especially if the indoctrinated people are proud and warlike, with a history of resistance that even the British Empire could only partly defeat, and who perceive themselves by such concepts as: 'If one Naga sneezes, all India gets sick.'

I'm also starting to sneeze and this breaks the silence that has started to pervade our room. It is a malign and forbidding silence and we listen for the screams or shouts in the darkness which seem likely to follow. Poangba, our host, enters the room. This friendly and well-educated man is the chairman of the local Konyak Union. With teeth red from betel nut, he grins at us. 'Don't worry!' are the only words he is able to say in English, 'All quiet?' I ask him, and receive the typically Indian form of head-shaking in reply, of which it took me many a journey to find out actually means 'Yes', but, in addition, may also include all other possible answers – like any answer in India.

Speaking for myself, I love India. I have been travelling here almost twenty times and I stay out of politics. I'm a stranger, a visitor, a guest, and try to the best of my ability to behave like one. I am happy that the Naga Hills are in Indian territory and not Chinese or (entirely) on Burmese ground. I suspect that if India were to comply with the Naga insurgents who for sixty years have been fighting for a separate and independent Naga state, it would soon be annexed by either China or Burma. However, I, as well as Jamie, am here solely because of a fascination with the culture of the Naga. This is our concern, rather than politics about which, since matters are very complex and our view is far too external, we do not dare to have our own perspective. This is also known to the Government of Nagaland, which has extended a cordial invitation to us and has offered us this rare privilege to travel here as the first foreigners for almost sixty years (and in one village for eighty-two years). We don't want to and we will not abuse this privilege. Even if we sympathise with the feelings of the people here and all the difficulties they are facing, it is not our fight. The Naga are aware of this and do not drag us into their dispute, for they are too cultivated, proud, provident and noble. That it is their culture which interests us hits them right in the heart and has enabled us to make many new friends who have opened their world to us. They give us the feeling of being associated with them – a feeling which continues even when we are back in our own countries, far away from these steep dark hills – provided that this night will end.

Toshi enters the room. Toshi Wungtung is a Naga from the ethnic group of the Yimchungrü, who since 2002 has been a dear friend and our faithful companion and guide in the central districts of the Naga Hills. He is the son of a former minister, an ecologist and sociologist by profession and works at the State Pollution Board. My question as to why there is nothing to be heard causes his familiar and

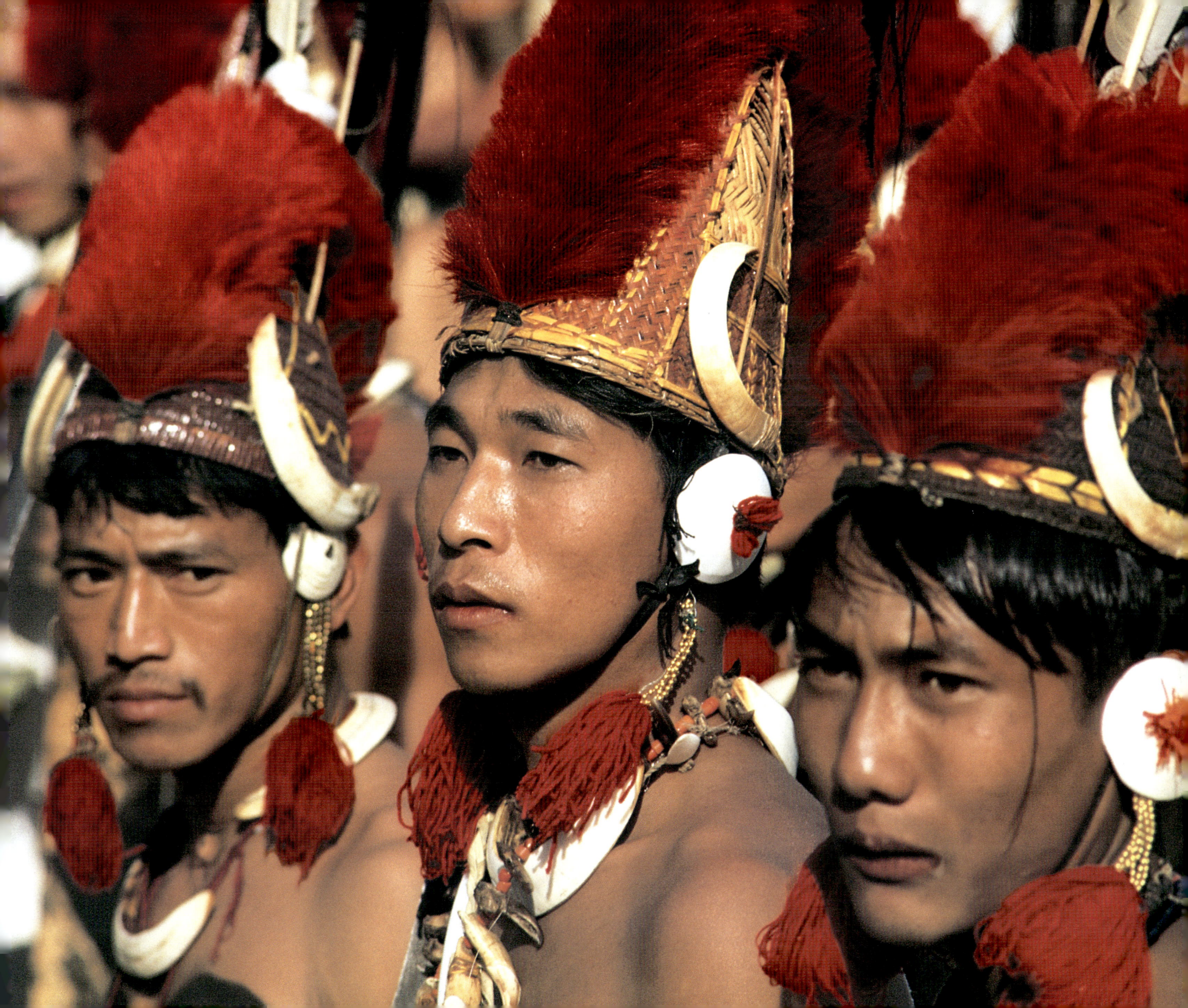

Left: Survey of India map from 1932 showing large tracts of the present Tuensang district and the regions on the Burmese side as 'unsurveyed' and therefore white areas. When Mills set out on the punitive expedition against the village of Pangsha in 1936 (see pages 120-127) he had only a vague idea of this village being located somewhere northwest of the lower white area. (MA/SPNH)

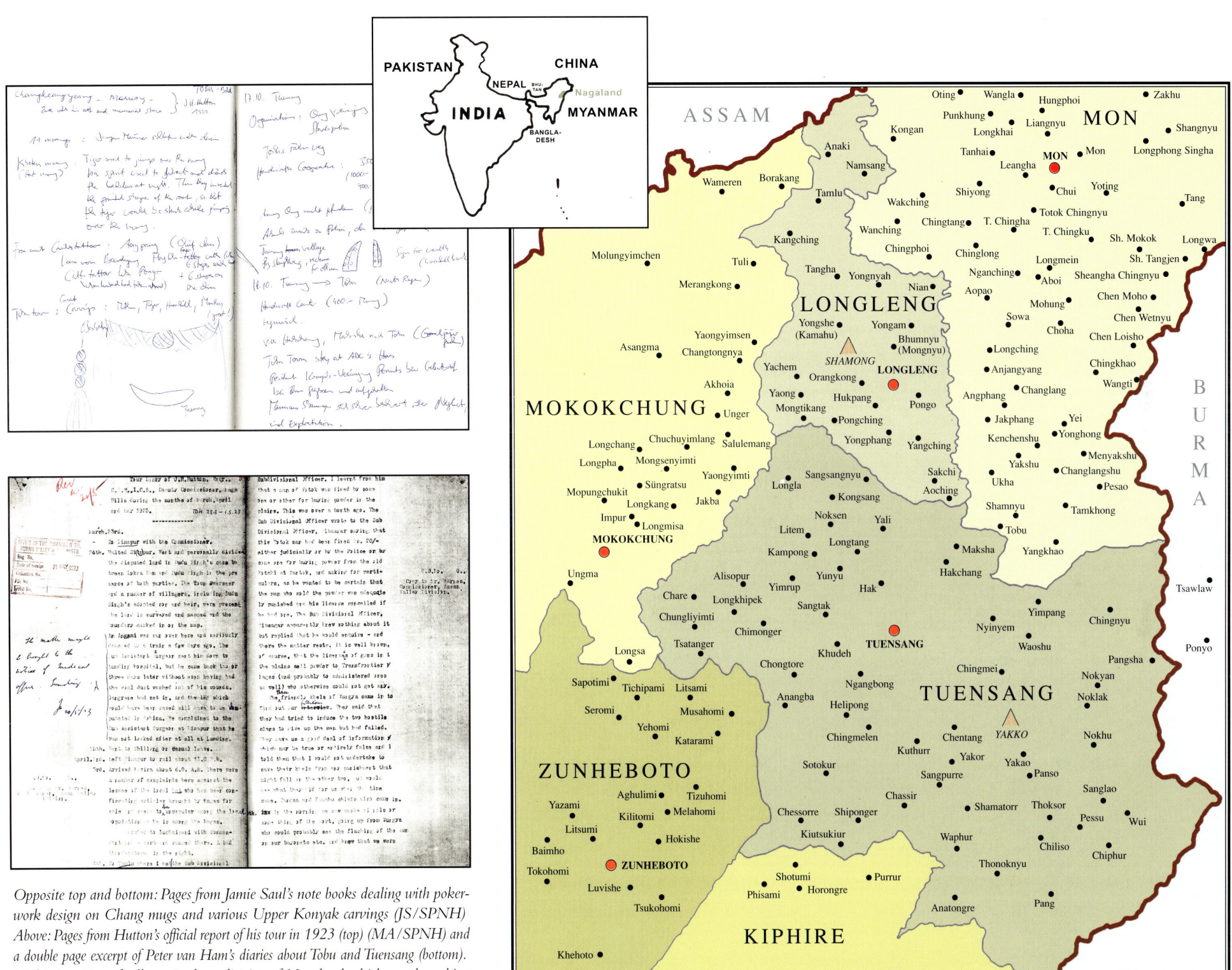

*Opposite top and bottom: Pages from Jamie Saul's note books dealing with poker-work design on Chang mugs and various Upper Konyak carvings (JS/SPNH)
Above: Pages from Hutton's official report of his tour in 1923 (top) (MA/SPNH) and a double page excerpt of Peter van Ham's diaries about Tobu and Tuensang (bottom).
Right: Location of villages in those districts of Nagaland which are the subject of this book.*

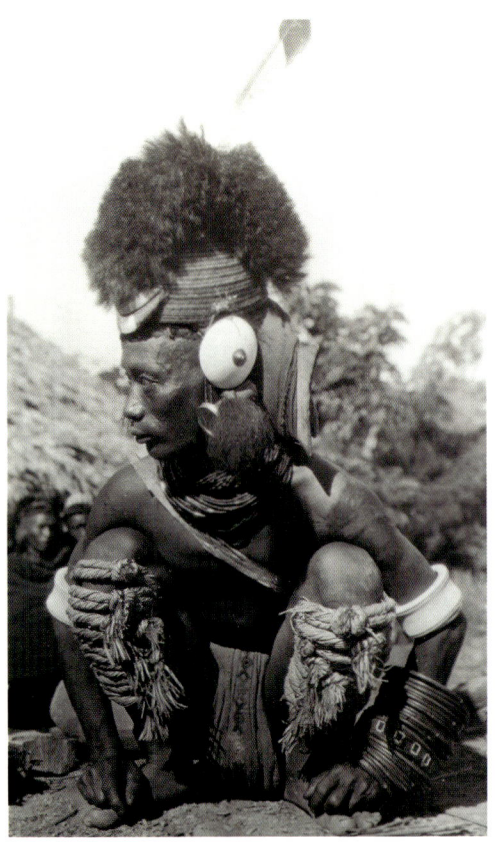
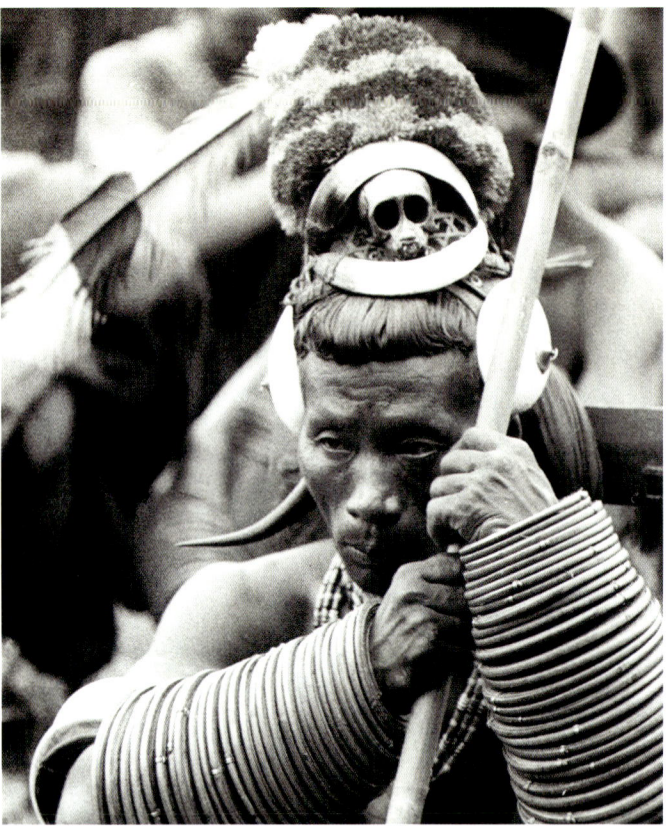
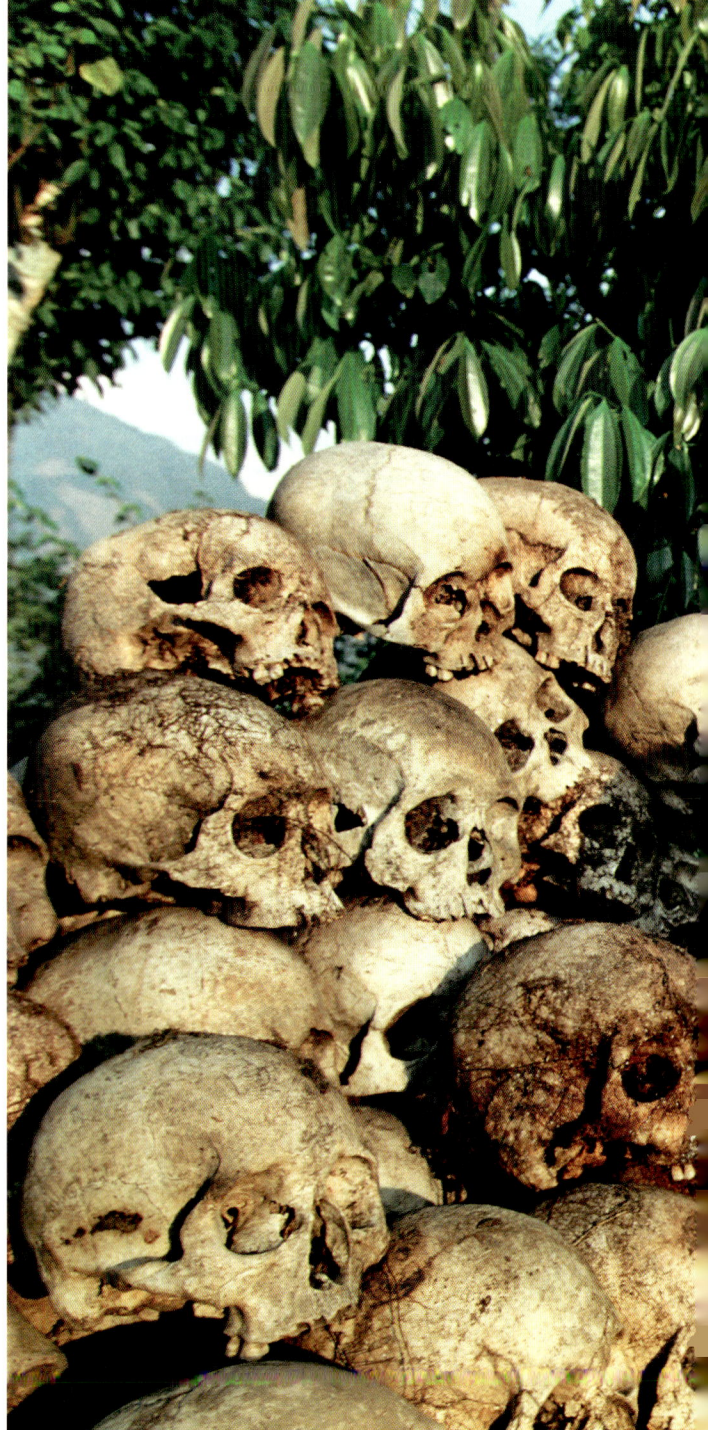

One of the primary goals of our expeditions was to find remnants of traditional Naga culture and to investigate their continuance. We hoped to find people mentioned in the old reports. One of these lucky finds was Khaopa, the late Ang of Sheangha Chingnyu, a Lower Konyak village near Chen. Hutton had photographed his father in 1923 (above left), as had done Fürer-Haimendorf in 1937 (above right – both: MA/SPNH). In 1998 French photographer Thierry Falise was able to take a last picture of the very old Ang surrounded by his village's skull collection (TF); as his spectacle tattoos indicate, in the meantime he had achieved the status of a headhunter – a fact which is underlined by the accounts written on his memorial stone. In 2006 Günter Gessinger photographed this stone when he ventured to Sheangha Chingnyu for the SPNH. He also was able to take a picture of one of the Ang's seven daughters, apparently the present Ang's aunt, and to copy a photograph of the 1960s showing Khaopa and two of his 18 wives. (GG)

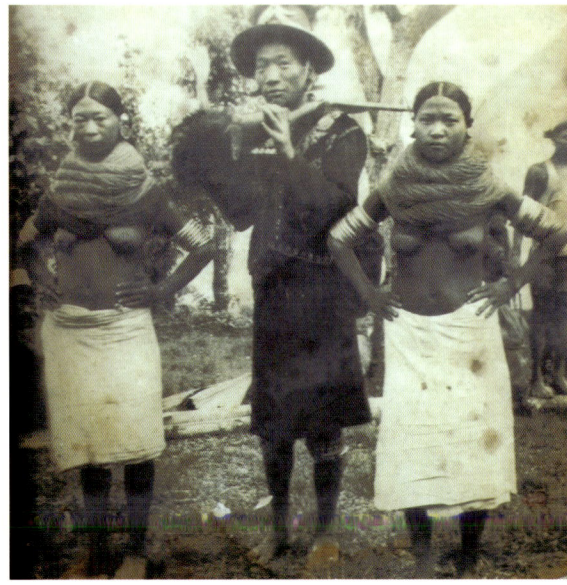

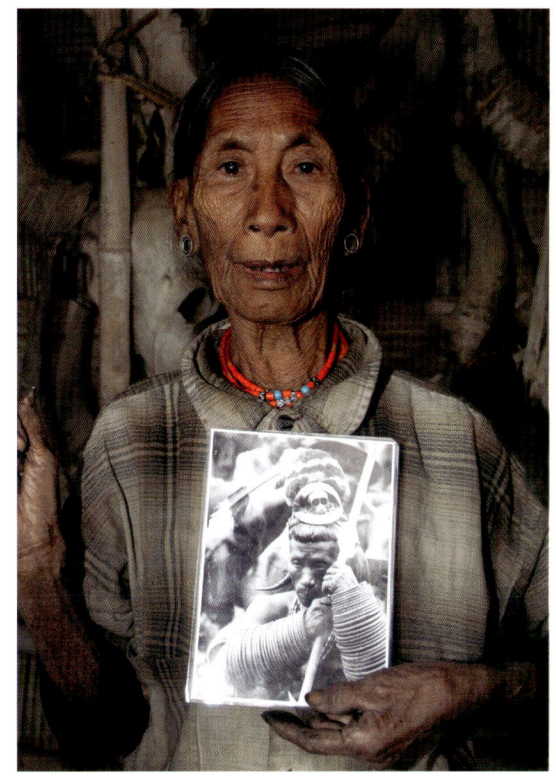

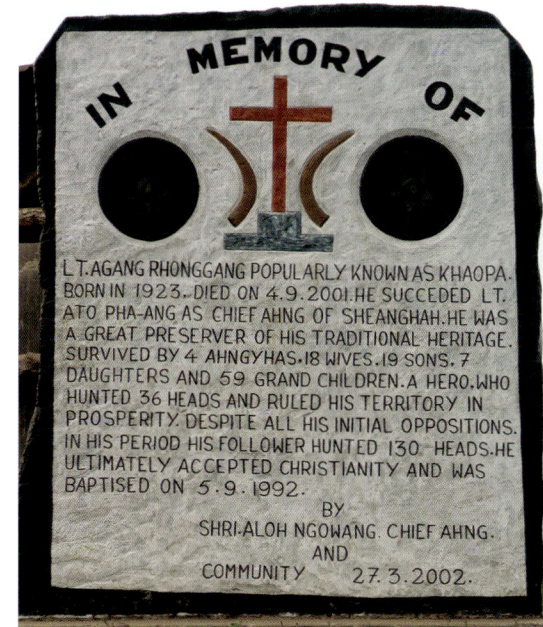

IN MEMORY OF

LT. AGANG RHONGGANG POPULARLY KNOWN AS KHAOPA.
BORN IN 1923. DIED ON 4.9.2001. HE SUCCEEDED LT.
ATO PHA-ANG AS CHIEF AHNG OF SHEANGHAH. HE WAS
A GREAT PRESERVER OF HIS TRADITIONAL HERITAGE.
SURVIVED BY 4 AHNGYHAS, 18 WIVES, 19 SONS, 7
DAUGHTERS AND 59 GRAND CHILDREN. A HERO, WHO
HUNTED 36 HEADS AND RULED HIS TERRITORY IN
PROSPERITY DESPITE ALL HIS INITIAL OPPOSITIONS.
IN HIS PERIOD HIS FOLLOWER HUNTED 130 HEADS. HE
ULTIMATELY ACCEPTED CHRISTIANITY AND WAS
BAPTISED ON 5.9.1992.
BY
SHRI-ALOH NGOWANG. CHIEF AHNG.
AND
COMMUNITY 27.3.2002.

Some villages in the Naga Hills, such as Wanching (above: CFH/MA/SPNH), are almost unchanged, while others, such as the Ao village of Longkhum (opposite – compare with page 32) have turned into deserts of corrugated iron.

somewhat hoarse laugh: 'What do you expect?' he asks. 'Certainly no gunshots: headhunting means that people set out in traditional dress and take heads with their machetes, the *daos*.' He counters our puzzled glances by stating with a shrug: 'It's a sacred act. And, after all, the fertility inside the heads is supposed to be conserved, isn't it?' This makes Jamie take out our daily literature from his jacket, the old book *Diaries of two tours in the unadministered area east of the Naga Hills*, written in 1923 by John Henry Hutton, former District Commissioner of the Naga Hills. Jamie opens it and by flickering candlelight starts reading aloud: 'With the head the soul of the dead is carried off to increase the prosperity of the captor.'[5]

Not only is this diary one of our few written guides to this part of Nagaland but it is also the reason for us being here. We are following in the footsteps of Hutton as well as his successor James Philip Mills. During their day this part of Nagaland was not under British administration, and for the most part remained independent till the British retreated from India in 1947. The colonial politics in this part of India differed considerably from much of the rest of the land. The British drew a so-called 'Inner Line', which served especially to protect the tea planters in the fertile lowlands of Assam from the 'warlike highland tribes'. Neither lowlander nor highlander was permitted to cross that line without special permission. At Mokokchung and the later capital Kohima, the British had their commissary establishments in the Naga Hills, at that time still a part of Assam. From here the Deputy Commissioners, such as Hutton and Mills, and their subordinates exercised a rather loose control over the various Naga groups of the region.

Headhunting and slavery were intolerable to the colonial rulers and forced them, time and again, to set out on punitive expeditions against villages who disobeyed their orders – but only if such incidents took place within the boundaries of their administered zone. Great parts of present-day Mon and Tuensang districts, where we are travelling, lay outside this administered zone and in 1923 Hutton was forced to set out with an expedition into unadministered territory since 'tribes' living there had undertaken a headhunting raid into the administered zone. This gave him the rare chance to get acquainted with the region and to take fascinating notes before retreating back to 'British soil'. Similarly, Mills in 1936 had to access entirely unknown and uncharted territory at the Burmese border to avenge a headhunt and the taking of slaves. His punitive expedition, the biggest ever to be equipped, was accompanied also by Christoph von Fürer-Haimendorf, an Austrian anthropologist of aristocratic descent; a man who, ever since I had started to become engaged with the Naga, had been very important to me. His book *The Naked Nagas* had inspired me a great deal.

The depth and intensity of Haimendorf's work, not only about the Naga but about many other peoples of India, had always interested me and, in particular, his fascination, amazement and philanthropy attracted me. His photographs spoke with the same compassion, depicting people full of dignity and recording what I had come to find out myself in my own journeys: the Naga are a proud and dignified people. This to me is the core of their being. And I am not alone in this opinion. Everyone who has had the chance to get to know and to live among them for longer periods of time has come up with a similar evaluation, be they anthropologists such as Verrier Elwin and Ursula Graham Bower, or administrators such as Hutton and Mills (who also became anthropologists later). Their works convey a comprehensive sympathy for the

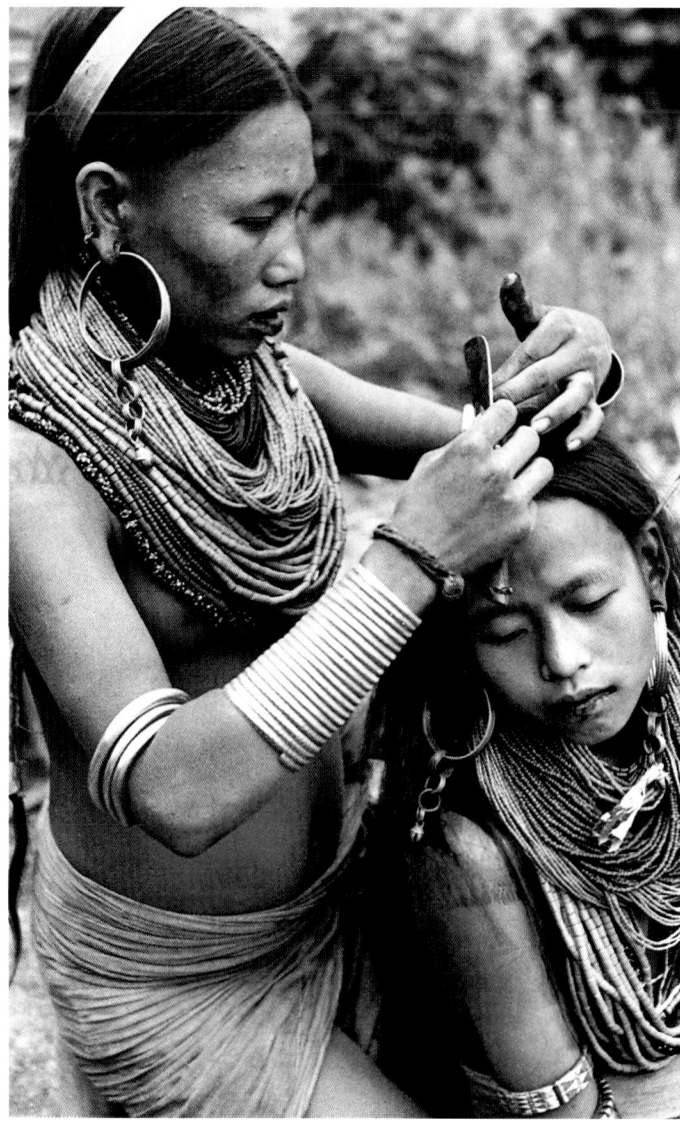

Princess Ngapnun of Longkhai having her hair dressed by her mother for the annual spring festival. This is a good example of the photographs of the Naga taken by Fürer-Haimendorf, which focus especially on the people's dignity and wealth in costume and personal adornment. (CFH/MA/SPNH)

6. Sardeshpande 1987, vii.
7. Hutton 1924, 4, footnote 4.

Naga. Even S. C. Sardeshpande, an Indian Army Major-General stationed for four — the 'best' as he calls them — years on the troubled Indo-Burmese border, who had to fight Naga rebels and therefore could certainly have had a negative outlook towards them, starts his book thus:

Nagas are magnificent! You have to see and live amidst them to believe this simple statement ... There cannot be a better friend than a Naga once he identifies his friend; there cannot be a worse foe than a Naga once he feels deceived and let down.[6]

When in 2002 I was permitted to stay for a considerable time in Nagaland and was struck by the richness of the traditional culture, I developed the idea of comparing my impressions with those of the old expeditions. I was supported in this idea by Alan Macfarlane and his wife Sarah Harrison at Cambridge, to whom I showed the photographs of this expedition. With the enthusiastic view of the anthropologist who has not forgotten to value the material culture of a people, they bent over the pictures. 'Finally we come to learn that this loincloth is blue and not black!', they shouted excitedly, explaining that they had seen only the black-and-white photographs taken before the 1940s which form most of their extraordinary archives on the Naga. They were impressed that so much traditional culture seemed to be still alive among the Naga and, thus encouraged, my idea evolved of contrasting the historic photos and records with contemporary ones. I never imagined that this would lead to two further expeditions into regions that are among the remotest places in the world. It was a thought as remote as being under curfew because of a headhunting alarm.

Outside it has started to rain. We sit around the candle, which is about to die down, drink Scotch, chew on nuts and take bites from a sweet amorphous mass that used to be 200g of wine gums before they were melted by the merciless heat of India. Our thoughts are with the people of Tobu, with whom some hours ago we had a wonderful day and whose carvings at their *morungs* (the traditional bachelors' dormitories) had left us awe-struck. We remember the many pillows and blankets we saw everywhere inside these communal buildings. They prompted Jamie to ask: 'Do the adolescents still sleep in the *morung*?' 'Of course!' had been the answer, contradictory to what we had heard at other places. But tonight we know why. The young men have to be together in one place in order to counter an attack fast and efficiently. Again, Jamie cites Hutton:

By taking the heads of their own side the defeated raiders would carry back the souls of their own dead to add to the store of vitality, fertility and prosperity in their own village, or at any rate prevent the enemy's doing so.[7]

We look at each other and are unified in the wish that this cup may pass by our new friends of Tobu tonight.

Sleep is fitful. Only Toshi sleeps like a bear. He seems to be accustomed to such circumstances. I lie awake and listen to the darkness where, amidst visions of human skulls dangling from cactus trees, I remember how it all began.

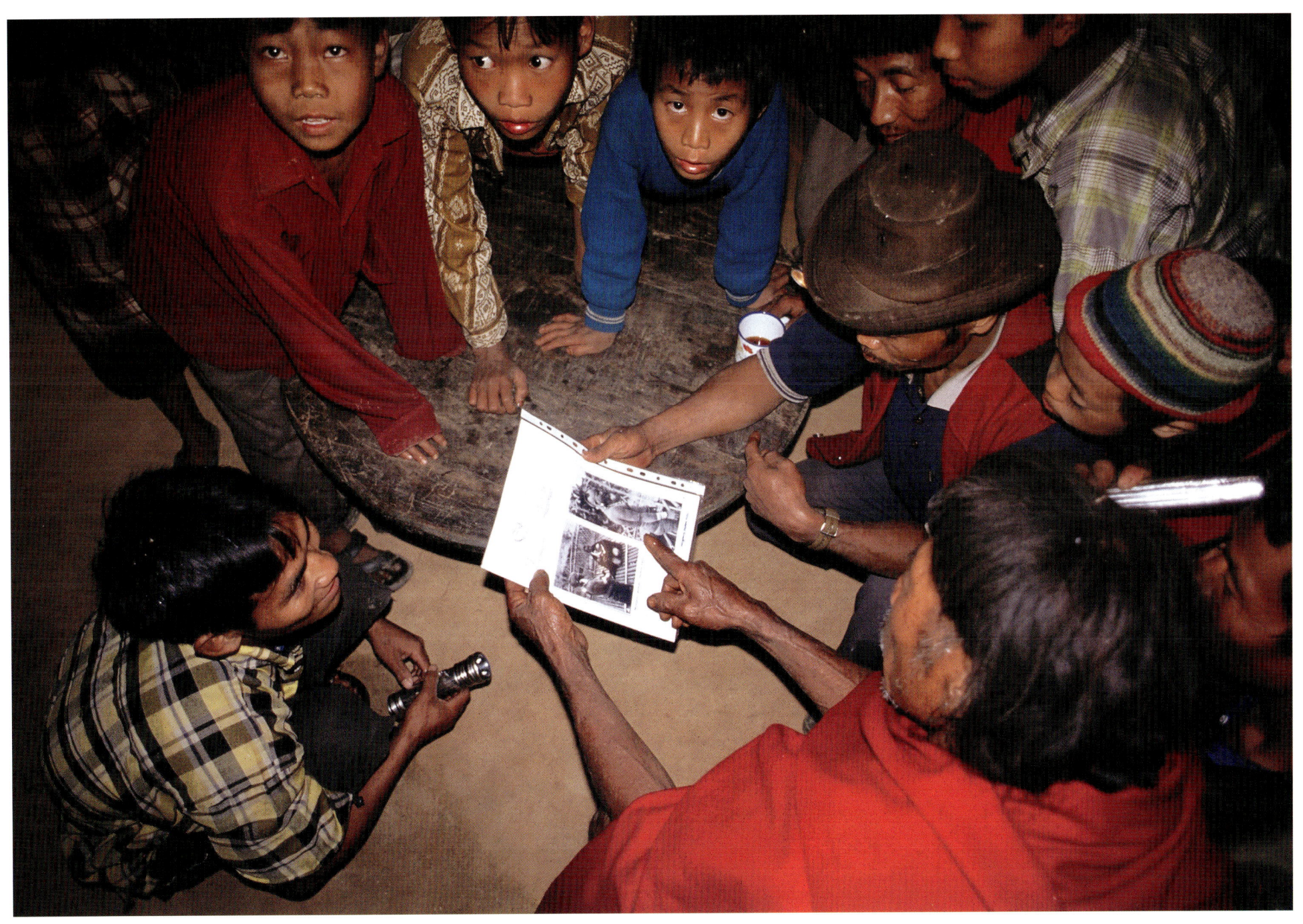

A lively discussion among the villagers of Yonghong over the content of photographs taken by Hutton in 1923 and given to them in 2005 – eighty-two years later.

AMONG THE PEOPLE OF THE CLOUDS

Dibrugarh – Ungma, 28 March 2002

We reach the small airstrip of Dibrugarh in Northern Assam on 28 March 2002, exhausted after twenty-two hours of air travel via Delhi and Calcutta. I had been to Nagaland for the first time in 1996, to the capital Kohima. It was a big disappointment. No fearless, richly adorned warriors, no thatched houses. Instead, corrugated iron and civil war. After a discreet but determined visit to my hotel room from the intelligence department, I left Nagaland just as fast as I had come. I was finished with the place. But then, in autumn 2001, I received a call from the Government of Nagaland. Through Mrs Thangi Mannen, who was Secretary of Tourism at the time, and with my then co-author, Aglaja Stirn, I was invited to travel the state and to document the traditions of the Naga. We were to come in the spring when the people were celebrating their age-old rites by which the soil would become fertile. Thangi spoke of it as a cultural revival, since these festivals had not been celebrated in such a vibrant way since the 1960s. We were hooked, and the following March we set off.[8]

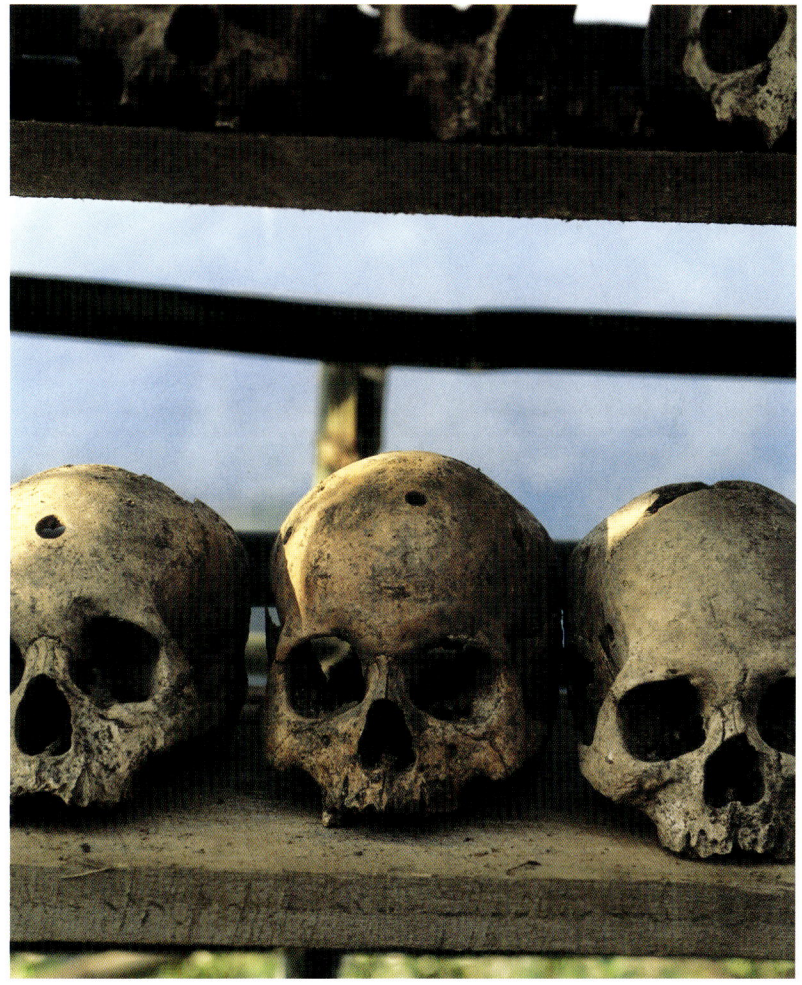

Preceding pages
Longleng District, home of the Phom in the 'Realm of the Clouds', seen from the forests above Yongnyah.

As one of the foremost Naga groups outside the zone administered by the British, the Phom were able to preserve many of their traditions, such as enemy skulls taken in raids (above), and traditional forms of architecture (opposite).

8. For a detailed account refer to van Ham 2006.

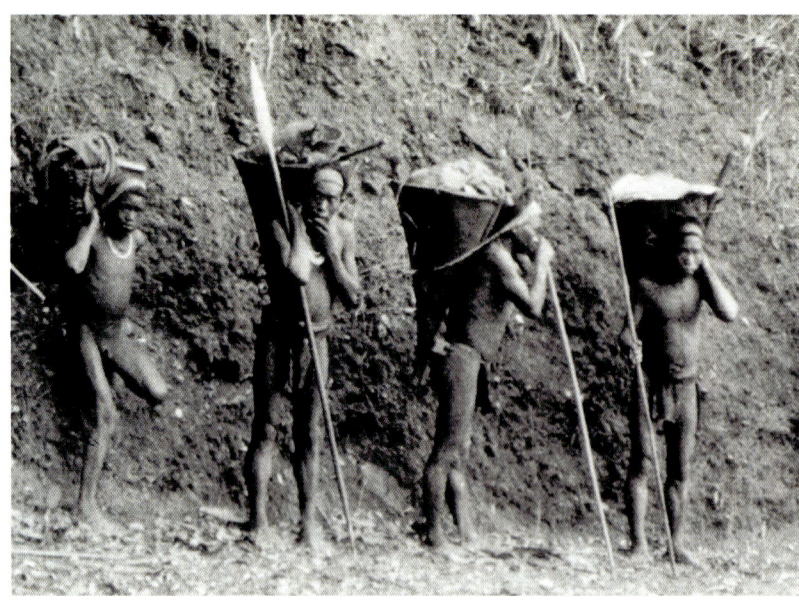

Three Jeeps have been assigned to receive us at the airstrip and take us to the village of Yongnyah. One is supplied by Ashish Phookan, the owner of Jungle Travels India. He is the son of a former Assamese minister for tourism and a good friend of Thangi Mannen. Ashish takes care of our transport and even supplies two of his staff members, Sanjay and Bona, to help us with our work. The other two vehicles come from the Nagaland Government and are to be our escort and security guard. What a difference compared to Hutton's experience, who writes:

April 3rd, 1923 — Left the Assam-Bengal Railway at Nazira and marched east to Luchaipani at the foot of the hills, where we camped. A severe thunderstorm in the night, the forerunner of many, unfortunately.[9]

Hutton's 'we' refers to J.P. Mills, his assistant, but even more so to the battalion of heavily armed Gurkha soldiers commanded by Captain W. B. Shakespear and a couple of hundred porters. As a small oddity he recounts:

Travelling in Nagaland has changed considerably since the 1920s when the British administrators were dependent on porters, recruited mostly from the Sema people, as was J.P. Mills (above and opposite: JPM/GH). Today most of the villages may be reached by Jeep, though most roads are unmetalled and especially bad after eight months of monsoon.

9. Hutton 1924, 2.
10. Hutton 1924, 1.

28

One advantage we had, which does not always attend such trips, our escort included two pipers and a drum, which in the shyest of villages succeeded in luring from obscurity a few of the more curious or musically inclined. Even so, it is possible that our hosts regarded our tunes as intended to blight their crops, although in April, the month of the tour, wind instruments are in season in most Naga tribes.[10]

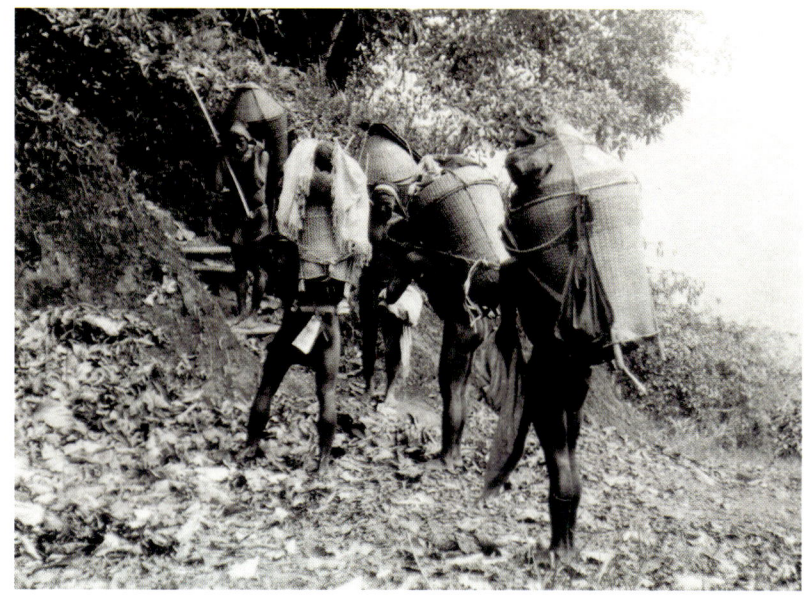

In contrast, we have Hindi songs, Christian rock and Bryan Adams in the car. Soon I ask the driver to turn off the nerve-wracking noise so that I can enjoy the luscious rice paddies and shady tea gardens we are passing. It does not take long to reach the border at Amguri, to complete formalities and start ascending to loftier heights, as is always the case beyond the borders of Assam. I wonder if what Thangi had promised will come true.

Thanks to our interpreter, Temjen Longkhumer, the first days among the Ao at Mopungchukit, Longkhum, Ungma and Changtongnya are very interesting. Next to the Angami, the Ao, however, are the most Westernised Naga group. They were converted to Christianity almost a hundred years ago and are now fervent missionaries themselves. They

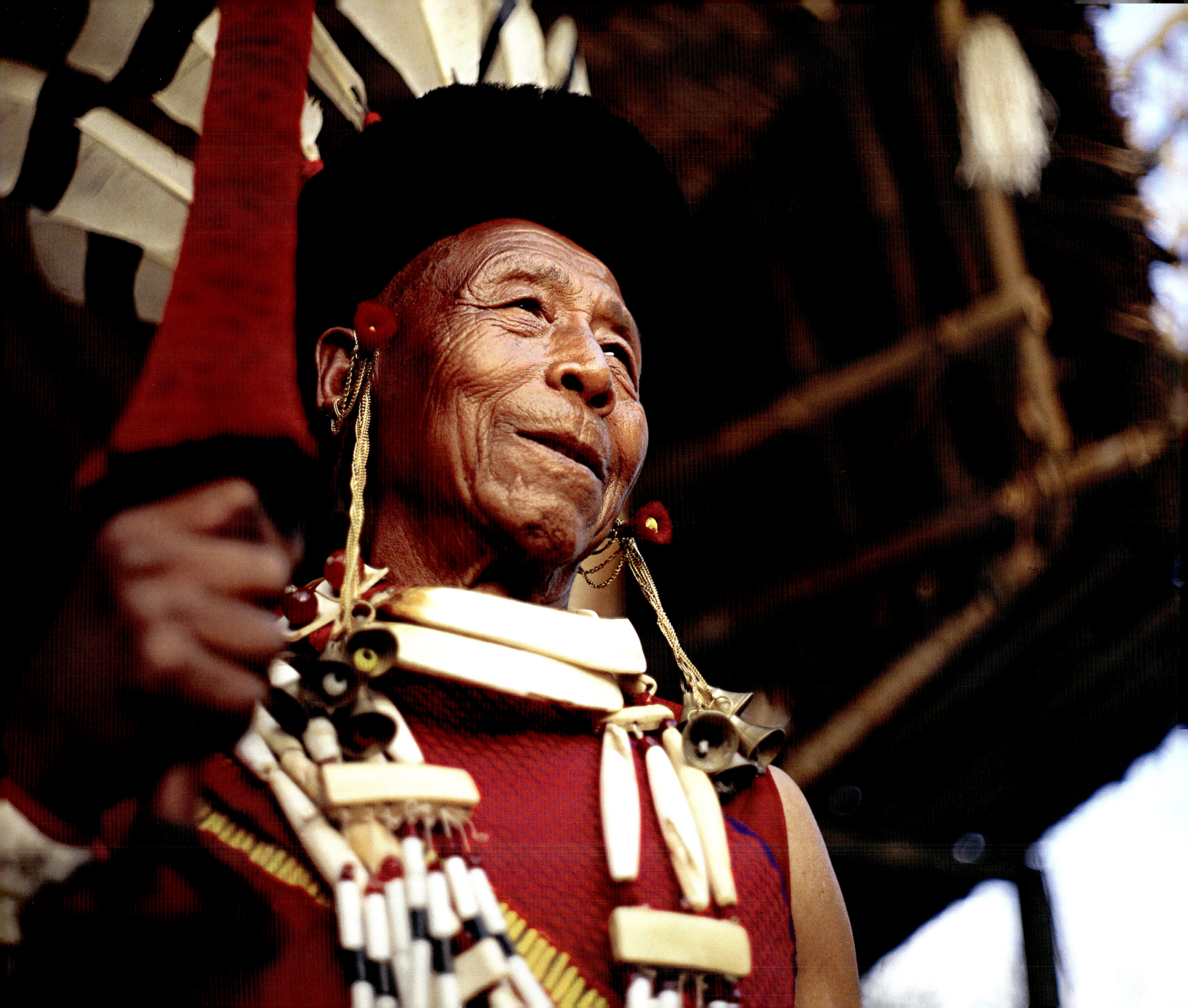

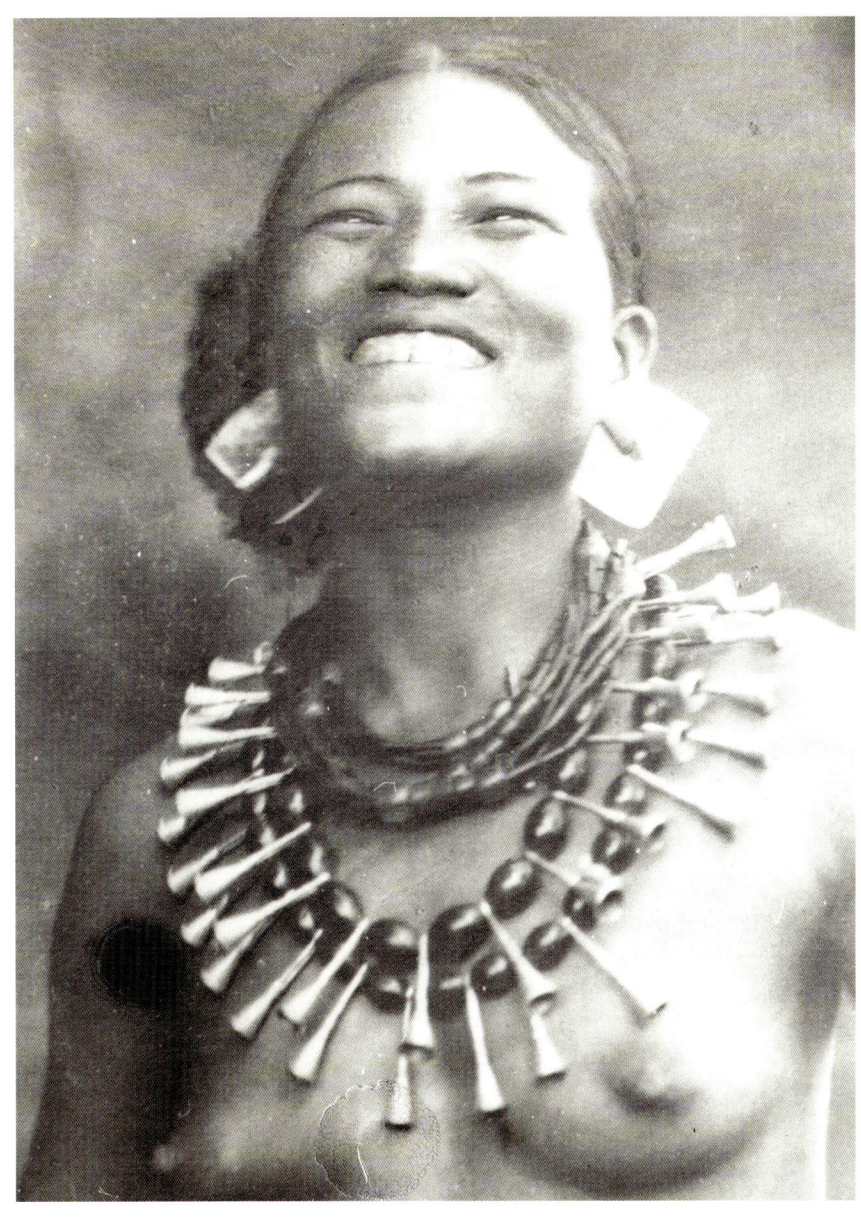

Portraits of Ao people from Ungma.
Opposite: A dignified elder in festive attire, holding a spear that was presented to the author.
Right: A woman wearing a dark blue shawl which signifies her clan and a triple necklace of carnelian and blue glass beads and indigenous silver ornaments. (AS/SVH)
Above: A laughing Ao girl photographed by Mills in the 1920s, wearing rock crystal earrings through her stretched earlobes and a necklace similar to that worn by the woman in the modern picture. (JPM/GH)

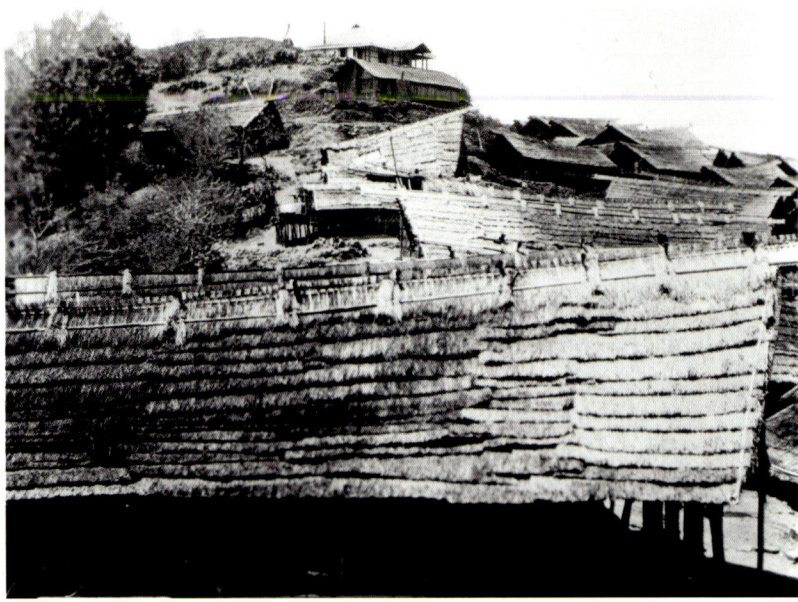

also maintain aspects of their traditional culture, although a concrete *morung* amidst all the tin roofs of their villages seems more folkloristic than part of a true living culture. However, there are a number of impressive songs and stories we come to hear and, at Ungma, we even become acquainted with a group who every three years travel to all the Ao villages to tell people about their past and their traditions.

On 31 March we say goodbye to our hosts and, to my astonishment, Bendangkokba, in whose house we slept, takes me aside and whispers in my ear: 'I have heard you are heading to wilder places now – towards the territories of the Phom, the Yimchungrü, the Khiamniungan and Konyak. Is it true?' I agree and he continues: 'Be careful. These Naga are unpredictable. It is said that among them many of the ancient customs are still alive which have long been abandoned by us Ao. Do you have weapons?' I look at him rather alarmed: 'Why? Will we need them?' 'One can never say what is hidden amidst our misty mountains,' murmurs Bendangkokba. 'But if you are not equipped with weapons at least take one of my spears along.' He brings out a long Ao spear whose shaft is wrapped with shortly trimmed and red-dyed goat's hair. 'This one is made of the hardest of palm woods. In hand and in the air he is well balanced. Always remember: you are responsible for your own and your companions' lives.' I cannot believe what the well-educated brother of the Chief Minister has told me. What ancient prejudices and fears are still alive among these people? But most of all: what if he's right? I am speechless, not least for his valuable gift. Thus, I can say no more than a short and ridiculous 'Thank you'.

Instantly, Hutton's report comes to mind. We are about to enter the village that was responsible for Hutton having to mount a punitive expedition: Yongnyah (Yungya in his diaries). He writes:

> *I should add that one of the first objects we had, was to visit the Konyak Naga village of Yungya in connection with a recent raid in the course of which men of that village had wounded a man of the village of Kamahu,[11] pursued him on to the administered side of our frontier[12] and there had killed him and taken his head.[13]*

I am not sure anymore if I really want to get to Yongnyah village, even though during Hutton's time this must have been a much more dangerous enterprise – as well as military strength, it involved diplomatic skills and empathy for the rather complicated clan structures of Naga society:

> *April 4th — Up to Tamlu, where I met Mills…The three friendly clans of Yungya sent in their headmen to see us here. The village of Yungya is divided into five clans, of which two are hostile to Kamahu and friendly to the neighbouring village of Tangsa, the other three being friendly to Kamahu and ill-disposed towards Tangsa. The former had been responsible for the*

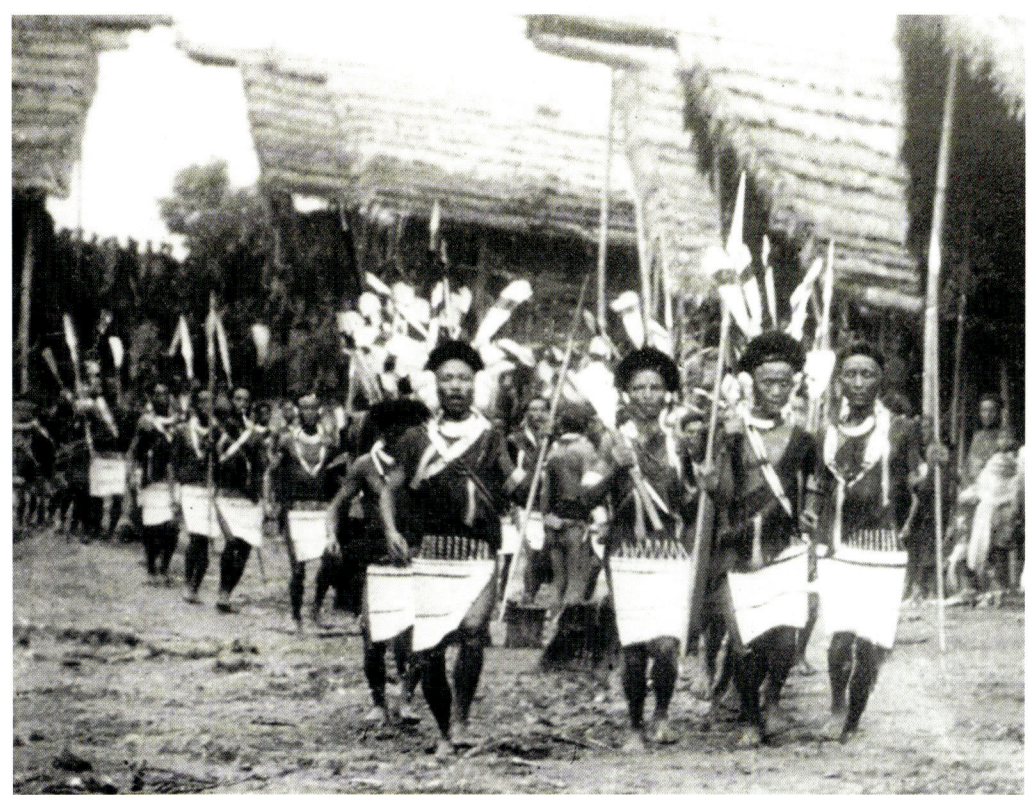

Opposite top: Longkhum village in the 1920s. All the houses are thatched and built in traditional Ao style. There is a log drum shelter in the front and an inspection bungalow erected by the British at the top of the village. (JPM/GH)

Opposite bottom: Most of the present-day Naga villages, especially those in the vicinity of main roads, boast of corrugated iron roofs and have lost much of their former ordered charm (Tesophenyu, Wokha District).

Below and left: The Moatsü festivities among the Ao photographed by Mills in the 1920s at Ungma (JPM/GH) and a view taken at Mopungchukit in 2002.

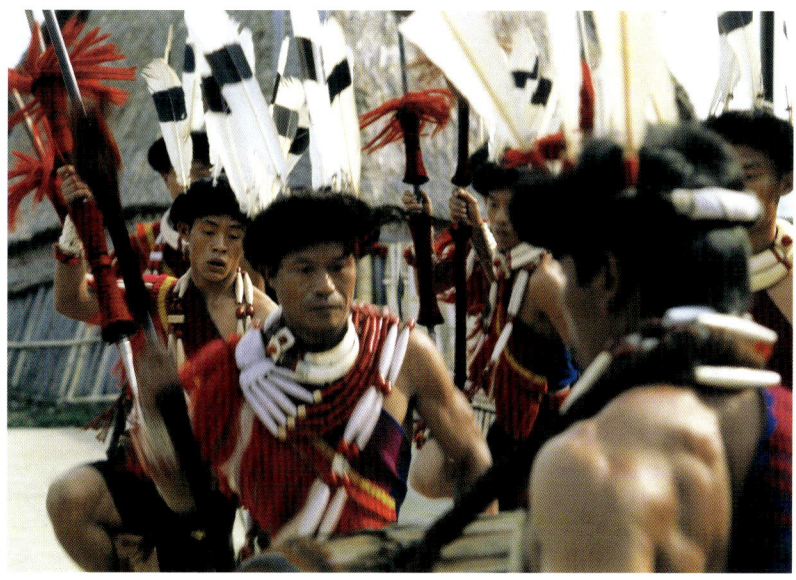

raid. *The Tangsa and Kamahu chiefs also came in, while the Namsang chiefs were there to answer the charge of having received Kamahu meat, viz. part of a hand and a bit of flesh from the head, from their old allies in iniquity.*[14]

At the same time Hutton regrets having to travel with a military escort:

Strangers passing with a strongly armed party through villages whose attitude can hardly be less than suspicious at the best, and is always liable to turn to active hostility as the result of any trifling misunderstanding, do not get much chance of getting to know the people.[15]

In comparison, our escort is rather small and, I think to myself, surely it must be safe – it is the year 2002. Haimendorf lived among the Naga without military escort for more than a year and the Brits left long ago. That the Second World War, when Germany was an enemy to the Naga, is over should be known to them too (and Yongnyah had never been administered, by the way). Thus, I try to take a relaxed view of this adventure.

11. The present village of Yongshe.
12. Located near Tamlu at the time.
13. Hutton 1924, 1.
14. Hutton 1924, 2.
15. Hutton 1924, 1.

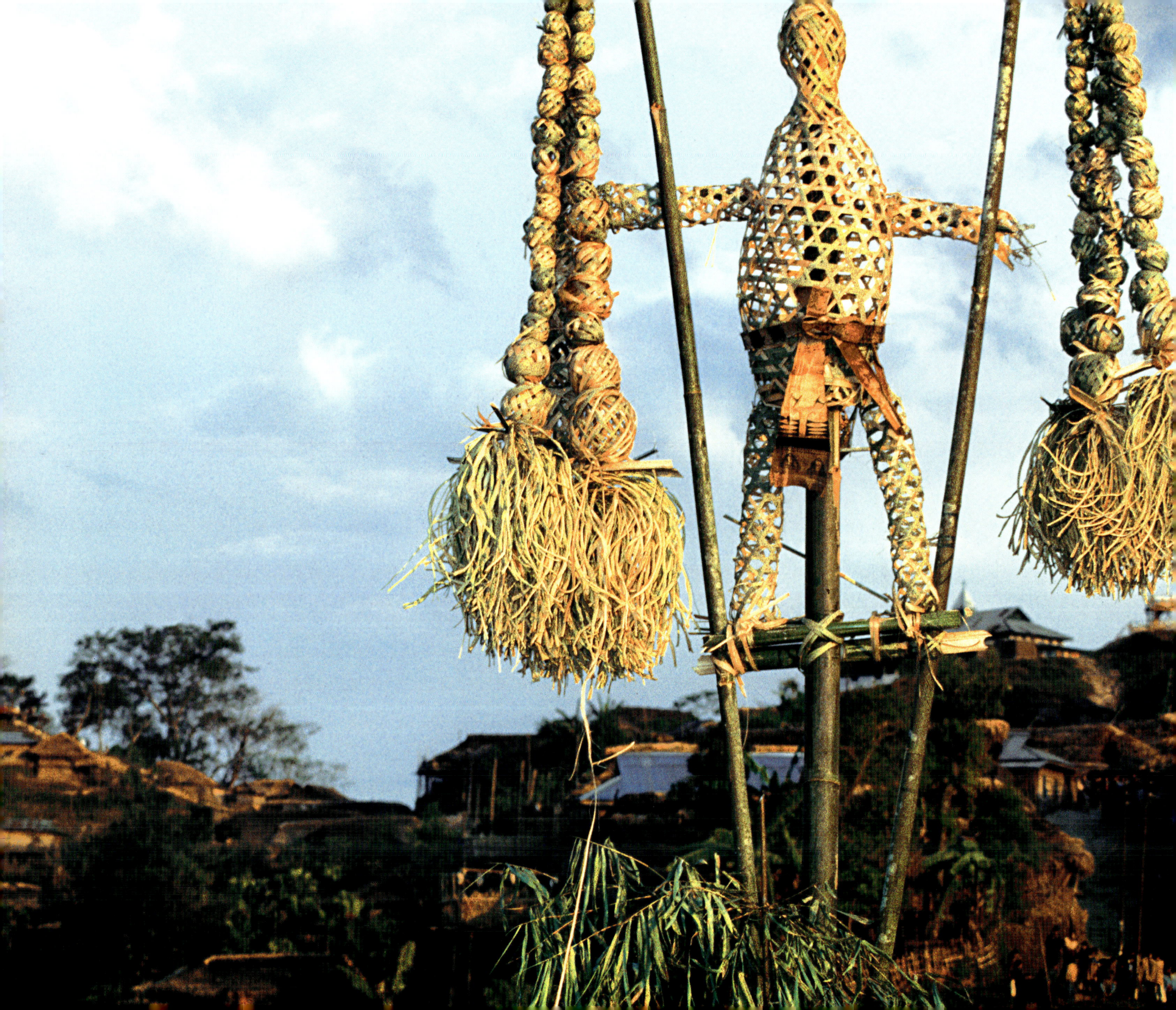

HEADHUNTING SEASON

Yongnyah, 31 March 2002

Driving through the Ao foothills towards the Dikhu river, the land is lit by splendorous sunshine. After crossing the Dikhu via a steel suspension bridge floored with rickety wooden beams, the landscape changes. The terrain becomes rugged, the hills steeper and more inaccessible. The road cuts through dark primary forest that opens to wide highland slopes where fields are cultivated by the slash-and-burn or *jhum* method. The sun is already past its zenith and bathes everything in a golden light. This is the realm of the Phom, their name signifying 'Cloud People', relating to their surrounding, which lies in clouds for most of the year. Only their settlements at the top of the mountains break through the mist, and when morning comes we will also be looking down on to this sea of clouds.

Suddenly at a junction we encounter a Jeep. A heavy, cumbersome man with tiny eyes waves at us and immediately mounts his vehicle without exchanging a single word with Temjen. He takes the lead up the *cacha* road of bare earth and stone that mounts the steep and heavily wooded hill. This has to be the road to Yongnyah. Bumping over countless potholes, which along the muddy road's edge are filled with brackish water, the Jeep swings us uphill mercilessly.

Opposite: A cane figure adorned with a loincloth made from tree bark placed on two bamboo poles in front of Yongnyah's main morung signifies that the seeds have been sown and that a headhunt, the traditional way of spiritually fertilising the soil, may begin

Above: A Phom warrior of Yongnyah on the lookout. (AS/SVH)

November 9th, 1923 — To Kudeh, about 9 or 10 miles, but exceedingly steep going. First dropping down to the Chimongchi stream, then up a very steep slope to the top of the Matong ridge, down again to the Chenyak stream and up to Kudeh—6,712ft.—probably down 3,000 ft. and up 4,000 in the day's march.[16]

Compared to the times of J.H. Hutton, in many ways travelling in the Naga Hills has changed dramatically – in others, however, it has changed very little or not at all. Today the main towns in Nagaland are connected by road. Villages along these main roads are fortunate since they are within reach of communication and many may participate in the developments taking place. However, due to the traditional settlement pattern of establishing villages on hilltops, most of the Naga settlements are remote and not easily reached. Poor *cacha* roads are the only means of getting up to many of these villages by vehicle. Days of marching on foot, as was common in Hutton's day, are generally a thing of the past for the average visitor or official. However, depending on the weather and the road condition, these visits still often need to be made on foot and this method is still the most commonly used by villagers travelling in the Naga Hills.

Over the centuries Yongnyah has gained the status of being the most powerful of all Phom villages and it counts a large number of villages among its vassals. This must have been the same even in Hutton's day:

Yangam was formerly a large and powerful village, they told me, which was eventually defeated by Yungya, treacherously of course, and now pays her tribute.[17]

From his writings about relationships between various Yongnyah clans and other villages, victory over a village did not mean that headhunting stopped in the defeated village. However, powerful 'mother villages' extended support and protection to their vassals when they set out to take revenge. Hutton writes about these confusing circumstances:

Phomching has just succeeded in taking three heads off Yacham, coming round behind by way of Urangkong land. Yacham sent out a pursuit party to Urangkong direct, who threatened to cut up the whole of that rather miserable village if they gave information, and waited in Urangkong itself for the returning Phomching warriors. One of these, the chief, rashly walked into the village, probably hoping to implicate it in the ensuing hostilities on his own side as a party to the raid. The Yacham men rushed out of a house and fell upon him and smote him, taking his head and recovering one of the Yacham heads which he was carrying. The other Phomching men had time to escape, however, though one of them, Kangshi, erstwhile a

An honourable reception by Yongnyah's young warriors…

16. Hutton 1924, 46; 4,000ft is roughly 1,200m.
17. Hutton 1924, 7.

...while a huge crowd of villagers gathers on the hills to see the first foreigners to enter their territory for almost eighty years. (AS/SVH)

Above: The girls of Yongnyah dressed in their finest. The spring festivals are also occasions to seek a potential mate. (AS/SVH)

Opposite: Details of loincloths made from tree bark covered with beautiful ornamental designs and also, as a curiosity, stylised depictions of aeroplanes.

18. Hutton 1924, 3. Hutton's remarks on headhunting are influenced by the British ideal of 'fair play'. For him the custom and the way heads were taken opposed the British concept of a 'fair fight'. Although he includes the spiritual component of headhunting in his interpretation – that it was about gaining a surplus of fertility for one's own clan – he is not able to transcend the thinking of his time. Not much is included in his writings about the ethics, regulations and taboos involved in the practice of headhunting.

19. Hutton 1924, 3-4. It was common punitive practice to burn villages that had disobeyed British law, often including their granaries, in order to deprive people of their livelihood.

Government interpreter at Mokokchung, had to leave his Yacham head hidden in the jungle, which Urangkong afterwards returned to Yacham. The third warrior got his head home safely. Now Urangkong are sitting unhappily on the hedge between Yacham and Phomching, afraid of both, but glad enough to work off any dirty Phom trick on either.[18]

We reach a grassy plateau and there it is – Yongnyah, set majestically on a ridge. Behind it the land drops to a steep abyss and looks out on the villages of Tangha and Nian below. From a distance I can already make out a number of large *morungs*. Is that a human figure hanging from the roof of one of the *morungs*? Distant drumbeats are carried on the wind. Assuring myself that the spear is still on the roof of the car, we continue our approach. We enter the village and face the 2,000 people who live here.

April 8th, 1923 — To Yungya. Water short, and a decent camping ground within reach of it simply not to be had. The hostile clans had absolutely cleared out. There was not even a chicken left in the place, and even the houses were in many cases dismantled leaving only the framework. The whole place was crawling with myriad hungry fleas, the only inhabitants, far too many of whom we brought away with us. Firewood, thatch, even lumps of clay for making pots, was all removed, and we came across some of it hidden in the jungle round the village. Even the great wooden drums had been dragged off into hiding somewhere for fear of what we might do to them.[19]

What a radically different reception awaits our arrival! Unbelievable chaos prevails. A large mass of people crowds the spaces in front of the hundreds of thatched buildings along the village's many ridges. The noise of log drums is deafening. Red. Everything I see is red. The many barefooted girls are wearing short red skirts. Red helmets with long tufts of red-dyed goats' hair adorn the heads of about fifty young and almost naked men who have formed a column for our reception. Their throats emit martial screams. The hornbill feathers that crown their helmets gleam in the light of the setting sun. While waving their long machetes about wildly in their right hands, with their left arms they swing black shields of mithun hide with ornate chalk-white patterns. Their bodies are adorned with masses of jewellery – earrings of flat sea shells from which red woollen pompoms dangle, glass bead necklaces with sea shells, boars' tusks, tiger teeth and carved human heads. Bracelets made from elephants' tusks enhance the muscularity of their forearms. Heavy armlets of cowrie shells guard their wrists. Their black loincloths are embroidered with cowries and buttons and are attached to brownish cane rings worn around the waist. The men suddenly turn around to ascend the ridge, revealing a phalanx of fifty buttocks naked

The ritualised raid begins: two warriors of the Thamji clan defend their territory against the slowly advancing Tangha clan, equipped with locally manufactured muzzle guns (opposite). This and the photo taken at Oting in 1937 (CFH/MA/SPNH), as well as its contemporary equivalent (opposite top), show the tradition among the Naga of ritually re-enacting raids as a vital part of fertility rites. In addition, they serve to relieve stress and to redefine the balance of power between clans.

but for a narrow strip of tree bark. 'A-haa-haa-haa, Wooooooooooohhhhh, Yongnyah, Yongnyah! Wooooooooooohhhhh, Monyü, Monyü!' they scream in unison as they make threatening movements with *dao* and shield.

Then a dignified elderly man emerges from the crowd. His bald head is crowned by a helmet of red-dyed cane to which two boars' tusks are attached. From his neck dangles an iron chain with two long tiger fangs and he holds a spear. His dark glance tells us to follow him along a steep path. Reaching the hilltop, I cannot believe my eyes. Hundreds of warriors crowd inside and in front of the giant Tangha *morung*, which is decorated with great carvings of tigers, elephants, hornbills, fish, mithun heads, monkeys, warriors, and human heads, all carefully painted in natural pigments of black, brown and white. Precipitous as a ship's bow, the thatched roof protrudes into the sky. From the eaves hangs an arrangement of bamboo rings and cane balls which symbolise the heads of slain enemies. From inside the *morung* comes the thud of the log drums and warriors' cries as they wield the long, heavy beaters that narrow down to the shape of hornbill beaks. As I marvel at the craftsmanship of the Phom, I catch sight of two enormous mithun bulls tied to the side pillars of the *morung*. They are licking slimy salt from the hands of two keepers, unaware that this is their final day as they will be sacrificed to the gods of fertility tonight.

Our two warriors join their fellow clan members on the drum. Two more take their place and, with shrieking cries, order us to follow them. We blaze a trail through the mass of people and walk over the highest ridge of the village. Our guides' facial expressions are a strange mixture of apprehension and fear as they take us along a path skirting the eastern side of the village. All of a sudden we hear a crack of gunfire above the beating of the drums, and the shouts of villagers commenting on our movements and local policemen trying to keep them from coming too close to us. We turn around and in the dust-covered streets see smoke rising from locally-made rifles, accompanied by screaming, and then become aware of a group of fifteen warriors jumping back and forth, bowing down and rising up. Their awkward monkey-froggish sort of walk depicts the traditional way of attacking an enemy. Our guides signal to us to hurry up; their defensive shouting is getting louder and louder. The path leads to the next *morung*, that of the Thamji clan. This smaller *morung* has an enormous log drum painted in earth colour with black and white stripes jutting out through its front wall. There is a tiger carved on the *morung's* central pole and beautifully stylised elephants on the side posts. The front crossbeam is dominated by a carving of a human head flanked by rows of hornbills.

Next to the *morung* a bamboo platform has been erected, which is filled with seated clan elders and other people of honour who are drinking rice beer from huge bamboo mugs and mithun horns. On it are displayed a number of ornaments and some old *daos* which are

The Thamji warriors have retreated to the last stronghold of their clan – the morung (left). However, they do not stand a chance against the intruders who mercilessly storm their sanctuary (opposite top). As part of the ritual, one of the defenders is trampled underfoot and pretends to lose his life (opposite bottom).

said to have been used in the construction of the village. Our two warriors take position in front of the *morung*, signifying that they are ready to defend their sacred treasure house against the intruders following us. However, the distance between our 'enemies' and us is getting smaller and smaller. Then something happens that I still find hard to believe. A deafening roar arises and the attackers storm into the house uttering screams and shouts. Our brave guardians do not stand a chance. One of them is literally run over; he falls to the ground and is attacked by two men. In all the chaos of dust, smoke and noise, it is hard to see precisely what is happening but I see the defender lying motionless on the ground when the attackers let go of him. The group vanishes inside the *morung* and shortly afterwards we hear the sound of the log drum. A man next to me leans over to attract my attention and says: 'Very good, isn't it?' He is one of the village pastors, with a bible under his arm.

We too enter the *morung* through its oval doors that signify a vagina and where, upon initiation, a person is considered to be newly born. The attackers are busy beating the

drum at an ever-increasing tempo and chanting triumphant tunes, accompanied by menacing 'He-ho, he-ho, he-ho...!' The men of the Phamjong clan have conquered this *morung* and defeated their neighbours. However, this is not the end of the spectacle. After an orgasmic drum roll, the men take their *daos* and chalk-painted mithun shields and indicate to us that we should follow them. In the golden light of the setting sun, we follow our new patrons who swing their weapons like eagle wings down to their own quarter. Turning up the hill they lead us between closely built houses, the terraces of which are thronging with people watching and shouting at us. Traversing a ridge from which we can see almost the entire village, we make our way to the third and eastern *morung* – that of the Phamjong clan. The Phamjong *morung* is the oldest structure in Yongnyah, which may be ascertained from its state of preservation and the style of its carvings. In front of it is erected a huge stone of peculiar shape which the villagers describe to us as depicting an 'enemy's throat'.

At the *morung* a group of elders has assembled around a huge earthenware pot from which they take turns to suck rice beer. Weasel and marten furs attached to long sticks

Above: Konyak men of Wanching dance victoriously, waving their shields and daos on the joyous occasion of receiving parts of a head that Christoph von Fürer-Haimendorf had taken from Pangsha and dispensed among the villages where he lived and worked in 1936/37. (CFH/MA/SPNH)

Right: Members of the Phamjong clan strike the victory tune on the log drum inside the morung of the defeated Thamji clan.

dangle from a bamboo rack on which is displayed something I can hardly believe: masses of human skulls stare at me through hollow eye-sockets. As I catch my breath, I count sixty-five skulls neatly displayed on three shelves, plus various cranial parts such as jaws and skullcaps. The skulls all have holes drilled into their sides. Formerly, mithun horns had been attached to them, associating the head symbolically with the force of fertility and at the same time rendering them deaf so that they could not hear their relatives calling for them.

In the light of the setting sun the Phamjong men descend to their own quarters, singing and shouting after having ritually proven their superiority over the Thamji clan. They display the same shield and dao moves as Haimendorf had probably seen at Wanching in 1937 (opposite), which is not surprising since Yongnyah is culturally closely affiliated to this Konyak village.

Having "conquered" the Thamji morung the Phamjong warriors leave it again through its oval doors (above). The shape of the doors symbolises the female organ, as it is said that the morung gives second birth to the men. Here they are re-born into their true destiny: becoming mature and serving their community through their "male abilities", such as agricultural skills and enrichening the clan's fertility through their fighting abilities.

Proof of the latter are sixty-five enemy skulls, jaws and pieces of crania, all hunted by members of the Phamjong clan, that have been painstakingly preserved by the elders since ancient times and are now proudly displayed, waiting for the shaman to perform his fertilising rituals on them (right).

47

Right: Detail of the skull and crania collection at Yongnyah; the metal rings indicate a female head. Holes made in the crania were for hanging the skulls on ropes and those on the sides for attaching buffalo or mithun horns.

Below: Some of the skulls Hutton collected at Yongnyah in 1923 displayed at the Deputy Commissioner's bungalow in Kohima for a photographic record before being sent to the Pitt Rivers Museum in Oxford. (JHH/MA/SPNH)

One of the elders gets up and in a dignified voice assigns to each skull its place of origin and owner. Names are even cited that are not those of villages. Through Temjen I ask him how he can recall all these names after so many years. The startling answer is: 'It was customary among us Naga to name the next-born child of our clan after the enemy we had beheaded – provided there was enough time to get that information from him before his death.' This astonishing answer offers the first hint of how much respect and credit the Naga extended to their enemies. To remember the name of every single skull shows a respect that is heightened by the practice of naming a child after a beheaded enemy and indicates a completely different approach to concepts such as 'guilt', which may not have existed among these headhunters and that were not associated with this practice. Hutton had been astonished when he was given the details of the skull collection at Yongnyah:

April 10th, 1923 — They [the soldiers of the escort] did find a few of the Yungya heads, some of which were identified as having grown on Mongnyu and Kamahu bodies when alive…The Yungya trophies consisted of skulls decorated with horns on the lines of those I got from Yacham in November 1921. We brought away eighteen of the best or most typical of

them. Five were complete human skulls. One of them must have died hard, for he was fearfully chopped about, and another had the jaw all broken up and an old spear-head thrust through the skull. I imagine this is to facilitate the spearing of the victim's relations or fellow-villagers, but I have not met with the practice before. Another of the trophies was a human skull wanting both the face and jaw. Grass tassels were hung where the face should have been, and an old spear-head was attached to the base. The horns were buffalo horns, and had grass tassels at the ends of them, above which beans from the huge pods of the sword-bean were strung. This sword-bean [Entada scandens] *probably has a particular association with fertility, doubtless on account of its prolific nature. The grass tassels are attached to the skull to swing and rustle when the owner is dancing with it. Four were human skulls, on which bears' jaws replaced the originals doubtless taken by some other sharer in the head. One skull was divided vertically, and the left half replaced by a piece of hollowed wood with a hole for the orbit. Another was human with a wooden jaw. Three were monkey skulls, representing no doubt human originals, one being surmounted by a bit of cranium and with a wooden jaw, another combined with a human jaw and with several bits of crania, presumably human, strung above it; the third simply a monkey skull with what appeared to be the jaw of a young bear. Perhaps this last represented trophies which had been burnt or in some other way destroyed or lost. One trophy consisted merely of two bits of crania on a knotted string, and two more were basket balls, one with a fragment of cranium attached and adorned with the horns of a serow* [Capricornis sumatrensis rubidus], *the other without horns but with a human jaw and a fragment of bone attached to it. With one exception, the horns on all the other trophies were buffalo horns or else wooden substitutes. The exception had horns of the domestic mithun* [Bos frontalis].[20]

The clan's shaman invites us to sit down and strikes up a murmuring, beseeching tune and all the elders join in. He removes the banana leaf cover, lowers the branch of a shrub into the beer and then sprinkles the rice beer in the direction of the skulls. Finally, he gets up and gazes over the plains. He raises his arms in the air and ends the tune with a penetrating 'Hui!' From the area below us comes the even more resounding answer from a thousand throats: 'Huuuuuuuuuuiiiiiii!'

The tension among the people is slightly relieved. Nevertheless, there is a lot of shouting and we are urged towards the fourth of Yongnyah's *morungs*, that of the Awman or Chingong clan. Many large gongs are hung from the building's terrace – signs of the royal status of Yongnyah. The Awman *morung* also has many carvings, among them black hornbills adorned with white dots and a row of monkeys. Again there is singing and drumming, and a display of traditional artefacts has been prepared for us. Finally, the

Two skulls collected by Hutton and Mills from among the Phom. These display the traditional custom of attaching buffalo horns to the skulls, which signifies their association with fertility and is also thought to render them deaf so that the souls inside them cannot hear their relatives calling. The lower skull is from a raid of Yongnyah against Yongam in 1925 and was presented by Mills to the Museum of Mankind in London in 1949, and the upper one is stored at CUMAA. (both: MA/SPNH)

20. Hutton 1924, 3-4.

Above: A Phom elder with traditional haircut in front of the skull rack. (AS/SVH)

Right: The rice beer ritual at the Phamjong morung.

Opposite top: The shaman in front of the clan's gun collection getting ready to spray the skulls with rice beer. Bottom: The chief of the Phamjong clan speaking to the villagers through the megaphone.

warriors lead us down to Yongnyah's main *morung*, that of the Yongjong clan. We approach it from behind and thus gain a rare sight of the back of a *morung* with carved planks (depicting a tiger, snake, mithun head, fish and hornbills). Finally I get to see what had made an impression on me when we arrived – what appeared to be a human body hanging from the eaves of the *morung*. A plaited cane figure wearing a loincloth made from tree bark has been erected on a frame of long bamboo poles. From its side hang four chains of plaited bamboo balls signifying slain enemies' heads. 'So that the headhunt will be successful' shouts one of our companions and grins at me with his teeth stained red from betel nut.

We take our seats at the village ground in front of the *morung* and then, in the cool evening breeze, I realise that I am bathed in sweat. Rice beer in bamboo mugs is handed to us and an elderly man wearing a hat adorned with brass horns approaches the middle of the festival ground. He lights a fire by the traditional 'firestick' method, whereby a stick of lime wood is split at the front and the two parts are kept apart by a small stone; tinder is then stuck into the slit and a strip of cane is rubbed against the wood until the tinder catches fire. When the fire is lit the old man places an old earthenware pot on it and, shouting a proud tune about the strength of the Yongnyah

people, rams the blade of an ancient *dao* into the earth. This is explained to us as signifying the re-establishment of Yongnyah as the most powerful of all Phom villages. To underline this meaning, many of the warriors who had accompanied us before start a lively war dance.²¹ A megaphone is handed to the dignified elder who had accompanied us to the Tangha *morung*: 'For so long Yongnyah has not followed its age-old traditions,' he says, 'and almost has forgotten them, but thanks to your presence' – he glances in our direction – 'we have been reminded of our former strength. Today we have celebrated the *Monyü* festival the way we always used to do – with all its efforts, pride and glory. And such it shall be from now on. Because we are the mightiest.' Roaring applause breaks out as the men hit their shields with their *daos*. Then the young man who had been run over at the Thamji *morung* steps forward, his body covered in a layer of sweat and dust. One of the elders approaches him and ceremonially places a necklace of four large boars' tusks around his neck. 'A-haa-haa-haa Yongnyah, Yongnyah, Wooooooooooaaaahhhhh Phamjong Phamjong!' screams the young man and raises his arms towards the sky. As if they have been called, five more young men run towards the piazza and join in another war dance.

The amazing day ends with gifts. Cloth, *daos* and beautiful festive hats find their way to us overwhelmed strangers. Over the subsequent dinner we are able to pose a few questions. Most important to us is that we haven't been mere witnesses of a show. On the contrary: what we were privileged to experience was the way Yongnyah used to celebrate its *Monyü* spring festival. Everything was a coherent ritual following various steps:

1. The erection of human figures made from cane to signify the beginning of the headhunting season. This is a symbolic reminder of the olden days as headhunting is now prohibited.

2. A mock fight between two rival clans intended to strengthen the established clan relations (we had this today between the Phamjong and the Thamji clans), and to display the strength and prowess still prevalent among the clans, but also as an initiatory phase mandatory for the successful execution of the third part of the ritual.

3. The 'fertilisation ritual' with the ancient skulls. (A village elder explained its meaning to us in simple terms: 'We still have so much fertility left in our many ancient skulls that it is not really necessary for us to go for a new head. It's the ritual that has to be performed'.)

Concerning the ritually slain, overrun young man at the Thamji *morung*, they tell us that he volunteered to suffer defeat as a representative of his entire clan. In compensation for his scapegoat role, which is traditionally loaded with disrepute, he was awarded the insignia normally reserved for the victor – the boar's tusks necklace, the traditional badge of the Phom headhunter.

21. Stirn-van Ham Archives/SPNH (2004): track 31.

Above: The final victory dance of the Phamjong clan in front of hills packed with spectators.

Opposite: The chief of the Yongjong clan who presented his bark loincloth to the author (for an interview with him refer to the DVD, track 5).

22. Phom, C. 2002.

The village elders then hand manuscripts to us that they have painstakingly put together about their village, their history and the significance of what we have witnessed today. In one of these, Chungda Phom states that Yongnyah consists of 1,286 households with more than 12,000 villagers.[22] There are two churches, four schools and a community hall in Yongnyah. Further discussion is difficult that night. Too jolly is the mood, too curious are the villagers to see the first white people since Hutton, and the rice beer is flowing. Before we have to leave, however, we are able to find out that people here still know the ancient ways of hunting tigers and that the belief in a spiritual relationship between man and tiger is still adhered to – a subject I am deeply interested in. We promise to return and during the affectionate goodbyes one of the clan chiefs hands an amazing present to me: his own loincloth made of bark, which he had not removed for forty years.

53

Clan Feuds and Screaming Morungs

Yongshe, 23 October 2004

November 16th, 1921 – To Kamahu, through the deserted site of the Tangsa clan[23] cut up by Yungya last year, when Yungya took 27 heads or more, though they lost 2 themselves when they came back the next day to polish off the rest of Kamahu which they failed to do. Kamahu is extraordinarily well defended with fences and panjis[24] and the ground on the Yungya side and indeed all round, holds a succession of bamboo spiked fences with the ground in between bristling with panjis.[25]

Yongshe is located so close to Yongnyah on its southern side that its houses may be seen from there. My reason for visiting the place, which during the British time had been called Kamahu, was a monkey skull I had acquired. It had been given by the people of this village to the last British Governor of Assam, Sir Robert Reid, at some time in the 1940s. I wanted to find out more about this strange object, which carries a patina of blood and painted lines indicating the tattoo marks of a slain enemy. Human hair adorns the skull's cap, glued to it with resin (see page 60).

Smoke rises from the main morung of Yongnyah (opposite), bringing back memories of the hostility once reigning between this village and its neighbour Yongshe (Kamahu), as indicated by the photograph taken by J. P. Mills at Yongshe in 1921 (above – JPM/MA/SPNH).

23. Old name for the Tangha clan, which is also present at Yongnyah.
24. A *panji* is a sharpened bamboo stick hardened in the fire. Stepped into they can cause fatal wounds
25. Hutton *Tour Diaries* 1921, n.p.

Above: The cone-shaped peak of Mount Shamong in the vicinity of Yongshe is believed by the villagers to be their mythical birthplace.

26. 'Americans', which is the typical name given by the Naga for any foreigner who is not British, probably due to the missionaries or the presence of American 'listening posts' in the area during the 1940s.
27. Mangthong, Bongtu, Wangjong and Lamien.

We reach Yongshe only in the afternoon as one of our cars broke down and it has taken two hours to make temporary repairs. This village has not been informed of our coming. Thus, practically nobody is present. Everybody is out in the fields. However, the village headman is in and thrilled to see us. Immediately he starts to spread the word towards the fields that four '*amarigans*'[26] had come. Although we hadn't intended to stay and had wanted simply to enquire about the skull, as far as the headman is concerned it is out of the question that we leave the place without enjoying some of its hospitality. Furthermore, he tells us that there will be the inauguration of a *morung*, which we definitely should record. We gladly accept and he organises a number of young men to take us around the village. We marvel at the beautiful location of the village, from which the mythologically important Mount Shamong can be seen in the distance. All of the villagers I ask tell me that this strikingly shaped mountain is the place from which they originated. How good to meet people who cite mythology to explain their origins, I think to myself.

Yongshe consists of four small clans.[27] Nothing seems to exist of the Tangha clan mentioned by Hutton. I remember that Naga villages are not communities according to our definition but are aggregations of clans who have formed a village through peace treaties or other arrangements. However, within the village the clans remain more or less on their own. As I

walk the village streets I think it better not to ask clan-related questions because, as our guide Shayung Phom had already told me, the pain of the past still weighs heavily on people's minds. So, I merely enjoy the *morungs* of Yongshe in the pleasant setting sun. These *morungs* appear particularly 'alive' in the sense that a lot of maintenance and repair work has been done to them recently. Unfortunately, however, the results are not very aesthetically pleasing. Thick layers of synthetic wall paint in garish colours have been applied to the already mediocre carvings. Some of the *morungs* appear to be over-decorated in the sense that all of the traditional symbols indicating headhunting prowess, wealth, strength and so on are often repeated twice or three times and thus look more modern than traditional. To me they appear as a desperate effort to evoke strength. Yongshe had been the victim of many a headhunt in the past. In 1923 Hutton was here for the second time in order to avenge the raids of Yongnyah against this village, and from his report of the incident it can be ascertained that at the time Yongnyah had been associated with Yacham, parts of which Hutton burns down – of which more later.

November 16th, 1921 – One of our Kamahu coolies ruptured a muscle in his brain from pure joy at the downfall of Yacham and had to be carried home paralysed down all one side of him.[28]

Apart from taking into account the context in which Yongshe had designed its *morungs* (and that it could be the artists are simply inept), I have learned on many a journey that one should try to see such things through the eyes of the local people. For instance, in many villages the only houses with tin roofs are the *morungs*. To the eyes of a Westerner, these are aesthetically inferior to the original thatching, but local people regard tin as a material that is less likely to catch fire, as requiring less maintenance, and, due to its price, as a sign of wealth. The provision of tin roofing indicates continuing reverence for the traditional values signified by a *morung* because it involves collecting donations from all the clan members who are by no means all wealthy. Given a choice, they would provide tin roofs for the private houses immediately. However, it is still the *morung* to which the highest reverence is extended.

Therefore, I take the 'screaming *morungs* of Yongshe' as symbols of the people's liberation from the indoctrination and moral hardship they had suffered at the hands of missionaries, who told them that everything connected with their traditional culture was evil and led to eternal burning in hell. Also, Hutton speaks about the missionaries while staying at Kamahu (Yongshe) in 1921:

Meanwhile I was drinking rice beer on the veranda of the chief of Kamahu in front of a Missionary picture of the 'Birth of Samson' in which an angel enjoined Samson's parents (and the general public) to 'drink no strong drink'.[29]

Above: A Konyak man of Wakching prepares one of the skulls taken by Haimendorf from Pangsha for display in the local euphorbia tree (CFH/MA/SPNH). These trees, which exude a milky substance when cut, are still held in high regard by the Naga (opposite – photographed at Yongshe), as they are symbolically akin to the concept underlying headhunting: the plant symbolises the head; the milk inside and exuding from the plant symbolises the fertility which becomes available when the head is being cut off.

28. Hutton *Tour Diaries* 1921, n.p. Unfortunately in 1923 at Yongshe Hutton forgot to ask about this porter's fate.
29. Hutton *Tour Diaries* 1921, n.p.

Although somewhat garishly ornamented, the morungs of Yongshe retain many of the ancient symbols of headhunting and traditional Naga spirituality. Stomping boards at the entrance display the symbols of solar or lunar eclipses. Animal carvings stand for particular virtues: turtles and fish for prosperity; mithun for wealth; tigers indicate strength; elephants equal power; hornbills signify beauty; hornbill feathers convey success in headhunting; and snakes denote freedom from evil influences. The oval doors are symbols of the vagina: the men are initiated into the morung and are born again into their true designation – that of a warrior – as can be seen in the carvings (opposite).

When I return from my walk through the village, our host, unfortunately, has not been able to find out anything regarding Sir Robert Reid's monkey skull. Maybe he does not want to – the skull is a relic from the past. However, a painting is shown to us of Yongshe's first translator, H. Bongngoi Phom, who had served among the British at Mokokchung between 1918 and 1946 and thus could have been acquainted to Reid and could have had presented this skull to him (presumably at Mokokchung).

The evening comes and the villagers return from their fields. Whoever has not found out already about the rare visit tonight is now instructed by the village headman. I am touched to see the faces of the people when they realise and, after a brief glance at us, immediately hurry towards their homes. 'They want to be especially beautiful tonight', explains the headman. Word reaches us that not only the Mangthong clan but all other clans have spontaneously decided to celebrate our presence at their respective *morungs* and perform certain rituals in our honour. Although we are a bit worried about the state of our Jeep

SHRI H. BONGNGOI PHOM, YONGSHEI VILLAGE (KAMAHU)
FIRST D.B DURING BRITISH GOVT PERIOD FROM 6TH FEB. 1936
TO 1946, SERVED AT MOKOKCHUNG TOWN

and how we will reach our quarters at Longleng tonight, it is clear that we simply cannot refuse this offer or disappoint the villagers – not to mention our being moved by so much amazing hospitality, of course.

An hour later, a dozen or so Phom women appear in their finery and dance and sing their hearts out, led by a woman swinging a shaved bamboo stick as a baton. As soon as they are finished, people start rushing towards the Mangthong *morung*, where the inauguration celebration is to take place. Although it is pitch black, the entire village is wide awake and everybody is on their feet. Torches lend a mysterious light to the area, and we stumble through the rocky village streets. All of a sudden gunshots are heard. We have reached the Mangthong *morung* and see two parties of people in full war dress confronting each other. The defendants have positioned themselves on the platform in front of the *morung*, screaming and waving their *daos* and beautiful mithun hide shields which bear chalk-white sun motifs. The aggressors come creeping from the open space, ducking and rising again, quite like we had already experienced at Yongnyah. Each party sings a different tune, which leads to an eerie and threatening soundscape.[30] The aggressors take formation and in unison jump forward further and further towards the *morung*, firing their guns with every jump. The defendants' song and cries get louder and louder, and when the aggressors reach the steps of the *morung* a mock fight between the parties begins, the defendants hitting their enemies with their shields and the aggressors trying to push their way through their lines. All this is accompanied by an enormous and deafening roar from fifty or more throats, gunshots, the rattling of *daos* and the banging of shields. Finally the defendants give in and, still screaming and shouting, the aggressors storm into the *morung*.

What is surprising now is that both defendants and aggressors unite to strike a tune on the log drum. This is completely different from what we have seen in Yongnyah. But later, when the ritual is over and we can pose some questions, the whole drama is explained to us as the traditional ritual to inaugurate a *morung*. The aggressors actually belong to an associated clan and have been invited to join the festivities. Before they are allowed to enter the *morung*, however, it is compulsory to engage in a mock fight in order for the true inhabitants of the *morung* to demonstrate their strength and fighting prowess. That the 'associated aggressors' invade the *morung* is a deliberate expression of the united strength stemming from combined forces.

It is getting late. The people have brought unbelievable amounts of food. It is hard for me to grasp all this hospitality and it makes me sad. As we leave the village in a cloud of diesel fumes – our vehicle urgently needs repair – the whole village is present and everyone waves at us. In the headlights I catch glimpses of laughing faces and waving hands. The children are running behind us. The headlights touch the ferns and the tree

trunks and then the Jeep dies. All we can do is get out and push, but without success. I don't want my recent experiences to be buried in the stink of diesel and, as I have little knowledge of engines, I leave, trying to reach Longleng on foot. It is wonderful to hear the voices of the swearing drivers fading away and dissolving into the chirping of cicadas. A glistening full moon lights the path making torches redundant. I walk down the *cacha* road in silence for two hours. I have to admit to a touch of fear – there are supposed to be tigers still present in this area. But just before I reach Longleng, our Jeep joins me from behind. I could have managed those last few metres alone.

Opposite top: A painting of H. Bongngoi Phom, Yongshe's first translator for the British, who worked between 1918 and 1946.
Opposite bottom: Sir Robert Reid's monkey head, a present he got from Yongshe (Kamahu). (VH)

Above: Mangthong morung being ritually stormed for its inauguration (see DVD, track 6 for details).

30. Refer to DVD, track 6.

Retaliation and Healing

Yachem and Yaong, 25 October 2004

When I awake the next morning in Longleng I am greeted by the fantastic sight of the village of Hukpang covered with morning mist, which gradually descends and then dissolves in the day's rising heat to reveal dense and dark green forest and the village perched on a narrow ridge.[31] Because of a village *genna* (taboo period) due to a conference of church representatives, we may not enter Hukpang today. Therefore, we set out to visit our guide Shayung Phom's home village, Yachem, and its neighbour Yaong, towards the border of the Ao country. Hutton visited both villages in 1921 to avenge a raid by the Yaong people on the Changs:

> *November 12th, 1921 – Have come to know that the Chang had made an attack in comparatively small numbers on Yacham after establishing friendly relations with Yong,[32] but that Yong had suddenly turned and attacked them in the rear. The Changs escaped with the loss of 14 killed and one captured – very cheap indeed seeing that they were taken in the rear in Yong village and attacked inside and from the terraces of the houses and entirely surrounded. It was a piece of particularly dirty work by Yong, who would have been wiped out by the previous Chang expedition which was a very*

Opposite: The shaman of Yaong calling to the spirits of all four cardinal directions to participate in the healing ritual.

Above: A hand and a foot of a beheaded Chang from Mongtikung village hanging from the head tree at Yachem in 1921. (JHH/MA/SPNH)

31. Refer to DVD, track 1.
32. Yacham is the present Yachem, Yong the present Yaong.

Thick primary forest covers large tracts of Longleng district. In the 1920s this made expeditions to hostile villages, as undertaken by Hutton and Mills, a dangerous exercise. (Above – JPM/GH)

33. Hutton *Tour Diaries* 1921, n.p.
34. Hutton *Tour Diaries* 1921, n.p.
35. Ganguli 1978, Plate 3, 1 and 4 top; Ganguli 1993, 61.

big one, if Koma of Yamrup had not saved them by turning the whole lot back when he found that Yong was likely to suffer. I sent a message to Yacham that they were to see that the prisoners came to no harm, Yacham having the reputation of resorting to horrible tortures of their prisoners.[33]

Getting to Yachem in Hutton's day was an entirely different experience from ours. Five days later, when on the actual journey, he wrote:

November 17th, 1921 – To Yacham. The road was panjied against us all the way with fresh panjis put in that morning or the day before all across the path. We expected an ambush and the four Kamahu Nagas who helped to clear away the panjis were very cautious and kept their shields up all the time they were not using them to flatten panjis. The jungle was very thick in places along the sides of the path and we had to put out flankers through and altogether we crossed the 7 miles or so in 9 hours, to find that Yacham had either never meant to make a stand or had thought better of it. They have received a message through Tangsa that we did not want to harm them and that they had better stay in their village, but they preferred to send their women and children across the Dikhu inside the district, where they well knew they would be safe, and to desert the village after sowing the place with panjis.[34]

We reach the two villages, which have expanded so much that they have now merged, after a three-hour drive through hilly landscape alternating between dense forest and *jhum*. Shayung takes great pride in showing us around Yachem. We meet his parents who serve us great food in the modern house Shayung has built for them. The last Westerner to visit the villages was the Czech writer, Milada Ganguli, in the 1960s: through her marriage with a member of the Tagore family, she was able to attain rare special permits to enter Nagaland. She published valuable accounts of her trips and in Yachem and Yaong took photographs of *morungs* that are among the most amazing structures I have ever seen.[35] We want to find out what is left of these buildings which, according to Ganguli, were already decaying when she was there. Unfortunately, none of those original *morungs* have remained, although the villagers recall them when I pass pictures around. There is even a stone erected at a memorial site on which stood the 'original' *morung* of Yachem. The villagers are grateful for the photos and looking at them seems to bring the old days to life. A student leader who has opened a small museum says he would even try to convince the villagers to re-erect 'Ganguli's *morung*' as a sort of legacy to the past – although he might run into trouble with the church due to the *morung* being so heavily carved with symbols relating to ancient beliefs and headhunting. He is happy to show us the artefacts he has collected over the years and I take a particular liking to two ancient *dao* sheaths. Contemporary sheaths, which are equally artistic, are shown to us in a lively dance that the villagers perform in our honour.

The Phom are famous for their elaborate dao sheaths, none of which display the same design but are artistic expressions of personal achievements such as tiger and/or headhunter status.

65

Top: The photograph of the amazing morung at Yachem taken by Milada Ganguli in 1968. (MG/VH)

Above: Modern carvings and paintings on a newly built morung at Yachem.

Opposite: Parts of ruined morungs are incorporated into the new structure at Yaong. The carving style of the human being is unusual in showing close similarities with the style of the Zeliangrong and Angami, who inhabit the southern border of Nagaland and adjacent Manipur and Assam. The fence supported by rows of monkeys is unique (far right and see also overleaf), as was noted by Henry Balfour in his line drawing of 1921. (MA/SPNH)

36. Hutton 1924, 69.
37. Yaongyimchen V.C.M. 2004. Presumably the villagers perceive Jackba and Jangma as their ancestral villages.

The modern *morungs* are rather disappointing. Most of them are concrete with tin roofs. However, they have two interesting features: fantastic bamboo roots project from the gable edges, a fact that Hutton had noted as being 'so beloved of Yacham';[36] and the log drums stored in them have a combination of Ao and Phom features. A walk through the village, which is divided into clan quarters, shows that the Phom of Yachem have preserved a style of architecture which combines features of traditional Ao architecture with that of the Phom. The flying ridge with a miniature roof that continues beyond the main roof is a style common to Ao architecture, but then a secondary semicircular roof protrudes from the gable under it, as is found in some houses in Phom villages. This same flying ridge occurs in the *morung* architecture.

By far the best *morung* in terms of carvings is preserved in Yaong. The people here have taken the ancient carvings of a *morung* that had fallen into despair and have incorporated them into a new concrete structure. Similar carvings can be seen in Ganguli's photos – the monumental elephants with curiously tiny ears that are more like those of a bear, and rows of monkeys forming a fence are particularly expressive. It is here that I first notice a motif that is more common among the Upper Konyak – a tiger approaching a human being and reaching towards him with his claws.

It appears that stones are still greatly revered in Yachem and Yaong. At every *morung* there are stones of peculiar shape on display as well as indications that these are used in various rituals. We are allowed to witness one of these rather complex four-part rituals at Yaong. The clan elders have gathered in their finery. Swinging sticks decorated with bushy red-dyed goat's hair, they dance in front of the *morung*, inviting the spirits as well as the people of associated villages to take part in the ritual. Their dance is accompanied by a song:

We are sending the best of the best of meat to you. This can be yours to share. Accept it instead of the flesh of man. So do not take the shadow of man but bless the meat of our animals. In the name of the two villages Jackba and Jangma may the blessing of this earth remain like the rainfall from the skies on this village.[37]

The village elders have prepared a manuscript of the ritual for us. It sets out traditional forms of healing, which Hutton described eighty-four years ago, saying that 'illnesses occur if the spirit catches a person's shadow'. Hutton noted that the Naga interpret sickness in the sense that a person has lost his shadow and the shaman has to call it back in order to reunite body and shadow so that the person may be cured.

In the middle of the square in front of the *morung* a man has taken his seat – guarded by the glass-beaded eyes of a tiger carving. This man is said to have 'lost his shadow' and thus has

Morung decorations among the Phom and Chang indicate the clan's achievements and merits. Variations of palm leaf tassels symbolise human hair in which part of a person's fertility is believed to reside. Bamboo roots, often in fantastic shapes, mimic hornbill beaks and stand for fertility and growth as do the sheaves of grass, cane cornucopias and rows of small bamboo spikes on the ridges overlapping in V-fashion. Cane balls symbolise hunted heads (this page: morungs at Yachem and Yaong; opposite: Pongo, Yachem and Tuensang).

The healing ritual at Yaong*. Above from left to right: The elders place themselves as spectators beneath the morung's impressive carvings; inviting the earth spirit to send its healing powers through the stones placed amidst grains of rice as an offering on the cane platter; inviting the lost shadow to return and binding it back to the body.*

Opposite: The shaman dances amidst the elders during the invitation of the spirits to participate in the ritual.

38. Refer to DVD, track 9.

fallen sick. One of the elders moves to the side and positions himself beside a cane platter on the side of the *morung*. It is filled with rice grain on which are erected six stones. These signify the six ancestral stones of Lungtrok from which the people of this part of the Phom area believe they have originated. The central, black stone – called *checklon* – has a special position as it is said to be the stone through which the earthly blessing is received. Waving a banana leaf, the shaman prays to the stone and loudly calls out in all directions to receive spiritual blessing. Then he turns towards the man sitting in the middle. The shaman waves the leaf over his head and sings in the direction of all of the neighbouring villages and forests to find out if the lost shadow is roaming there. In his song he offers the spirit, who had kept the sick man's shadow in custody, the meat of a sacrificed cockerel instead. He reminds him of the reigning powers of the earthly spirit, which had been invoked at the rice platter before and thus is still present. Then, all of sudden, he breaks the banana leaf in half. This, as the people explain to us, causes the 'lost shadow' to return immediately to the patient's body, thus curing him. The healing of the patient is finally celebrated by all the participants beating the log drum inside the *morung*, a special rhythm and song indicating their gratitude to the spirits.[38]

Hutton's day in Yachem, however, did not end as harmoniously as ours:

November 18th, 1921 – As Yacham had refused to come in and panjied their village, I burnt part of it, and destroyed the defences. Most of the clan quarter, which I had not burnt, caught fire mysteriously, probably from a spark, and got burnt as well. It was unfortunate but almost inevitable. As Yacham had said quite clearly that they did not intend to obey any orders, but if we burnt them would only go and raid Kamahu again, as they could rebuild as easily as we could burn, I thought it advisable to do something more than merely fire their houses, so we put the Kamahu coolies to clear up the pig, and the Chang coolies to catch the mithan [mithun]. We caught 7 mithans and two calves, and a considerable number of pig. The diet of unlimited pork made several of the coolies ill but the Kamahu coolies revelled ecstatically in their work.

The camp was made almost uninhabitable by the pungent smoke from the village and the burnt sites of 300 houses made a melancholy spectacle, and I could almost credit the Yacham elders with the thought which Tacitus ascribed to Caractacus, 'Desertum faciunt, pacem appellant.'[39] *It is to be hoped that our remote ancestors were less unpleasant than the men of Yacham, but in any case one is only teaching to others the lesson we had to learn from Rome. There really isn't any other way of making a Naga village behave itself and at any rate it was satisfactory that no one had to be killed by us – though there are 3 or 4 men of Yacham who would not be missed at all by anyone.*[40]

Opposite: The women of Yaong pound the rice as it has always been done among the Naga, by hand at huge pounding tables accompanied by an impressive trance-like song (refer to DVD, track 10). Especially among the Konyak, these tables tend to be huge and ornately adorned.
Top left: Longkhai, 1936. (CFH/MA/SPNH). Top right: The pounding table of the Ang of Mon, where a law prohibits people from owning one larger than this. Above: A pounding table divided into three carved sections at Yonghong.

39. 'They deprive it of people and call it peace'.
40. Hutton *Tour Diaries* 1921, n.p.

HEADHUNTING HEROES

Pongo, 1 April 2002

April 13th, 1923— To Pongu. Like Mongnyu, it has, I believe, never before been visited. The whole village was effusively friendly, and had a line of contiguous vessels of rice liquor lent against a low rail and stretching for about 150 yards along the path for the column to refresh itself after its climb. The village is a very stony one and with exceedingly strong defences– ladder, wall, ditch, wall, ladder, palisade, ladder again, wall and then solid wooden door. We estimated the number of houses at about 180. Pongu is permanently at war with Hukpang and dislikes the idea of making peace with Hukpang, as that village is so notoriously treacherous that it is a great deal safer to be at war with her. Knowing what I do of Hukpang, I think the men of Pongu are wise.[41]

Reaching Pongo, as Pongu is called today, which is about an hour's drive from the District Headquarters in Longleng, we find nothing remaining of the old defences. The villagers, however, are friendly. No wonder – it is the season of the fertility festival, *Monyü*. For six days all of the Phom villages will be celebrating according to the same schedule:
Day 1: *Shamthung* – beating of log drums to signal the beginning of the festival;
Day 2: *Yiüjep* – brewing of rice beer;

Opposite: With a watchful eye an old women of Pongo observes the dance performances of the young warriors on the occasion of the Monyü festival.
Above: As it was at Oting in 1937, the celebrations begin by beating Burmese gongs with stone beaters. (Bottom: CFH/MA/SPNH)

41. Hutton 1924, 10.

Day 3: *Aiha Okshok* – getting together, feasting and dancing;
Day 4: *Ching-i-Okshok* – visits of relatives and sacrificing of animals;
Day 5 & 6: *Yenthü* – wearing of traditional costumes, feasting and dancing, playing games.[1]

In an open space below the village next to the thatched granaries, a *morung* has been erected according to traditional standards as a temporary housing for the many celebrities, including politicians, and our patron, Thangi Mannen. She and her department have selected the Phom *Monyü* at Pongo as the festival to which they will lend special financial support this year.

From all over Longleng district, groups have come to present a cross section of Phom culture. Differences in dress indicate the various groups. The Pongo crowd is easy to recognise by the distinctively shaped bandeaux made from bamboo leaves and the cane leaves stuck through their earlobes. Most of the older women display facial and leg tattoos. Next to the festival ground, the villagers have prepared a kind of 'display of traditional customs' – basketry, weaving, pottery, ironwork and the making of gunpowder with the aid of ground crystallised human urine, the ammoniac of which gives the gunpowder its explosive effect.

Above: Pottery among the Naga is done without the wheel but by shaping clay around a stone with various hammers.
Right: Crystallised human urine being ground and mixed with the rest of the ingredients used in gunpowder production.
Opposite: The true dignitaries of the festival are half a dozen old headhunters seated in a specially erected hut, distinguishable by their chest tattoos and jewellery. (Portraits: AS/SVH).

42. Phom, P. 2002.

Next to the *morung* a smaller bamboo and thatch house has been erected for the local dignitaries. A group of five old men dressed in nothing but loincloths approaches the site, carrying spears and long *daos* in sheaths on their backs. They are introduced as 'village heroes', former headhunters, as can be ascertained by their chest tattoos which depict the 'fountain of fertility'. What better symbol could there be? Only he who has presented his clan with a surplus of fertility (through headhunting) is permitted to wear it and is considered to be a 'carrier of great fertility'. Most of the old men are wearing double boar's tusk necklaces and brass medallions consisting of two to five human heads underlining their headhunting status. One of the heroes wears his hair wound round a thick wooden tile, and has long strands of black human hair hanging from his chank shell earrings. With great dignity and pride, they take their seats and wait for the festivities to begin.

The sound of a huge gong played by a man with a round stone indicates that the festivities are about to start. Groups of men and women perform dances and songs and watch each other closely. Festivities such as these are still occasions to get acquainted with each other, to fall in love, to find a potential mate. The old women watch the young men performing war dances, commenting and applauding, or even denigrating certain moves of the dancers. We watch the program and during a break decide to take a walk through the village.

Monyü is celebrated in great gaiety. One of Pongu's clan chiefs carries his basket displaying monkey skulls painted red, which indicate his headhunter's status, and drinks from an ornately painted bamboo mug reserved for high dignitaries of his clan. The women's dances and songs of Pongu, all performed in rich festivity dresses, are noteworthy for their complex harmonies.

Left: From all morungs at Pongo comes the massive sound of banging on the log drums. Some Phom groups have incorporated into their festival dress the beautiful sun motifs painted with chalk onto their mithun hide shields (as seen in Pongching in 2006).

Opposite: In 2006 similar carvings as aroused Hutton's attention at Pongo in 1923 (line drawing – JHH/MA/SPNH) were found at the Ang's house at the Lower Konyak village of Leangha.
(All photographs – GG)

43. Hutton 1924, 10-11.
44. Elwin, 1958, 153, 176. See page 85.

April 13th, 1923 – Pongu. One morung, at the edge of a cliff, had two posts to the outer veranda, carved with a man and a woman respectively, which particularly took my fancy, as the figures were combined with the posts in a way I have seen nowhere else in these hills, the usual method being to carve them completely in relief and to adze away the post flat behind them.[43]

We find five modern *morungs* in the village, with carvings that, from a traditional artistic point of view, are of little interest. None of the carvings illustrated in Verrier Elwin's book, *The Art of the North-East Frontier of India* (1958), have remained.[44] However, there is a great atmosphere everywhere with people feasting in all the *morungs*, singing and beating the log drums. And considering how often fires break out in the chimneyless houses that spread in no time at all, the fervour of the people in re-erecting their beloved *morungs* is truly admirable. Due to the danger of fire, granaries in every Naga village are erected on the outskirts. Here at Pongo these 'outskirts' are idyllic copses close to the festival ground.

Naked and at One with the Universe

Nian, 18 October 2004

Nian is a village that I have longed to visit ever since seeing pictures of some of the most impressive examples of Naga art in Verrier Elwin's book, so I was very excited when I heard that we could go there.[45] The *cacha* road takes us eastward alongside Yongnyah's paddy fields towards lower altitudes. Nian is situated on top of a gentle hill in rather open territory. Compared with the lofty position of Yongnyah, I can understand why Nian is its subordinate. I can imagine the old raids and how the warriors of Yongnyah headed towards Nian to 'fill up with fertility'. In winding curves the road continues down into the valley till at last it ascends through thick jungle and finally ends up at the main village square. Chicken, dogs and pigs scatter in panic and the villagers receive us full of excitement and hospitality. They stop, let go of their heavy baskets, and some even head back to the village square to find out what rare guests are hidden behind this Jeep's windows.[46]

Entering a village is always a very special moment. These faces full of expectation may never have seen a white face in their lives. Where else on earth has something like this

Opposite: Nian village behind one of its slash-and-burn fields, located in fairly open territory.
Above: Again, a huge crowd of villagers is trying to catch a glimpse of the first foreigners to visit them in 50 years. The three roofs indicate differences in local meaning and status of the people living beneath them. Foreground – morung; middle – rich man's house; rear – commoner's house.

45. Elwin, 1958, 177.
46. Refer to DVD, track 1.

Right: Chingda morung, Nian's "eco-morung" – a "true place of fertility" – as indicated by the various grasses and plants growing from its thatched roof. The moss-covered stones on its right are all connected to headhunting. Often enemy skulls were buried underneath them or hung from the menhirs.

Opposite: Phom morung carvings photographed by Verrier Elwin in 1954. (Clockwise from top to bottom) Warrior leading a boy by the hand at Sakchi, commemorating an incident when a boy was captured, and, after being led through the village, decapitated; a buffalo head and two warriors, one with a gun, at Nian – possibly rebuilt at Jaiching morung (see overleaf) – displaying the local penchant for chalk face painting (see p 90 ff); 8 ft (2.5 m) tall warrior with chest tattoo approached by a tiger at Yungphong; row of hornbills and two snakes carrying a human head at Sakchi; life size carvings of men, one with various adornments such as a basket, hat and necklace, at Pongo. (VEMA/SRNH)

47. *Gaonburas* are designated people from the village serving as middlemen between their village and the Government authorities. This system had been invented by the British and was retained after Indian Independence.

48. Hutton 1924, 17.

49. The entrance to the village is inhabited by the Chingda clan, followed by the Jaiching clan towards the village centre. Taking a side path down the mountain, one reaches Bhamjong *bang*. Considering that the people of Nian call the clan (*pang*) 'bang', this is possibly the same clan as 'Phanjong' in Yongnyah. Near the church is located the Shaüjong clan and the area towards the end of the village is taken by the Langchong clan, whose *morung* is located below a huge assortment of stones erected to indicate successful headhunting raids.

survived? It gives one a feeling of great responsibility and every time I experience this rare privilege I hope I will be able to do justice to it. One of the *gaonburas*, in an official red waistcoat, receives us and tells us that no white man has visited them since Elwin in 1956.[47] I am reminded of a passage in Hutton's diaries telling of a similarly long memory span for the village of Ukha:

Ukha wanted to know if they should 'clear the camping ground which the sahibs used the last time they came,' i.e. forty-eight years before, the only previous visit ever! Another typical instance of the length of village memories in the less sophisticated parts of the hills was afforded by the village of Angfang, who mentioned that they had given Woodthorpe two goats, a pig, ten fowls and twenty eggs, which may probably be taken as correct to within an egg or two.[48]

The *gaonbura* says they are glad to have us at their village as within the spring festivities there are rituals scheduled for the next morning that no white man has ever witnessed. And certainly tonight there will be a great party in our honour.

We have arrived early in the day, so we leave our bags at the local pastor's residence, grab our equipment and follow Shayung and the friendly *gaonbura*. Our first impression is that most of the houses in Nian are still thatched. Generally speaking, there are two types – those with open gable fronts and others with small semicircular secondary roofs projecting from the gable – which, from the old books, I know signify differences in rank or wealth.

Nian consists of five clans, all having their respective *morung* as cultural focal points.[49] The *gaonbura* tells us that all Nian's *morungs* were rebuilt during the 1980s. Their carvings vary considerably in aesthetic appeal. Their main features are thick main and side posts, which make an overall impression of a 'V'. These are elaborately carved on all sides with rows of points alternating with balls and discs. The log drums placed in each *morung* display some very fine ornamental carvings on the elongated snouts of the drums that are reminiscent of whales or dolphins. The side posts are adorned with tigers – often depicted approaching the dial of a clock or warriors – and human beings, as well some human heads and grotesque beings. There are also hornbills and snakes carved on the main horizontal crossbeams. Chalk white and black are the colours that dominate, with occasional dots of blood red. Only Jaiching *morung* features oval entrance doors and only Chingda *morung* has retained its thatch roof. It appears to be a particularly 'ecologically healthy' structure in the sense that green shoots are growing from the thatch. Huge moss-covered boulders frame the right exterior of the structure but, on the whole and despite the grass hanging from the front eaves, the *morung* appears to be abandoned. Bhamjong *morung*, with voluminous white posts, thick bundles of cane straw put up at the eaves and cane balls hung from the

Jaiching morung at Nian displays some beautiful carvings of men and tigers that used to be painted with earthen colours. In 1923 Hutton saw similar carvings at the Lower Konyak village of Chinglong (JHH/MA/SPNH) and also noted down grotesque carvings at various places such as Yonghong and Yungphong (line drawings – JHH/MA/SPNH) similar to those still found at Nian.

apex to indicate headhunting prowess, makes the greatest overall impression in terms of artistic quality.

Dusk falls at around 5pm and people slowly return from the fields, the women heavily laden with firewood, yam roots and strange jungle leaves. They have heard that foreigners have come to their village. I see it in their eyes as they rush past me and counter my 'Hello' with their shy and indefinable sounds, somewhere between exhaling, laughing and the syllable 'he'. Their baskets exude a rich fragrance of rain-soaked soil and fresh greens. Checking my equipment, I place tripod and films around me and take a seat next to the children in the open space in front of Jaiching *morung*. I wonder what they feel when they gaze at the carvings inside the *morungs* – the tigers, the skulls, all the monstrosities. Is their upbringing better than that of Western children? Is fear among the Naga so much part of life that there is no need to create such artificial challenges as adventure playgrounds, video games and horror films for them, which in Western society serve as vehicles for coming to terms with fears during the process of becoming an adult?

Traditional Naga education did not aim at developing individuals as per the Western ideal. Instead, Naga children grow up as integrated members of society. In this regard the *morung* system into which all children are initiated has proved valuable for centuries. At about ten years old, they are no longer regarded as children but are young adults within the extended community of the clan. Until they get married they stay in the *morung*, which serves as a bachelors' dormitory. Adolescence, which may be accompanied by serious problems, especially between fathers and sons, becomes a communal experience and thus can be controlled and directed in favour of the clan's demands and needs. Both children and young adults are organised in strictly managed groups in which they learn everything they need to know for the survival of the clan – cultivation of the land, hunting, warfare. But the *morungs* are also centres of arts and crafts such as basketry, metalwork, metal casting, pottery, woodcarving, storytelling and music. And it is here that adolescents learn everything about their clan affiliations and family relations.

I look around inside the *morung* and Shayung accompanies me. 'In Nian, do the bachelors still sleep in the *morung*?' I ask him. 'I'm not sure,' he replies, 'probably only in times of danger. The *morung* has many functions. It is also an armoury and guardhouse. In an emergency it is important that all the men of the clan are together and ready for action.' An old warrior with a smiling face and cropped hair, wearing a red body cloth rushes by, and, using the firestick method, lights a fire in the middle of the *morung's* clay floor. Shortly afterwards the carved wooden posts come to life as the firelight casts long shadows that make the tigers an impressive sight and the log drums appear even bigger. From the eaves hang cane balls signifying human heads and I am transported back to Hutton's time.

Women returning from the forest to the village carrying firewood and water for the night. As seen by Fürer-Haimendorf at the Lower Konyak villages of Longkhai and Wakching in 1937 (CFH/MA/SPNH), water is still carried in bamboo tubes.
Opposite: Children are greatly adored by the Naga and much care is taken of their education, which formerly took place in the morungs. Depicted here are the children of chiefs being dressed up in their fineries – the Ang's little daughter photographed by Fürer-Haimendorf at the Lower Konyak village of Longkhai in 1937 (CFH/MA/SPNH), and Lamsong, 11-year old Khiamniungan chief's son at Nokyan in 2002. (AS/SVH)

'Where are the girls' *morungs*?' I ask Shayung. 'Why do you want to know?' he replies with a wry smile. 'Here I don't know,' he continues. 'If they still exist they are secret, their locations known only to the villagers. At Yachem I could have shown them to you. But these houses are not as eye-catching as the men's dormitories. If love is concerned, however, they are much more significant.' 'Why is that?' I ask. 'Because young couples used to spend the night there together before they got married.' 'Pre-marital sex was not prohibited among the Naga?' 'No, on the contrary', Shayung laughs. 'However, it was mandatory that the elders took care that the couples were not related to each other,' he explains. 'Apart from that they promoted any relationship between boys and girls. There were no arranged marriages or forced relationships of any kind. Even divorces were no problem at all. One simply gave back the same number of mithun bulls and *daos* one had received as a bride price, or the glass beads and agricultural implements that had been given as a dowry, and then the couple were divorced. Mothers with small children easily found a new husband. Once the children were bigger it was even less of a problem as the children were already associated with their respective *morung*. The whole social system was designed in such a way that the community, that is the clan, was the main beneficiary.

For festival purposes various Naga groups used to paint their faces and bodies with white chalk, as was witnessed by Fürer-Haimendorf in 1937 during the Ouliengbu spring festival at Wakching (above and opposite – CFH/MA/SPNH). The motifs indicate headhunter status gained not only by oneself but also within the family or clan lineage. In Northern Nagaland the Phom of Nian keep this tradition alive and are fully aware of its manifold meanings. (AS/SVH)

Thus, one was aware that personal difficulties in the long run were undermining the unity. This again was certainly to be avoided in a headhunting society.'

As if on cue, a bloodcurdling scream rips through the night sky: 'Aaaaaaaamaaaaaahhhhh Shuah!' Twenty voices answer in unison: 'Hee!'[50] The village warriors appear in a long procession and at the village ground give praise to their strength and prowess. They are all wearing only woollen loincloths with stitched designs of human figures. Some wear belts made from bark over which are dark cane rings. Their headdresses appear quite poor – none exhibit the typical cane weft for tying boar's tusks to their hats, some even have white-painted wooden substitutes, and only a few still have real hornbill feathers. Their singing, however, is all the more impressive. And many of the younger men display chalk marks on their faces – lines over the eyes, crosses on the cheeks – just as I have seen in photographs from colonial times, but have never seen myself in the Naga Hills. Hutton's days are back:

> *The younger bucks were dancing in full war paint, swinging their shields from side to side and banging their daos on them. They had lines of white lime splashed across them, across faces, chests, arms and backs. This represented wounds caused by dao cuts, but whether the badges of their own bravery, or aids by sympathetic magic to the gashing of their enemies, I could not find out, and I am not at all sure that they had any idea themselves.*[51]

Simple monochord string instruments played in violin fashion with a bow generate a drone tone to which mainly elegiac and sentimental songs are sung. (Above: CFH/MA/SPNH)

50. Refer to DVD, track 2.
51. Hutton 1924, 25.

Our 'bucks' are fully aware of the meaning of the marks they wear – they define their warrior status – and not only their personal accomplishments but also their ancestors' prowess.[52] Thus, a stripe running diagonally over the nose indicates that one head has been taken within the family. Two heads taken are signified by crosses on the cheeks, three by circles around the eyes, and so on. In times when tattooing is on the wane, these painted marks keep the memory of glorious deeds of the past alive. Furthermore, this custom shows the collective meaning of a headhunt. The successful headhunter did not take the head just for himself but for his entire clan, as it provided life-force and fertility surplus to his needs. Surrounding the headhunt with collective ideas is logical – if every man counted the heads he had taken, the Naga would have been extinct long ago.

Then a group of women dressed in short red skirts with brass bandeaus on their heads and feathers through their earlobes appears on the scene and sings a tune similar to their male counterparts' performance just before. Probably they also praise the prowess and successes of their men and, therefore, the vitality and strength of the clan. A second male performance follows in which the village elders sit in a circle and two men start playing a droning sound on a one-stringed violin. Deep voices add a melancholy melody which so moves the spectators that within a short while the entire village is quiet.[53] At the end of each verse another elder takes the lead in yet another verse, which all the others repeat. It takes a long time for the men to finish but nobody seems to mind. Then the warriors appear again to bring the occasion 'to a glorious end'. Accompanied by a lot of shouting and shrieking, they rush into the *morung* and there follow some of the most impressive drum performances I have ever witnessed among the Naga. At first a middle-aged man with a moustache joins hands with another to play a double stroke roll, bouncing two beats each back and forth. With amazing fluency they increase the tempo and reduce it again just as smoothly. Their performance is followed by fixed log drum beats accompanied by singing, which appears to have verses and choruses or at least to follow a kind of A-B pattern. They involve changes of rhythm, picking up and slowing down the tempo, and a fixed structure of bars.[54]

When the men are really enjoying themselves and their performance is about to reach a climax, one of the players suddenly drops out and strips naked before getting back to the instrument. He is not mocked by his fellow musicians (although the children surrounding the scene laugh) and afterwards everybody agrees that it used to be common practice to perform music completely naked. In recent years this has changed to appearing in festive dress. Music, as I have already understood on former travels, is something very immediate to the Naga, something which makes them feel in touch with everything surrounding them – one could say at one with the universe. Through it they become united with

The British missionary-turned-anthropologist Verrier Elwin was fascinated by the beauty and craftsmanship of the Phom when he toured their country in 1954. He photographed these two dancers at Longleng. (VE/MA/SPNH)

52. Presumably this is part of the revival movement, now that headhunting is prohibited.
53. Refer to DVD, track 2.
54. Refer to DVD, track 2.

Left: One of Nian's gaonburas skilfully performing a double stroke roll together with his companion positioned on the opposite side of the log drum.
Middle: The chief's son acting as chant leader in the night performances.
Right: One of the drummers returning to old Naga tradition – being naked while performing music which is perceived as an expression of unity with the universe. Nobody mocks him, except for the children. (AS/SVH)

Opposite: For the Naga log-drumming is a communal experience, symbolising the strength of their clan and its unity. Therefore, log drum performances, where tradition still prevails, are exciting not only for the listeners but moreover for the performers themselves.

55. Fürer-Haimendorf *Tour Diaries* 1936/37, n.p.

creation again – and who needs clothes for that? Also I think of Hutton's photograph of three young Konyak men from Longmein and start to understand why Haimendorf's choice of 'The Naked Nagas' as a title for his book did not have mere exoticism as motivation. Haimendorf's diaries are full of similar episodes written in Austrian-English:

Wanching, December 12th, 1936 – To the beat of a drum a completely naked man, no longer young, is jumping around like mad. However, only once the up and down flip-flop of his penis is realised it causes great merriment even among the Wanching people.[55]

Our evening ends with a rich meal of rice, pig, chicken and jungle leaves served on banana leaves. Tired but full of excitement about today's experiences, I retreat early to our residence. Later, as I leave our sleeping quarters to find a place in the open for my evening toilet, I notice all the young men who had performed for us strolling down the dark village street towards Langchong *morung* with blankets under their arms. Could it be that here in Nian *morungs* do still serve as sleeping quarters for the young men after all? Or has our presence maybe done its part to revive the old traditions? I may never find out.

The Chicken Knows the Future

Nian, 19 October 2004

I wake at 6.30 and look through the dirty window above my bed. Thick fog covers Nian and the weather is chilly and humid. The first sounds of morning enter the hut – a dog barking, someone threshing grain, another humming a tune, and a few birds singing unfamiliar songs. In this uncomfortable atmosphere I find it difficult to get out of my sleeping bag and decide to keep my pyjamas on beneath my jeans. Washing at the bucket of cold water is restricted to basics and breakfast is not to be thought of as we are to take part in a sacred ceremony for which we have to remain without food. With our equipment packed we stumble down the path to Bhamjong *morung*. There's a cosy smell of log fires burning, but dense fog flows through the village and a light rain is falling. Such must be the atmosphere here for five months or more when the monsoon comes. A barefoot man scuttles along next to us, covering himself with a large toko palm leaf. He descends the path with great skill, avoiding big boulders but not the puddles, which make squelching sounds as he steps into them.

In the mysterious atmosphere of a misty early autumn morning, the shaman of Nian and the members of his clan perform the sacrifice of a chicken for predicting the future from its intestines at the impressive and ancient Bhamjong morung. By painting a face on to a head-shaped stone positioned at the base of the morung's main pillars, Lichaba, the ancient spirit of fertility, is invoked to participate in the ritual. (Above: AS/SVH)

Opposite: (clockwise) The chief's son in full war regalia (last night's main chant leader) keeps an attentive watch on the execution of the ritual; the ancient ritual requires fire to be lit by hand; after the chicken's throat has been cut the main shaman smears a bit of blood on to the stone and then along the main posts of the morung, symbolising fertility to be spread upon the community.
Left and below: As a sacrifice to the spirits of the earth, air and water, blood is dripped on to the leaves which the shaman had waved at the beginning of the ritual to summon the spirits to be present. The meaning of this is further enhanced by the crumbs of soil being placed on to the leaves and the participants all spitting on to the leaves (symbol of water and fertility), thus becoming an integral part of the spiritual blessing and unifying the various elements into one. (Below: AS/SVH)

We reach the amazing *morung*, and shortly afterwards the village elders and the young warriors appear, wearing even less than the night before. They have brought a chicken with them. We greet each other and the young men disappear inside the *morung*. The 'master of ceremonies' – supposedly the clan's shaman – walks towards a banana tree next to the *morung*, opens the lime box of his *paan* set and waters its content with the fluid which has gathered on the leaf overnight.[56] With the resulting viscous white colour, he paints a face on a stone shaped like a human head and neck, which is placed at the base of the *morung*. Then, murmuring prayers, he prepares three banana leaves by stripping away parts of their stems and reinforcing them with slices of cane. Meanwhile the young men have reappeared from the *morung* and now take their seats in a row in front of the building. The shaman gets up and, waving one of the leaves, calls upon the ancient fertility spirit *Lijaba* to join the ritual. When he is sure of his presence, he crouches amidst his fellows, places the leaves in front of them and an apprentice lights a fire using the firestick method. He requests the chicken to be given to him, holds it by its throat and cuts it with a bamboo knife. When the first drops of blood appear, he gets up again and, while chanting prayers, smears the blood on the central pole of the *morung* and the 'head stone'. Further drops of blood are dripped on each of the banana leaves and then everyone present is ordered to spit on the leaves.

56. *Paan* is a light stimulant favoured all over India and Southeast Asia, consisting of betel nut, lime and betel leaf, with varying additional ingredients

Right: The shaman waits anxiously for the moment of the chicken's death. As well as reading from the intestines, the particular way the bird crosses its legs at the point of death also serves as a way of predicting the future. In the entire Northeast of India chicken, and especially cocks, hold a special symbolic position. Among the Naga they stand for luck. As affordable animals they serve the purpose of sacrifice well, in contrast to the more expensive mithun, which is used only on most important occasions. Eggs are also highly valued as sacrificial objects and even serve as primal myths for explaining the emergence of mankind.

Above: A rather curious carving of a chicken is found on one of the five morungs at the Konyak village of Wakching. On the left is an erotic scene with a couple involved in intercourse. It seems that the female is reaching out to the tail of the bird. On the right side, the detoriated carving of a hunter shooting the chicken with a gun may be seen. This carved panel might possibly be interpreted in the sense that here the chicken symbolises the luck of begetting offspring as well as hunting prowess, as among the Naga both are understood as signs of fertility surplus. (GG)

101

Upon its death, the shaman pulls out the chicken's rectum foretelling the clan's future from it (which of course is favourable if traditions are heeded). As an acknowledgement of the spirits' benevolence the men perform a final dance in their honour, which concludes the ritual.

57. Refer to DVD, track 3.

Once the chicken is completely dead, the master of ceremonies starts feeling for its rectum. It takes a while till he gets a hold of it. But finally he succeeds, pulls it out and inspects it in an expert manner. Showing it to all the people present, the shaman announces that the coming year will be favourable in terms of crops and the well being of the villagers of Nian. This is a signal for the community to perform a dance around the fire in front of the *morung*. They form a circle and take turns in the middle to lead the signing. Again and again others find another verse to sing, all of which concern the strength and prowess of the villagers and the beauty of Nian. Their recitations are answered happily by the rest of the dancers with *daos* raised into the air. Far and wide their chant is to be heard today – the fog is thick but well, as the Naga used to say.[57]

Scenes from the dance of the men who had participated in the fortune-telling ritual at Ntan, recalling what Furer-Haimendorf saw at Oting in 1937. (CFH/MA/SPNH)

The Tuensang-Mon Diaries

Jamie Saul

Hornets for Supper

Calcutta – Mokokchung, 15 October 2005

I am on my way to the airport, having negotiated a taxi the previous evening, and arrive in plenty of time for the next stage. Apart from the usual tale of poverty, and an attempt to make me feel guilty for dragging this poor taxi man out to the airport where he would battle to get a return fare, the journey passes in silence. I am already inured to the scenery and must admit that, apart from watching out for makeshift temples erected a month ago to the honour of Kali and now being dismantled again, I do not pay much attention any more. The poverty is simply too much to bear.

Entering the cavernous airport hall, I find myself enfolded in a big bear hug by Peter – we finally meet. For three years we have communicated via email, sent pictures and information back and forth to help each other finish our books on the Naga, and finally we are about to unite forces. Having first read of the amazing trip made by Hutton in the original published diary version loaned to me by the man himself in 1967, I never thought for one minute that we were ever likely to have the honour of following in his, as well as Mills' and Haimendorf's, footsteps some thirty-eight years later – eighty-two years after he himself, as the first in our series of 'Naga celebrities', had set out. I was thus incredibly pleased to be included in this trip organised by Peter

Preceding pages: Humid and foggy landscape en route to Tobu, bordering the districts of Tuensang and Mon, at the end of the monsoon period.

Opposite: Necklaces of tiger and leopard teeth are typical for the Yimchungrü, Khiamniungan and Upper Konyak, the main Naga groups of Tuensang and Mon. Adorning them with brass spirals, the ubiquitous symbols of life, symbolises the close relationship the people feel for their closest predators, as for them killing a tiger is like killing one's own brother. Should such an incident ever occur, long taboo periods have to be heeded, which end with the bestowal of such jewellery, meaning that, as in headhunting, death has been transformed into life-force for one's own clan.

Above: Vast tea plantations dominate the landscape between Jorhat in Assam and the border to Nagaland near Mariani. (JS/SPNH)

A detail from the 1919 edition of the Assam Road and Rail Map showing the route from Jorhat in Assam to Mokokchung in Nagaland. Nothing much has changed concerning the roads and railways since then. (VH).

for autumn 2005. And now – lost in a liberating embrace at Calcutta Airport – we are just about to enter regions of the Naga Hills that have been entirely closed to foreigners.

There is a bit of upheaval at the Indian Airlines counter with a clerk telling us that foreigners need a special permit for Assam (which has been obsolete for six years). Until his superior arrives, he refuses to issue our onward tickets. Having cleared this bit, we are facing the incomprehensible delay typical of Indian domestic flights, as well as the senseless security checks whereby pocket knives may enter the plane but batteries have to enter the rubbish bin. Finally the sort of antique metal bird ascends the skies – with us and our pocket knives on board but not our batteries.

Soon the vast valley of the Brahmaputra, which looks more like a shallow sea than a stream, is in sight. The flooding this year has certainly been extensive. Via Tezpur we reach Jorhat in northeast Assam. No problems at immigration and then there is Sanjay from Jungle Travels India, the organisation behind Peter's two previous expeditions through the Naga Hills, waiting for us outside. A decision on what vehicle to take is to be made: a low narrow Maruti Gypsy Jeep with four-wheel drive or a large comfortable Bolero without. Both Peter and I have had our share of uncomfortable and stomach-churning experiences with Gypsys, the Bolero is cheaper and the driver, Hilary from Assam, seems friendlier, so choosing the Bolero is fairly easy – after two weeks we will be questioning this decision. Soon the deposit is paid and we are packing the vehicle. A little penguin hops in the front passenger's seat, who introduces himself as a delegate of the Art and Culture Department of the Government of Nagaland. He is to make sure that our passage into 'the realm of the warriors' is as smooth as possible. Toshi Wungtung, our friend, guide and companion was supposed to be meeting us at the airport too – he has not. We wait for another half-hour and then start the car. Here we go.

The journey takes us through acres of rice fields, which have a distinctly Indonesian look, with small huts on stilts dotted around, and extensive tea plantations, which date back to British times. We reach the border and encounter our first problem. Peter, along with our new chum from Art and Culture, sets off with our passports to clear formalities and disappears into the hut occupied by the border guards. We wait and wait and, eventually, decide to find out what is happening just as an inebriated official, tie askew and muttering savagely, emerges from the building. We have been refused entry – our papers are insufficient and we must be accompanied by a certified guide. Our new chum has no means of identification, the guards are adamant: we cannot enter. We drop the name of the Chief Commissioner, but they are unimpressed. Peter tries mentioning Rintila Subong, the eighty-two-year-old curator of the Spring Villa Museum in Mokokchung, but they look incredulous and retaliate by demanding that she get her backside down to the border and vouch for us.

Left: Trouble at the Nagaland border checkpost en route to Mokokchung. (JS/SPNH)
Below: A board at the Deputy Commissioner's Bungalow at Mokokchung stating all Sub-divisional Officers' names from 1880 till 1957. People connected to the writings on the Naga and other groups of Northeast India are found at the positions 7, 9-11, 16, 22, 26, 28. The list includes Hutton, Mills, Pawsey and Archer, the latter of whom served even after Indian Independence, being succeeded by Naga and Indian officials from 1948. (TM)

Then Peter, realising that bullying is the name of the game, shows his other side and gets tough when the commander of the checkpoint – the third person to hear our case – enters the hut. Peter repeats that our papers are in order and that it is not our fault if our companion does not have ID. He says that the moment we reach Mokokchung our good friend, the Chief Commissioner, will call the commander immediately, intimating that the border official is worthy a call from the highest police officer – despite the fact that phone calls to this checkpoint are impossible. Eventually the boss sees reason, but in a series of face-saving lectures puts the blame fairly and squarely on the head of our man from Arts and Culture and tells us to get in touch with him as soon as we reach Mokokchung. Unnerved – it is already getting dark – but happy about having come through and not having to spend a night on the hot plains of Assam, we head off as fast as we can, the road steadily climbing higher into mountains stripped bare in patches where shifting cultivation has taken its toll on the natural jungle. It certainly feels good to be back in Nagaland.

At approximately 7.30 – in the middle of the night in Naga terms – we reach the government guesthouse of Mokokchung, where a smiling Toshi awaits us leaning against his Gypsy Jeep. He and his driver have preferred to remain within the borders of Nagaland, although we could have certainly used Toshi's skills at the border. There is not enough time to get into all the details of this annoying episode as Thangi and her husband, T.N. Mannen, the Chief Commissioner of Nagaland, come towards us and welcome us. There is a meeting of all the Deputy Commissioners of Nagaland in Mokokchung today and tomorrow and we have been invited to attend the post-meeting celebrations and dinner, a great honour and a good introduction to the DCs we will meet later on their home ground. The dinner takes place at Hutton's Bungalow – his residence whenever he came this side. What better introduction to our adventure could there be?

The Sub-divisional Office at Mokokchung – "Hutton's Bungalow" as it is reverently called today – in 1921 and 2007. The ancient structure remains but has expanded without losing its original charm. (Top: TM; bottom: JPM/GH)

Time is short; we leave in convoy. An armed soldier, automatic rifle at the ready, hops in the back of our car, and scouts in a Jeep bristling with weaponry lead the way. In the wide garden in front of the bungalow, cocktail tables and a stage have been set up. The concert is already halfway through. Ice-cold beer is a welcome accompaniment to the 'cultural programme', which tries to combine 'the old' with 'the new', the latter being a couple of country and western numbers the Naga have come to like since the American missionaries brought them here. Tonight these are performed in a clear voice by a bearded, long-haired Naga. The old is more to my liking, being a group of Yimchungrü Naga in full ceremonial dress who have come all the way from Tuensang to perform some dances. Soon their sonorous and powerful voices echo through the mountains, hornbill feathers nodding on their helmets, and long tassels of black human hair swaying from their hip baskets in which they used to store their bamboo spikes. They have their long *daos* pulled out and the polished gongs on their black loincloths, to which cowrie shells are stitched, reflect the neon lights hung on the house wall. Mannen seems to prefer this kind of culture, too, and soon he is dancing with the warriors.

A gong announces traditional Naga food being served in non-traditional style on the veranda. Everyone grabs a plate and somehow I am pushed to the front of the queue behind Thangi, while all eyes watch expectantly. I do not recognise half of the foods but try a little of most, although I am reluctant to mix fish and meat on the same plate and mumble some sort of excuse. However, I am not allowed to sidle past the bowl of boiled and fried hornets – 'delicious and full of nutrition', Thangi sings out. I have to put some on my plate before I can leave the room and find a place on the terrace. Thangi does not want to miss out on the spectacle and under the eyes of everyone present – I notice the Indian wife of the Assam Rifles commander has passed on the hornets – I manage to bring myself to bite into one of the weird insects. The 6 cm/2 in-long chitin shell cracks and the inside tastes nutty. Peter enquires about the two different colours of hornet on his plate. Different species is the answer; the brown ones being easier to digest and the white ones more difficult. He bites into a brown one and quickly finds an excuse to get lost in the crowd and out of the public eye.

After some valuable conversations with the DCs of Tuensang and Mon, it is time to leave. We take off in armed convoy again and soon are back at the guesthouse. I am to share with Toshi in a run-down room in the basement, reeking of damp. The toilet seat lies mouldering on the floor beside the bowl. Still, there is a trickle of water from the tap and a cold shower, a real home from home. It is here that I learn of Toshi's secret addiction to a vile-looking viscous green liquid, which he refers to as 'chlorophyll'. Toshi appropriates my drinking water and adds this to his ghastly brew, before swilling it down in some sort of night-time ritual. He had taken a generous helping of garlic from the feast, a delicacy I had avoided, so he will be a great companion tomorrow.

Scenes from a Indian Administrative Officer's life: *(clockwise from bottom left) In his position as SDO and DC, Mills' duties included settling the numerous feuds and disputes between clans, which often involved days of discussion and negotiation; while on tour he would take an occasional rest day for himself and his staff, often camping beside a river so that he could fish, as here at the Doyang; his wife, Pamela, unlike many spouses, loved to join him when possible on his official tours. They travelled mainly on foot but where there were bridlepaths they would use ponies, such as "Whitey". When unavoidably parted, which was often, they wrote to each other every day. This close relationship is revealed also by the "Pangsha Letters", the letters Mills wrote while being on a punitive expedition (see p 117 ff), edited by their daughter Geraldine Hobson. (All photographs: JPM/GH)*

The men from Tuensang, dancing on the occasion of the meeting of the Deputy Commissioners, have brought some of their finest adornments: tiger teeth necklaces, tiger claw hat straps, finely woven body cloths and intricately plaited wristbands. Commissioner T.N. Mannen joins hands with them after an intense day of discussion.

Right: Not exactly hornets, but food equally difficult to get used to, namely worms, are another dish perceived as a delicacy by the Naga and sold at the local market of Nagaland's capital Kohima. (HH)

115

Last Bits of Present

Mokokchung – Chare – Tuensang, 16 October 2005

The next day, a Sunday, is warm and sunny. Our morning walk through the tin-roof oasis of Mokokchung takes us to Rintila Subong's small, well-maintained and well-equipped museum around the corner from our guesthouse. It is a cordial reunion with old friends of Peter's and we tell them of our border experiences of yesterday. Mannen, by the way, had just laughed and told us that someone seemed to want to take advantage of us. Of course, he does not even think of trying to get in touch with the border post. Overhead in the trees are massive spiders' webs filled with hundreds of small spiders in what appears to be a great community effort. We stop to examine them but are already running late. Our presence has been demanded at the Baptist church. This is an opportunity to participate in the modern way of Naga life while observing the local interpretation of the American Baptist teachings that dominate a good deal of contemporary Naga society. In 1936 Haimendorf wrote:

The Eastern parts of the Tuensang District are inhabited by the Khiamniungan and Yimchungrü. Their log drums are open at both ends and shaped more like xylophones.

When travelling through Ao country, Fürer-Haimendorf was disgusted by the dry and ugly Baptist churches, which, in his opinion, were entirely opposed in design and conception to the magical perception the Naga had of the world. Left: Akhoia village 1936. (CFH/MA/SPNH) Over the ages the wealthy American religious sects have invested much in Nagaland, thus churches, especially in the long Christianised Ao area, are huge now, appearing somewhat pretentious in comparison with the rather poor living conditions of the population. Bottom: T.N. Mannen at his speech. (JS/SPNH)

Mongsenyimti July 15th, 1936 – The church with its green and red window panes is such a horror that I photographed it both inside and out. The inside is a hall with benches and a reading desk instead of an altar. The most atrocious colour prints hang on the wall showing scenes of the Old Testament and with English inscriptions. The 'Battle of Jericho' might still be the most comprehensible one to the Aos.[58]

Again under armed escort, we arrive at the massive central Baptist church but manage to avoid being taken in the main entrance by pleading that we do not want to interrupt the service, which is already underway. We are taken to a side entrance and plastic chairs magically appear at the top of the aisle. The service is held mostly in the Ao language. We listen to the various choirs perform before being blown away by an obviously important prayer, which is delivered in dramatic fashion to the accompaniment of rolling thunder-type noises somewhere off stage and ecstatic hand shaking by some of the more fervent members of the congregation. The main blow has yet to fall: Mannen is called upon to deliver a speech and introduces us, one by one, to the audience as we shuffle around looking suitably modest. I suspect this is a well-orchestrated move to demonstrate the official backing to our trip.

After the service we repair to the house of Mrs Chubala Shilu Ao, the wife of a former member of the legislative assembly, and enjoy bananas and bread eaten around the traditional hearth that

somehow continues to thrive even in modern Naga homes. Peter sits next to Toshi and receives the full effects of his garlic repast, Toshi eulogising on the benefits of garlic, to which I agree as I am not sitting next to him.

After vigorous goodbyes to all except Thangi – who would meet us again that evening – we are on the road to Tuensang. Just like that. Two Jeeps full of enthusiastic travellers, no escort, just the great unknown ahead. During British times this was quite different. When, in 1936, J.P. Mills and his friend Christoph von Fürer-Haimendorf set out for Tuensang, theirs was a military expedition of uncertain fate. Haimendorf recalls:

Mokokchung, November 10th, 1936 – Mokokchung is understandably in turmoil as 150 men (2 platoons) of the Assam Rifles under the command of Major Williams have arrived from Kohima as well as 360 permanent volunteer coolies and 20 temporary coolies, under the command of Mr. Smith, interpreters and headmen. It looks as though it will be a very big undertaking. The situation in our field of operation is extremely confused as every village is in feud with a whole group of others. Pangsha supposedly a two day march east of Chingmei (it is not on the map) only recently, together with other villages, completely destroyed Saochu, took 150 heads and captured several slaves. Now they are supposed to have about a dozen. Fighting cannot be avoided, it seems.[59]

The magical worldview of the Naga had found its expression also in the impressive indigenous morung architecture with all its symbolic carvings, as it was still in existence as late as the 1960s, even among the Ao. (left: MG/VH; right: AA/VH) However, in 2004 not a single person in the many villages we asked was able to tell us where these morungs might once have been located.

58. Fürer-Haimendorf *Tour Diaries* 1936/37, n.p.
59. Fürer-Haimendorf *Tour Diaries* 1936/37, n.p.

The Pangsha Expedition I

In 1936 District Commissioner J.P. Mills found himself obliged to set out on a punitive expedition against the Khiamniungan village of Pangsha, which had long been terrorising its surrounding villages and, united with the villages of Tsawlaw and Ponyo on Burmese ground, had not only taken numerous heads from its neighbours, but wiped out entire villages and sold the survivors to its Burmese neighbours as slaves. This to the British was intolerable as both Indian and Burmese governments had for some time been fighting against the practice of slavery and headhunting in their territory.

Today reaching Khiamniungan territory is still an arduous task and involves driving on terrible cacha roads and crossing numerous waterways. Via the Chentang saddle one climbs steadily towards steep hills near the Burmese border.

In 1936 it took the column 12 days to reach its destination via large tracts of difficult, unknown and unsurveyed terrain. The expedition was joined by Christoph von Fürer-Haimendorf and set out from Mokokchung for its four-week trip on 13 November 1936, with 150 men of the Assam Rifles, a paramilitary police force under Major Williams, and 360 porters under Sub-divisional Officer Smith. They marched via Chare, Helipong, Kuthurr, Chentang, Chingmei, Yimpang and Noklak in addition to a number of villages never visited before. (CFH/GH)

The Pangsha Expedition II

Every night, after hours of marching over steep terrain, camp had to be pitched for over 500 men and taken down again the next morning, such as at Helipong, the highest and coldest place of the region – a logistical masterpiece (above). The loyalty and support of the villagers en route was crucial for the expedition. Although they did find it among old friends of Mills such as Chingmak, Chief of the Chang village Chingmei, who sent scouts along with the column (top right), Mills used the trip to get acquainted with as many villages as possible, e.g. the Khiamniungan village of Yakao (top left).

At the Sangtam village of Anangba, Chief Chirongchi, who had served for the British in France during WWI, showed them the head of a notorious Sema he had killed along with carved substitutes for heads they had taken in collaboration with other clans (right). (All photographs: CFH/GH)

Opposite: Yimchungrü, Khiamniungan and Chang men overlooking the hills of Tuensang.

The Pangsha Expedition III

The first real difficulty experienced by the troops arose at Noklak, a day's march from Pangsha. This Khiamniungan village was at war with Chingmei, which had provided scouts to Mills, and did not want to offend Pangsha. Thus, the entire footpath was covered with panjis and no campground prepared. "Winged words" from Mills, however, made them at least produce some supplies and food. (Photo above: CFH/MA/SPNH). In 2002 our reception was far more cordial with log drums being beaten and dances being performed. A great number of men still displayed dozens of "human beings" as tattoo marks, each signifying a slain victim. Slate-roofed buildings, from which the Khiamniungan's former name "Kalyo Kengyu" – slate-roof dwellers – had been derived, were still in existence as well as drum houses, crowned, however, by the signs of Christianisation.

The Pangsha Expedition IV

On 26 November 1936 at 5.30 the offensive on Pangsha was started. At first the troops under Williams were successful in advancing without receiving much defiance, resulting in the burning of most of the village. But when Mills, with a platoon of 50 men, went to a separated khel of Pangsha the next day they faced 500 warriors coming at them over a ridge with a roar, showering them with spears. In the end the British got away with no losses, a dozen fell on the side of Pangsha (which today is a rather insignificant village (HN)), the slaves were returned and Mongsen, Chief of Pangsha, signed a peace treaty with Mills. (All other photographs CFH/GH)

At the separate khel of Pangsha Fürer-Haimendorf took four heads from the head tree, at first intended for museum collections. Since, out of uncertainty regarding their "ritual position", none of the porters would carry them, he carried them himself. Later, however, he presented three of those heads to his Konyak friends and thus was able to record the performance of head reception ceremonies in various villages. Other heads taken by Mills at Yimpang are now at Oxford's Pitt Rivers Museum. (CFH/GH; contemporary photo: MA/SPNH). For an interview with Fürer-Haimendorf about the expedition, refer to the DVD, section "Return to the Naked Naga", tracks 7-9.

Above: Slash-and-burn fields en route to Tuensang ripe with mustard in early autumn.
Opposite: In the 1920s Chare still had a couple of enemy heads exhibited on bamboo sticks. (JPM/MA/SPNH)
Today the only surviving – and rather drastic – traditional custom is the village's "itchy wood jail".

Most of the villages we will be entering have last been visited either by Haimendorf and Mills in 1936 or by Hutton thirteen years before that. After their last experiences with white men, how will the people receive us? I try to hide my excitement behind conversation about clan relations and theories of migration. I think of Hutton and how he handed his diary to me in the late 1960s, and how a feeling of pride rose up in me; that one day I would be following in his footsteps I never dared to dream back then.

Approximately half way to Tuensang is the Sangtam village of Chare, which was also visited by Hutton in 1923 on his November tour:

It is a long time since there was any head-taking here, but I noticed a row of old gourds representing heads on the outer wall of an Ao house, one of which had a cranium attached and two others lower jaws.[60]

And in 1936 Mills adds:

The very tall mithan [mithun] posts, branching almost from the ground, are noticeable, as are the elaborately carved posts of the grave-houses and the offerings to the dead...[61]
They told me that Pawsey made them burn all their old heads when they were taken over. I wouldn't have believed him guilty of such an act of vandalism.[62]

Chare has changed dramatically since Hutton's day and the only traditional-looking structure is the roof over the village gate, all other houses being modern wooden-plank style with corrugated iron roofs. However, what arouses our interest is an unusual, triangular construction at the head of the village, which turns out to be a sort of jail for unrepentant sinners and is apparently retained as a curiosity. It is built from logs that have a devastatingly itchy effect on human skin. The naked sinner is locked into this small space where his or her body cannot help but come in contact with the itchy wood, which doubles the punishment. All this is explained by an elderly Sangtam woman with tattoos on her chin and forehead and robed in a traditionally patterned cloth.

The drive to Tuensang drags on and, due to some stops for taking photographs and sucking on sour tangerines, dawn is breaking when finally we reach its outskirts. But our journey is in no way comparable to the efforts Mills, Haimendorf and Hutton had to perform in order to get here, as entries in Mills' *The Pangsha Letters* reveal:

November 13th, 1936 – Smith is as bad on hills as ever. It certainly was very hot and I was fairly cooked on the climb myself. He won't let his subordinates run their shows. He ran about

60. Hutton 1924, 44.
61. Mills *Tour Diary* 1936, entry 13 November, n.p. Two of these posts, acquired by H. E. Kauffmann the same year, are now in the Museum of Cultures, Basle (see Stirn & van Ham 2003, 176).
62. Mills *The Pangsha Letters* 1936, entry 13 November, n.p.

and looked after things when we got to camp, while we other three sat peacefully and had our sandwiches. But the poor boy did hog it before tea: I thought we should never wake him up again – and that in the most awful babel of hundreds of voices you ever heard. But he'll soon learn. We had two or three halts, and at one I was much amused by a Lhota coolie stuffing rice into his mouth and eating enormous red chillies exactly as if they were sticks of chocolate! [63]

November 14th, 1936 – We had our bellyful of hills today, not a hundred yards level in 10 miles. First we dropped 2,000 ft. to a stream and climbed 1,500 ft. to Thungare, then down another 1,500 ft. to a stream which is the frontier, and up about 3,000 ft. to our camp, a fine spacious one. We had heavy rain for our slide down the first mile, and the coolies must have had hell with their heavy loads. But they have worked splendidly, and have kept well closed up, an important thing when a column can string out to nearly two miles. We were all pretty cooked, I took off my boots and slept like the dead till tea. I think tea is the best meal of the day on these shows, and there is no doubt it does cheer one up.

Tuensang is no longer the major Chang village of Hutton's day, with heads hanging in the *morungs*, but a fully fledged town with all its advantages and disadvantages, the original village existing almost as a suburb further down the slope. Stretching over numerous mountain chains, the skyline dominated by three huge churches, the town could be anywhere in India; a series of hole-in-the-wall shops, mostly run by plains Indians, line the streets and there is a constant stream of foot traffic. Most pedestrians are wrapped in colourful cloths in traditional patterns, the synthetic bright colours of the modern wool in glaring contrast to the softer vegetable dyes formerly used. Tuensang still has an almost frontier quality, as though you are now standing on the borders of only recently charted territory. The 31,000 Chang, along with the Khiamniungan and Yimchungrü, form the core of Tuensang district's population. They are proud of maintaining their customary law system on a high level, the execution of which has been granted to them by the Constitution. In it are mirrored the highly democratic structures of their society. Everyone who may contribute to a case may be heard, however long this makes reaching a decision. The Chang do not mind. Thus, when in the 1990s their feud with the Konyak reached a new level, they held month-long meetings in their semi-traditional courts, which are built everywhere throughout Tuensang town. When a satisfactory solution could not be found, they brought representatives from other Naga groups to their discussions. The mediators came first from the Khiamniungan and then from the Yimchungrü. The hearings took years and in the end the dispute was resolved peacefully. This is remarkable among peoples whose national pride and strong feelings for

Top: Despite its ugliness, a certain frontier quality inherited by Tuensang town cannot be denied, shrouded in mist as it is and staring out towards the mysterious, rather unexplored hills northeast of it. (RK/MKB (F) IIb 4852)

Above: Huge modern morungs dot Tuensang town. They are used as council halls and court houses where the Chang dispense justice according to customary law.

63. Mills *The Pangsha Letters* 1936, entries 13 and 14 November, n.p.

clan identity may easily cause bad feeling. Unfortunately, however, this bad blood seems to be stirring again.

We are again quartered in the government guesthouse, and Toshi and I share the same room my wife, Jean, and I had stayed in some three years previously. The room has deteriorated and I am happy that we are to head down to the DC's house for supper, where we again meet Thangi, who has travelled on her own from Mokokchung complete with bodyguard. Supper is washed down with a variety of beers, including 'Knockout', 'Superstrong' and 'Thunderbolt', all variations of the local penchant for ultra strong beer and guaranteed to give instant headache if taken liberally. I am reminded of the conversations about food – reminders of civilisation brought from home into hostile surroundings – which feature so prominently in the old accounts. Looking at Peter, I remember Mills' descriptions of the aristocratic Fürer-Haimendorf whom Mills lovingly calls 'the Baron' and whose aristocratic behaviour, untouched by the harsh realities of the colonial assignment in the Naga Hills, inspires jokes at his expense. Of course, Peter is nothing like Fürer-Haimendorf, but our combination is similar – I from Scotland, with a penchant for black humour, and Peter from traditionally rich continental Europe, slightly more contained and cultivated than I am and, as I have to acknowledge without envy, equipped with a similar talent for photography as Haimendorf. I designate him 'our *Fürer*', which puts a big grin on Toshi's face.

The Baron lies down and goes to sleep the moment he has finished his sandwiches, just where he is sitting! He is always full of stories and says he wears Austrian national costume whenever he goes into the country in Austria. Apparently everyone does, a few women have their costumes called dirndls in silk and bright colours. The men wear leather shorts which must never be cleaned, and are only really smart when fifteen years of wear have put a bit of colour into them! He is disgusted at the idea that the Hapsburgs might get back on to the Austrian throne. He says Otto knows nothing of the world and is entirely run by his mother who is a foul woman. She used to have awful scenes with her husband in public! Austria crawls with Archdukes, all of whom are utterly degenerate and must have married much beneath them...

The effect of heights (about 8,000 ft.) and steep hills on the Baron is to give him a furious appetite. He eats everything he can see and seriously depletes our stores! He says, 'I want meat, meat, meat!' He is looking better already, Attebrin which cured his malaria had turned him bright yellow! But that is wearing off now...

This afternoon the Baron showed us his Konyak photographs. I suffered one of the few fits of jealousy I have ever had. He is just starting his Anthropology, but has the most marvellous equipment, that was not invented when I was doing the same sort of work. The results are so good that I feel I never want to take a photograph again! [64]

Top: Christoph von Fürer-Haimendorf enjoying a sip of rice beer from a bamboo tube, together with the Ang of Sheangha Chingnyu (right) and the Ang of Chui (behind him). (CFH/MA/SPNH)

Above: Two examples of photographs by Fürer-Haimendorf which must have made Mills jealous; Mauwang, the Ang of Longkhai, his wife and their little daughter in festive attire. (CFH/MA/SPNH)

64. Mills *The Pangsha Letters* 1936, various entries, n.p.

ROAST PIG AND PRIVILEGES

Tuensang, 17 October 2005

The next day we are back at the District Commissioner's house, this time for delicious peas paneer – Punjabi style – and sticky bagels for breakfast. In the ensuing rain, we head out to the police station – we have to register so that, in case of loss, our heads may be collected. Attempts to secure permission to travel on to Tobu are met with a cool response by the police chief. Under no circumstance could we be allowed to proceed: there is trouble looming at Tobu; issues of land ownership have been simmering for the last fifteen years at least and lives have been lost between Tobu and the Chang villages of Maksha and Hakchang. Toshi launches into a long debate with the chief and, through his contacts and by clever negotiation, eventually wears him down sufficiently to allow us limited access to proceed.

As we leave the police station, the weather has slightly improved but, as usual, yet another problem looms. Toshi's driver has disappeared and cannot be found anywhere. Toshi's Gypsy had, not unexpectedly, wheezed its way down to the repair shop when we arrived. We ask at the market place for the driver – strangers are still recognised here – but without success. Then we stop for a brief look into the stadium, where the one thing guaranteed

With far protruding ridges Chang houses make a ship-like impression. Once their owners have died it is taboo to touch the houses and they are left standing till they collapse. During Fürer-Haimendorf's days Tuensang was much more crowded, and the khels, due to hostility between them, weren't able to expand. Thus, streets were narrow as houses were built so close that their roofs were almost touching each other. (CFH/MA/SPNH)

to set the modern Naga ablaze, a football match, is in full swing. From the comments it looks as though it is going to develop into a bit of fun, but time is tight, we have to move on. As we still want to visit Tuensang village and there is no sign of the missing driver, we are advised to stay another night in Tuensang. We agree and repair to a local greasy spoon for lunch.

Eventually, Hilary takes us down the rough road to rainy Tuensang. We arrive in the Bilaeshi clan quarters just as the elders are slaughtering a huge pig, which is now lying on its back, most of its bristles already singed off. It is a friendly reunion as Peter has brought photographs from his previous visits in 2002 and 2004. What staggers me is that the elders seem to remember every single photographed scene, because as we take our seats at the council hall they complain about a number of missing photos.

Despite its proximity to the town, Tuensang village is probably the most traditional of Chang villages and retains thatched *morungs* complete with carved posts and log drums, some sporting tusks representing hornbill heads. True, the quarters or *khels* of Tuensang – those of Lomao, Bilaeshi, Chongpho and Kangsho – still exist as they did in Hutton's day, but they are no longer fortified against each other. Also the houses are not as close to each other as they were when their prolonged gables touched each other. However, rich people still hang large sheaves of grass and cane balls from their ridge poles and decorate the ridges with rows of small bamboo spikes

Opposite: (clockwise from bottom) As seen by Hutton in 1923 (JHH/MA/SPNH), a few women with forehead tattoos intended to scare away tigers are still to be seen at Tuensang; the authors taking notes with Toshi Wungtung and the members of Bilaeshi khel. (RK/MKB (F) IIb 4858)

Above: Women weaving the typical Chang body cloths at a curious double loom. Refer to DVD, track 11.
Right: A fine carving of a hornbill beak at the entrance of the council hall of Bilaeshi khel, denoting wealth.

When Hutton toured the area in 1923 he noted that at Tuensang the Chang danced continuously for two days. (JHH/MA/SPNH) A similar strength was present in their performances in honour of the foreign guests in 2002.

Opposite and above: Various house decorations denoting headhunting prowess. The stone head (top middle) seems to have a distinct Picasso-esque flair to it.

65. *Coix lacryma-jobi.* Tropical plant from the maize family, cultivated at an approximate height of 2500m/8000ft, boiled like rice by the Naga and used for beer brewing, as well as for jewellery.
66. Hutton 1924, 49.
67. Hutton 1924, 47.
68. van Ham 2006, 178-9.

overlapping in 'V' fashion. At the front of the houses women still pound rice in round wooden mortars. They often still wear the distinctive facial tattoos – against tiger attacks, as they say. And from some of the houses' gables still hang the ancient signs of successful headhunts: heads carved from wood, or heads adorned with glass beads or Job's tears seeds for the eyes.[65] Hutton recounts:

November 10th, 1923 – Thensang. At the edge of the Lamao khel was a fairly fresh head recently taken from Ninyam and not yet ripe for hanging in the morung in front of the drum. The eyes of the skull were pierced with bamboo skewers 'to give the spirit pain in the next world'. Behind it the fingers and toes of the dead man were strung together and hung on another pendant. They were not complete however, as the owner had been some short before his head was taken...[66]

We ask the house owners, most of whom are impressive elderly men with 'fountain of fertility' tattoos on their chests and brass head necklaces around their necks, about the geographical origins of their trophies. They give some hints about the old clan feud, the background of which Hutton recounts as being shrouded in myth:

November 10th, 1923 – The quarrel with Tobu was started by Tobu and the other villages having a contest to see which could ring a hill holding hands all the way round. Tobu's opponents held winnowing fans in between each man and the next, so that they looked like men at a distance, and doubled the length of the line, a deceitful act which annoyed Tobu, who tried to ring their hill honestly and failed. The enmity between the Bilaeshi khel and Tobu still continues.[67]

In 2004 in Tuensang Peter had received similar explanations for other incidents, of which we are reminded as we see the many beehives hung on house entrances.[68] The spirits of the bees are supposed to sting away the spirits of attackers. Again and again we are astonished how

Facial tatu of Hamshang, a Konyak of Shiong, Naga Hills. 12 Nov., 1922.

Pattern tatued on the chest of an Ao man from Yacham. Chantongia, 8 Nov. 1922.

Shoba, a Konyak of Wakching. Sketched in camp on the Dikhu R., 13 Nov., 1922.

Man-ang, a Konyak of Tamlu. Mokokchung, 30 Oct., 1922.

Hingkap, an old Konyak of Tamlu, 11 Nov., 1922.

Male tattoo patterns of Tuensang, Longleng and Mon
Opposite: Left column (downward from left to right) Khiamniungan, Nokyan; Khiamniungan, Noklak; Yimchungrü, Sangpurre; Chang, Tuensang (all three). Right: Phom, Pongo.

Above: Phom, Sakchi (typical also for the Upper Konyak of Tobu); Lower Konyak, Mon. Above middle: Watercolour drawing by R. G. Woodthorpe of a Lower Konyak Ang (c. 1875); Remaining: dated line drawings by Henry Balfour. (All: MA/SPNH)

141

naturally the men tell us about their headhunting activities and use gestures to clarify their actions, such as 'karate-like hands hacking at naked nape sections'. Maybe it has something to do with the heroic appreciation these warriors continue to receive from their community. One of these proud heroes shows us a bamboo mug on which the story of a headhunting raid has been carved – a tribute to his prowess, which only he is entitled to own and drink from.[69]

The Naga's openness may also indicate that they trust us. We are probably the only foreigners who have visited them for a second or third time. On each visit we have given them photos, and we also made contributions to their village kitty after they had participated in Peter's documentary last year. However, the people's gifts to us were even more generous. In 2004 Peter was granted a rare privilege, which Hutton certainly would have envied, and which I would have liked to share too:

November 11th, 1923 – I should very much like to have been to the place where the skulls of the dead are put at their second funeral. At the harvest festival each year, the previous year's dead are disinterred or taken from their bamboo platforms, as the case may be (for both methods of disposal are used according to the last instructions of the deceased, or, failing any, by clan custom) and are taken to a spot about a mile away in the ravine of a small stream where there are natural stone shelves formed by the strata in the rock. Here the heads are set out in rows on the shelves allotted to each clan, the oldest being thrown away when there is no more room for the new ones. No path may be made or cleared to this spot, and no one may go there except when conducted by the two official buriers, and then no one may look about them or behind them but they go stooping with eyes on the ground. They were most obviously unwilling to take me or to let me go, so I gave up the idea.[70]

69. Refer to DVD, track 12.
70. Hutton 1924, 49

The mysterious "Spiked Naga helmet"

A curious incident happened at Tuensang in the early 1920s. When J.P. Mills was on tour there he saw a man wearing a German spiked helmet, as was used by the German infantry in WWI, adorned with slices of mithun horns and human hair. The person had brought it back from the battlefields around the Somme where he served in the labour corps for the British army. Mills may well have been reminded of his own recruiting techniques as the British would probably have had to promise the Naga prestige and honour in order to persuade them to leave their homeland and travel half way around the world to assist their (colonial) comrades in a war against enemies of whom they had never heard. Back then, the only way these virtues could be achieved was by headhunting. Thus, it could even be that the British promised heads to the Naga so that they would join them.

Since a number of heads of Japanese soldiers from WWII, mostly crashed pilots, are known to lie in Naga morungs in Arunachal Pradesh and on the Burmese side of the hills, it is not too far-fetched to imagine that a couple of WWI heads from Germany had also found their way into Naga collections. This is even more probable if one considers that during that time a warrior could only wear a dance hat adorned with human hair like this if he had taken a head. The helmet might have served as a substitute for the (German) head, as surely the British would have not allowed a human head to be taken on or from the battlefields. The helmet is now at the Pitt Rivers Museum, Oxford. (Right: CFH. Both: MA/SPNH)

Opposite: Sangam Chang, head gaonbura of Chongpho khel, speaking about his headhunting activities and presenting a bamboo mug that in its carvings tells of a successful raid in which children's heads were also taken (detail).

Above: Pobang Mungo, reputed were-tiger of the Bilaeshi khel at Tuensang, and a detail of the 'tiger scars' on his hunchback.

Opposite: A rare opening in the thick jungle allows a view on to the cultivation area of Tuensang – a mixture of slash-and-burn and terraced fields.

71. Refer to DVD, track 13.
72. Fürer-Haimendorf *Tour Diaries 1936/37*, n.p.

From Peter's diary:

Tuensang 28 October 2004. On us is bestowed a rare privilege. We are permitted to visit the skull place of Tuensang. Accompanied by a large group of red-robed gaonburas, we descend an extraordinarily steep hill below the lowest clan quarters of the village. Our leader is the gravedigger of the Bilaeshi khel, a seemingly spiritually-minded and silent man in his mid-fifties whose back is deformed by a hunch. He is the shaman of his clan, and, as a person who is in touch with one or several tigers, may communicate with them, receive instructions from them and even may turn into one, is also known as the 'tigerman'. My curiosity is boundless. As he descends in front of me I notice two scars on his back, which is covered only by a red cloth. Through the interpreter I ask him about the scars and learn that they come from a fight his tiger was involved in one night. The next morning the same wounds also magically appeared on his body. What more mysterious company could there be for a trip to such a mystic place?
It is sticky and humid and in no time I am bathed in sweat. The dank soil is heavy and slippery and soon I ask for a walking stick to stop me slipping. The path seems endless. As the vegetation becomes more dense, our group becomes more and more silent. I feel transported at least a hundred years back in time. This place cannot be found without an expert guide. All of a sudden our leader takes a turn into the jungle and follows a narrow trail which leads upward. Brooks and other streams have to be crossed and sometimes we even have to jump over narrow gorges. After another climb we are finally there and I can hardly believe my eyes: under a ledge lies an unimaginable conglomeration of bleached bones, skull parts and jaws. Very few skulls are complete. The site, impressive as it is, feels neglected. 'Unfortunately the missionaries have prohibited our former burial practices,' the interpreter translates the tigerman's words to me. 'But fortunately this place still exists. Concerning our enemy skulls, we had to get rid of all of them.' I take a few photographs. Our companions become increasingly nervous and so we soon leave. Fortunately, we do not have to take the same route back but continue the slowly ascending side track back to the village. This passes by the place where the Chang have buried the relics of their warlike past – in their memories those days are far from being buried.[71]

Our meeting this afternoon is at the Bilaeshi *khel's* council hall, known locally by the Indian term *panchayat*. Guarding the entrance are two fine carvings of hornbill beaks, evidently denoting wealth, and also found among the Yimchungrü on the graves of wealthy men. Sometimes carvings of beaks can be seen in double form, suspended from the front ridge of houses of the rich, reminiscent of the buffalo or mithun horns attached either side of skull trophies or cane ball imitations strung up in the drum houses. Haimendorf recognised this form in 1936 in the Sangtam village of Anangba where it denoted that the warrior himself had planned the raid and led one of the groups.[72] Toshi explains the cultural proximity of the Chang to the Yimchungrü and the Konyak, which is supported by Hutton's diaries.

Right and below: The skull place of Tuensang's Bilaeshi khel.

Opposite: Our friends have dressed up and lit a bonfire in our honour. We are saying goodbye on our last evening before moving on towards the northeast.

The Changs themselves are a new tribe. Their chief village - Tuensang - has only existed for 11 generations, and a number of their clans now regarded as pure Chang in blood, and speaking no other language, are known to have had an origin from Konyaks from Angfang, or Yimtsungr from somewhere else.[73]

The meal we get follows a strict protocol: the elders are served first, then ourselves, and finally the rest of the assembly, all washing down the loads of coarse rice and pork (preferably with lots of rind) with mugs of crystal-clear water. The introduction of water with meals is a modern innovation – in Hutton's day, no meal, or indeed any occasion, would be complete without plenty of rice beer. However, officialdom, led by the Church, frowns on alcohol and Nagaland is, for all intents and purposes, a dry state (and, therefore, can proudly call alcoholism a serious problem now). Fortunately, my white hair has not been taken into consideration while apportioning the food, as we later see the pig's rectum, a delicacy reserved for old men, still hanging up, presumably ready to be collected by some favoured elder. Concerning peculiar Naga habits of eating, Hutton remarks:

Chongtore, November 8th, 1923 – Someone brought me in here a huge chunk of Sangtam toffee - really magnificent stuff (Mr. Pawsey is my witness; he ate it till he broke a tooth) - made by mixing in the flour of maize, or better still of 'stinking dall', with boiling honey and keeping it on the boil till solid. It tastes very good but is exceedingly hard.[74]

73. Hutton 1924, 46. Yimtsungr is an old term for Yimchungrü.
74. Hutton 1924, 46.

CURFEWS AND DEADLINES

Tuensang – Tobu, 18 October 2005

It is raining when we wake up the next day, and it looks as though it has been pouring all night, rivulets of water running down the streets reflecting the light from the small open shops. Toshi's driver has reported back and naively tells us about his nice meetings with relatives yesterday. I am surprised by the calm way Toshi responds to his stories but I do not regret the interesting day at Tuensang. We breakfast in the house of Toshi's absent brother and collect his vehicle, which we hope is reliable. There is still a visit to a local Khiamniungan craftsman scheduled, as well as an effort to revive the art of making Chang bamboo mugs through the supply of old photographs, which proves to be unsuccessful. After receiving our permit at the police station, we are on our rainy and foggy way towards the first of our long-awaited goals: Tobu.

En route we stop at a rice field where, at some fine built field huts, we meet two hunters who have just shot a *goral*, a small species of mountain goat that, because of its scarcity and remote habitat, holds a special position among the local Chang and Konyak – as we are soon to find out when looking at the carvings on their houses. On the way we pass

Opposite: A tattooed triangle on the forehead and black body cloths with red squares and light blue border stripes are typical for the men of the Tobu group of the Upper Konyak.

Above: N. Among Chang runs a small shop at Tuensang town selling traditional Chang items such as unique bamboo mugs with branded designs. The various stages of the manufacturing process, as well as some of the many shapes of these mugs, can be seen here.

Hakchang and Maksha, which are villages Hutton had visited. I had been to both of them in 2002 when I was conducting research into the Chang and had found them considerably changed since 1923. At Maksha, however, which is located on the edge of Chang country, I was taken to some stones high up on the mountain, the backs of which are decorated with various symbols, including a representation of the chest tattoo used by the central Naga groups, as well as circles like gongs and other designs. These stones are said to commemorate the victory of the village of Changsang, where the ancestors of both Tuensang and Hakchang came from, in a major battle with another, now deserted, village, Ungphang.

The stream below the village of Sangsangnyu marks the border with Mon district and from here Tobu is not far up the hill. Hutton had considerably more difficulty getting up there:

November 13th, 1923 – Tobu had sent word that, as they would be carrying our loads to Chingmei, would not come to meet us at all, but the Hakchang men should carry all the way up to Tobu; when we got to the river, the Hakchang carriers, not unnaturally, flatly refused to go a step further. We were ready for them, however, and at the critical moment had them parked in an open space between the river and one of its tributaries. At first we tried persuasion, which

*Top: Yimchungrü-style morungs. Hutton's sketch of Sangpurre 1923; Masungjami (possibly Makware on the Burma border) 1910 (both MA/SPNH); Hakchang 2003 (HH).
Bottom: Memorial stone at Maksha. (JS/SPNH)
Opposite top left: Tobu village in the rain; right: hornbill carvings on the central pillar of a morung in Tobu town; bottom: sketch by H. Balfour (1923) showing some of the many stylistic variations of hornbill carvings found among the Konyak and Phom. (MA/SPNH)*

was useless: then, at the suggestion of our guide, we quietly got sepoys[75] *all round the edge of the open space and then told them, (1) that they would be fired on if they bolted; (2) that they must carry, or the sepoys would 'spoil' them. Luckily they did not call our bluff and after another half hour of threatening, cursing, and coaxing, while many had their daos out, and all were either sulking or shouting, and looking rather nasty, we got them on the move across the river and up the hill. I was still very anxious, as it had been reported that someone, obviously of Tuensang or of Hakchang, had been 'dirtying our path', and there was a report about in Tobu that we had sworn 'to eat some village' this trip and the non-appearance of the Tobu men as arranged looked bad. However, they had cleared the path, and, when about half-way up the hill, two of the Tobu headmen turned up, much to my relief. It also reassured the Hakchang men a little, though we had a great deal of trouble with them before we finally got into camp just outside and below Tobu. There we let the Hakchang and Maksha carriers go after paying them in red wool—rupees do not run here—and they hared off down the hill in a scrum, daos drawn and shouting.*[76]

At Tobu we are extraordinarily well looked after by S. Poangba, president of the Konyak Union Branch Tobu, although we sleep in the quarters of the Extra Assistant

75. Indian soldiers serving in the British army.
76. Hutton 1924, 52-3.

Above: A lucky find – the impressive morungs photographed by Hutton in 1923 (left: Tobu; right: Yakshu; both JHH/MA/SPNH) had not changed much in 2005 and almost identical equivalents of thatched bachelors dormitories were to be found at Tobu. (Right: JS/SPNH)
Opposite top: Symbols of headhunting prowess at a morung in Tobu town; bottom: The heavily panjied gate of Tobu village closes up behind us at the fall of dusk. (JS/SPNH)

Commissioner at the upper end of the township. Poangba's hospitable home is like a pigeon house. Again and again people enter and leave who have heard of our coming and want to look at the rare strangers. Our host and his family are extremely amiable and we are to benefit immensely from letters and messages sent out to villages we plan to visit after leaving Tobu. Just up from Poangba's house is a *morung* that evidently serves the township and which contains carved posts and a plain carved log drum with a long snout. The beaters are short poles with the upper end carved to resemble a hornbill's head and with serrations, which we are told relate to heads taken by the members, one for each head. Outside the *morung*, the skulls of buffalo and mithun testify to sacrifices performed, and another basketwork effigy of a skull with horns attached testifies to (former) headhunting activities.

From the township we walk up the road to Tobu village itself, under the eyes of many curious villagers, entering through gates thick with sharp bamboo spikes or *panjis*, the first I have seen in the Naga Hills other than at fortified police and army posts. Many

more traditions must have been present in the area during Hutton's times, as we are enthusiastic about Tobu, whereas he describes it as being rather disappointing. In 2005 it has a wealth of traditions compared with the Chang villages. Most of the houses are constructed in the old style with small sub-roofs under the low gables and hump back ridges. Although corrugated iron roofs predominate among the *morungs* (Hutton writes about sixteen – we are shown seven), the odd thatched one can still be seen. In style terms, these *morungs* are exactly as seen in 1923 by Hutton's party: great high pointed gables sweeping up in front with semicircular apse-type roofs jutting out over an open fronted porch, where old men, wrapped in traditional black body cloths decorated with red rectangles in regular rows, sit warming themselves round an open fire. On top of the roof, crossed poles form a 'V' shape near the front ridge, some decorated with clumps of grass, others with cane balls representing enemy heads. We are particularly pleased to find the *morung* of the Changkeangyeang *khel*, which Hutton had photographed, although it is now protected by the more common corrugated iron roof sheeting. Because of the old feud, watchtowers have been erected at the side of the *morung* towards the Chang village of Hakchang.

At Khoten *morung* the villagers of Tobu explain their apparently unique style of roofs. In olden days, they recount, it was common for tigers to jump over the *morungs*, distracting and disturbing the bachelors at night. To combat this, they invented the sharply pointed shape of the roofs so that the tigers would be impaled and could be killed by the villagers. Tigers are still to be found at the *morungs* of Tobu, in the form of massive carvings on the main posts, crawling towards buffalo heads. Each *morung* contains a log drum, and towards the back and hidden up in the roof space are many basketwork effigies of human heads adorned with buffalo or mithun horns.

The people are friendly and obviously unused to Western visitors. However, with the onset of dusk at 4.30 the villagers start to get restless. A Jeep appears just before 5pm. From the corner of my eye I catch a glimpse of a number of fully armed warriors dressed in black, ninja-style, emerging from the crowd while the village guards bundle us into the Jeep and rush us over the rocky path and out of the village. The gates creak to a close and our puzzled faces confront only the razor-sharp *panjis*.

That night we find out when Poangba visits us at our sleeping quarters that there is apparently a deadline in place after which, if no resolution can be reached, a combination of Chang villages has threatened to descend on Tobu and wipe them out, once and for all. We are advised to remain inside our quarters and lock the doors and windows. So begins the first of two dark and anxious nights, with too much Scottish Malt and too little sleep.

The Explorer's Ideal

Shamnyu, 19 October 2005

You can imagine how thrilled the Baron was at achieving the explorer's ideal and visiting villages no white man had been to before.[77]

The next morning weather conditions are drier and the situation up at Tobu has, fortunately, remained peaceful. Feeling slightly more relaxed, we walk down to Poangba's for breakfast – the usual rice and pork, served around the central open fireplace. Meshang Nyakho, an old man from Tamkhong, three days' march away, has come to see us. News travels fast in the Naga Hills. Toshi is very pleased as Tamkhong is the second to last village before the Myanmar border, and during the entire journey he has been telling us stories about it and is keen to show it to us, as well as Pesao, the last village before the border. His hopes are dashed, however, when Meshang reports that military trucks have made such deep ruts in the soft ground that the road is impassable. I am happy to see Meshang whatever happens as he wears a type of tattoo that reminds me of the Burmese Naga, and one can feel that the border isn't far away now. He is happy too about our interest and

Phallic symbols found as carvings on morungs denote the spiritual meaning of headhunting: gaining a surplus of fertility and life power. Curiously, these depictions have remained despite the onset of Christianity even in remote villages such as Shamnyu.
Above: Chingmei village in 1936. (CFH/MA/SPNH)

77. Mills *The Pangsha Letters* 1936, entry 15 November, n.p.

Landscape and wooden bridge on the track to Shamnyu. Though certainly being adventurous, this bridge pales in comparison with bridges Mills had to cross in the 1920s. (JPM/GH)

explains the significance of each and every line of his tattoo, all of which, naturally, are connected with headhunting.

Despite the difficulties, Poangba succeeds in organising a robust but run-down Jeep for us. Our Bolero certainly would not be able to master the road ahead. At the wheel is a silent and proud Sumi Naga and soon we are on our way to Shamnyu – or Wangsu, as the local people call their village. I have the feeling of excitement and anticipation that takes hold every time I get into a vehicle which is to take me to a place even more remote than the one I am in – it is the same 'wanting to know what's behind the next mountain chain' the old explorers describe.

The 'road' certainly has not been made with vehicles in mind. First of all it is narrow and winding; secondly, it is heavily overgrown by man-high bush grass; and, thirdly, it runs alongside such a steep cliff that I'm worried to death whenever I get a view of the drop. At times our outer wheels must be skirting the very edge of the track before it falls away, while at others our four-wheel drive vehicle battles for traction on stretches of pure mud. After the last weeks of heavy rain, large tracts of the road are buried under landslides.

At first this 'highway to hell' is negotiated extremely slowly as we descend through the harvested fields of Tobu. Down, down, to the river, then again up, up, until we eventually will reach the village. So remote is the region that the bridges over this river, as well as its numerous tributaries, are not built with the usual iron but are made of wood. These log bridges are dodgy to say the least – care is advised and the driver is happier with a lighter load, so we cross the slippery logs on foot, the rushing streams of foamy water tumbling beneath us.

It takes three hours to reach Shamnyu. This morning at around 4am Poangba's friend, without our knowledge, had despatched a young man from Tobu to announce our arrival in Shamnyu. This man made it on foot in an hour, taking a directly vertical route down, which may have taken fifteen minutes, and spending the rest of the hour climbing up. No wonder, he is a Naga. Poangba had suggested we also trek to Shamnyu but, when we asked how long it would take, he had answered mischievously: 'Six hours, maybe…?' After all we have been through, I think this was a polite understatement. Hutton was right: these Naga are likes hares.

Passing a beautiful rest hut built in traditional style by the roadside, we reach the heavily fortified village of Shamnyu at about 11.30. The massive village gate is covered with *panjis*. To facilitate opening and closing, however, it has been equipped with seemingly archaic wooden wheels. Shamnyu lost three heads to Chang raiders just last year so is still mourning their loss. The herald has done his job; we are expected and the village council has even announced a village *genna*: nobody may work in the fields today – welcoming the

Shamnyu's upper khel (opposite) is beautifully located along a soft ridge amidst heavy jungle. Most of the residential buildings are still thatched, only the morung in the centre as well as a few houses of the wealthy (which even have separate log drum sheds – see front left) have been roofed with corrugated iron. Curiously, the architecture of the residential buildings and the general layout of the khel are quite similar to those of the Angami village of Cheswezumi, located far down in the south of Nagaland, as Fürer-Haimendorf saw it in 1936 (above). (CFH/MA/SPNH)

Above: A speciality of the carvings at Shamnyu are its depictions of goral, a mountain goat that roams the very remote parts of the area and therefore denotes extra special hunting prowess.
Right: Christian educational board found at a morung in Shamnyu implying that developmental advancement may be discerned by the style of clothing.

first foreigners to visit Shamnyu is too important. At the lower end of the village we are met by Kosam Kenpong, a local worthy who has evidently accumulated much wealth and now has his own private *morung* as well as a substantial house, both of which we are invited to visit. The walls of his small open-sided personal *morung* are decorated with carvings of hornbill and buffalo heads, as are the main posts of the house, and the number of buffalo and mithun skulls hanging on the front walls attest to the sacrifices he has given.

Houses of the wealthy at Shamnyu display a speciality: alongside the main carvings of *goral* on the central poles, which testify to special hunting prowess, there are panels carved in low relief with ornamental double buffalo heads and circular inscriptions. These are the same as the ones Hutton describes in his 1923 diaries in the village of Yonghong. Elephants carved on the *morung* posts verge on the grotesque, a long trunk sticking straight out from a head with bulbous eyes and small ears flattened against the head. Other *morungs* display tigers with their cubs as well as snakes.

Arriving at the top of the first section of the village, we are greeted by the entire village council plus *gaonburas* outside an impressive *morung* – one leathery hand after another takes mine and shakes it. The village has gone out of its way to make us welcome and dancing and singing have been laid on. Everybody is happy about our obvious delight. First, a group of attractive girls sings a Christian hymn for us as we shelter from the rain beneath the eaves of the *morung*, and the rest of the village gathers in a huge crowd around us, the *morung* behind us heaving with people. The girls' performance is followed by warriors walking and jogging in a circle as they fire guns and chant in a low monotone. One particular song is

Shamnyu boasts special carvings as Hutton noted them in 1923 at Yungphong, Yakshu and Yonghong (sketch: JHH/MA/SPNH). These days, the planks carved in low relief with ornamentally expanded depictions of buffalo horns are especially rare finds. Clay handmarks are intended to ward off evil influences from the house. The number of skulls of slaughtered buffalo hanging up outside denotes the owner's wealth as these were sacrificed during feasts given for the clan.

161

Left: Shamnyu men during their impressive war dance performance.
Above: The elderly village hero shouting his heart out about his clan's virtues and achievements.
(Both: JS/SPNH)

Opposite: A village elder with chest tattoo next to an impressively massive tiger carving at Shamnyu's biggest morung.

a haunting dirge, led by Beching, the senior *gaonbura* responsible for the maintenance of village custom, who sings the main theme, and the dancers respond in plaintive unison causing the hairs to rise on the back of my neck.

In front of the *morung* is a low pile of stones with flat stones on top forming a level surface. This was formerly associated with headhunting and only a man who had taken 'enough' heads could stand on this platform and shout out his deeds to the assembled company on the return of a war party. I ask the friendly *gaonburas* if such a hero is still alive in the village. But at such short notice, only a single old man can be found who qualifies for this honour and even he has to stand only halfway up the platform while chanting out his deeds, not having taken enough heads to allow him on the top. He proclaims his heroism into the cool, damp air, pointing his *dao* and pounding a mithun hide shield against his thigh until his skin turns red and his voice fades away. How impressive must have been the olden days.

Now it is lunchtime and we are shepherded into the church hall where a meal of rice, freshly killed goat and vegetables awaits. Lunch over, we hear some more touching speeches and then set out to explore the rest of the village. I can hardly believe my eyes: Shamnyu is vast: there are twelve *morungs* and the mainly thatched houses extend over three mountain ranges.[78] The *morungs* boast many carvings, and the overjoyed Peter finishes one roll of film after another. He is especially impressed by the giant wooden penises breaking through the porch of one of the *morungs*. We explore one clan quarter after another – the village seems to be endless. Just as we think we have reached the end of it, we are pushed into yet another side path leading to a different part of the settlement where further interesting sights await us.

After two hours we stop for tea at Khamba's, an old headhunter whose chest is adorned with the usual 'fountain of fertility' tattoo pattern. In addition, his upper arm displays a lozenge-type pattern, which stops at the elbow. We ask him why his entire arm is not tattooed, as was the case with our visitor from Tamkhong this morning, and Khamba states that he 'had managed to take merely two heads'. He, along with another elder, has taken a liking to Peter's medium format camera. They can't seem to get enough of looking through the viewfinder and seeing their opponent as if on television.

Because of bad weather, daylight disappears even earlier than usual; this, combined with the tense situation in these parts of the hills, means Toshi calls for us to leave. On the way back we pass an old woman who, when we stop, starts talking to us in Konyak. She has a facial tattoo similar to that of the wife of the Chief of Tobu and allows us to photograph her (whenever she holds still and stops giggling). We tell her she is much too good looking to remain in the village and that she must run away with us. She leaves cackling with pleasure and shouting remarks, presumably ribald, after us.

78. Shamnyu is divided into two major settlements. The lower one consists of six *morungs* and clans – those of Changlu, Lower Yeangmang, Upper Yeangmang, Phamjong, Hoangmai and Yautap. The upper part of the village is formed by a further six *morungs* and clans – Shanglam, Changthong, Changwe, Changyang, Phoekphen and Changkhaoyeang.

After thanking our new friends and saying goodbye, we drive through the *panji*-bridled gate. The horde of jeering village boys closes it behind us and, thus, the impressive wall construction turns into a continuous hedgehog. Our time here is necessarily limited, but our 'initial contact' has been felicitous. During the night, in which again a curfew is imposed on us, I try to find something about Shamnyu in Hutton's diaries. But all I can come up with while retreating to the rather uncomfortable toilet is:

> *When Shamnyu, a Konyak village, raided the Chang village of Phomhek, and lost thirty heads to it in the process, they cut off the heads of their own killed rather than leave them behind for the enemy.*[79]

Unnerved by a sudden power cut and concerned about the terrible smell of gasoline in the toilet, which seems to serve as a secret fuel reserve, I grab a candle and join the others in discussion, which we engage in almost every evening, about the historical circumstances of headhunting. It will be yet another long night, trying to stay alert with many drinks.[80]

Above: Khamba taking an interested peek through Peter's medium format camera. (RK/MKB (F) IIb 4908)
Right and opposite: Fiercely sharp panjis on the village gate of Shamnyu. (Opposite – RK/MKB (F) IIb 4879).

79. Hutton 1924, 4.
80. See also *Curfews and Deadlines* 148-153

The Artist and his Village

Changlangshu, 20 October 2005

The next morning it is still calm in Tobu and its vicinity. Going to Tamkhong and Pesao being out of the question, we say goodbye to our patron, Poangba, around eight o'clock. He equips us with a valuable letter of reference for the villages we shall be visiting next, Changlangshu and Menyakshu, which are meant to be as large as Shamnyu. However, we now have two extra passengers: Toshi, whose car needs repairing again, and a young Konyak originally from Changlangshu who has been hanging around Poangba's with a cell phone glued to his ear. We'll meet Poangba again when we pick up Toshi's car and driver.

The Konyak villages to the east of the main road in this area are set on a series of almost parallel ridges like fingers, sweeping down from the backbone of the Patkoi that forms the border with Myanmar, and separated from the adjacent ridges by deep valleys containing rushing streams and dense patches of jungle. The way to Changlangshu offers a magnificent view of the notorious Ukha, glinting in the sunshine. Ukha, Wakka and Ukhrul are my favourite names for Naga villages – they are so splendidly direct and at no time conceal the culture they come from. Next to Ukha are Yakshu and Yonghong, which we intend to visit in a few days' time. On the way, we pass a strange sight: a newish-looking

Opposite: Changlangshu in the early morning as seen from the opposite ridge at Yonghong.

Above: Mauwang, the Ang of Longkhai, and his deaf-mute brother carving two wooden heads in 1937. (CFH/MA/SPNH)

log drum, approximately 6m/20ft-long and evidently abandoned at the side of the road. Toshi explains that it is the custom to throw out a new drum if a period of bad luck has followed its installation. This would be left to rot. If only we had room to take it with us!

The hills in these parts are fairly heavily *jhum'd*, the fields are in various stages of being worked, cleared or recovering from being cultivated in previous years, and are a patchwork of different shades of green. We reach Changlangshu around 11.00 after having bumped and ground our way along the track, dug ourselves out once – of course Hilary has no tools with him, so we go for it the Naga way with *daos* – and being stopped by a patrol of Assam Rifles, who, after accepting our credentials, invite us round for tea that evening. We receive a friendly, although curious, reception from the local pastor and some village elders who are interested in the purpose of our visit and very pleased to hear of our interest in their culture. After exchanging information and receiving welcome speeches, we leave our luggage in some rooms adjacent to the church hall and then set out to tour a few streets of the lower village till lunch. From a brief inspection it is evident that again we are in for an informative and pleasurable experience.

Peter has made it a habit on such journeys of bringing along as many photographs as possible, prepared for the respective villages. This proves to be advantageous at Changlangshu – not only for cross-checking information, but as a door-opener to the people. Scenes in which young people recognize their deceased family members are very touching to witness. Peter is especially interested in a *morung* with a magnificent tiger carving that – as well as being in the background of one of an old man carrying a sleeping child on his back – is in a photograph he got from an Indian colleague some years ago. With the help of many villagers, the tiger carving is soon located. Unfortunately, the old man in the picture is dead, but the small boy has survived and is now an adolescent. With a glance of uncertainty, his mother accepts the picture as a gift and hides it under her body cloth. The tears in her eyes cannot be hidden.

Toshi makes enquiries as to who the carver of these extraordinary artworks may be, and soon Hongpe Lenba, a man in his sixties, is produced. He tells us that he is the main carver for the village and still practises the art, preparing all the carvings required for the *morungs*. Altogether, Changlangshu has twelve exquisitely adorned bachelors' dormitories. We are kindly invited to Hongpe Lenba's house where he shows us other examples of his craft, including wooden *dao* sheaths, carved *dao* handles, carved heads and other objects. In addition he invites us to return in the evening for a discussion.

We continue our walk through the village streets. Behind every corner there are new things to be discovered. Many of Changlangshu's houses are still built in the old style. Their roof shapes and the low-relief carvings on their panels indicate their owners' status and wealth.

In total we visit twelve *morungs* with protruding, sharply pointed roofs, full of impressive stylised carvings and log drums.[81] Changlangshu does not seem to have been affected by the Tobu clash as we are told that the adolescents do not sleep in the *morungs* anymore. Huge stamping boards are positioned across the entrances of most of the *morungs*. These boards, shaped like inverted log drums with a slit of varying dimensions hollowed out on the underside and the top flattened, are an additional obstacle to entry when under attack and are also used for rhythmical stamping by *morung* members during ceremonies to accompany the log drums. Unfortunately, these stamping boards are not as highly decorated as those of their Phom neighbours, which feature motifs such as new and full moons and solar eclipses.

I don't know whether it is my light hair, pale face or possibly the red, sunburnt nose that causes so much merriment among older Naga women, but at Changlangshu again I am an object of mirth for an ancient woman, who practically splits her sides when I appear. I'll probably have to wear a mask or balaclava in future.

Opposite top: The notorious village of Ukha, impressively located on top of Hongkhong ridge; bottom: the discarded 'evil' log drum lying neglected in the mists near Ukha. (RK/MKB (F) IIb 4943)

Above left: Photograph taken by Hemen Sanghvi in 1996 showing a man and his child in front of one of Hongpe Lenba's carved masterpieces.
Right: Crude stairs have been hacked out of a granite boulder and lead to the entrance of a thatched residential building.

81. Among them are the clan quarters of Shajong, Jokju, Obongju, Kheye, Shayu and Menthong.

Examples of Hongpe Lenba's morung carvings, tastefully painted in earthen colours. Above: A goral on top of a buffalo head vanishing in the straw which covers the morung's floor; right: one of a row of monkeys on a cross beam behind skulls of sacrificed pigs.

Opposite: An extraordinarily abstract carving on the side pillar of a morung depicting a monkey embracing a tiger's tail from behind.

Our attempt to report to the Assam Rifles camp turns out to be futile as the commander is on tour near Pesao (digging more ruts into the mud, I suppose). Instead, the elders take us to see a sacred stone by the name of *Yangkayla* ('place where heads are buried') in the bush between the camp and Menyakshu. The story goes that a man from a nearby, long-gone village called Jianghong had been captured and buried alive in an upright position beneath this stone, which was much smaller but has since grown due to having plenty of fertiliser underneath it.

Back at our quarters, supper is waiting, served round the open fire with the warmth and pungent smoke wafting up. This time it is a goat's bloody head hanging outside the shack that greets us on arrival. Soon it is time to take up our invitation to go to the artist's house. We are ready when Peter suddenly announces, with a wretched expression on his face, that he has to renounce the pleasure intended for tonight. Judging by the colour of his face, he has a stomach upset, which I can certainly sympathise with after all these hornets, pig rinds and mutton livers. I cannot help remembering Mills' hilarious if rather malicious descriptions of the dyspeptic Fürer-Haimendorf:

November 18th, 1936 – Camp Kuthurr: The poor Baron is in bed. He looked very green at breakfast. His trouble is a chill on the stomach. It was frightfully cold at Helipong and he is terribly careless about putting on a coat when he is hot....

November 19th, 1936 – Camp Chentang: I forgot to tell you of the most amusing thing that happened yesterday. The Baronial bowels were being troublesome and he had to go aside into the Jungle while the Column went slowly past (it's not far short of a mile long.) The Sepoys a little way behind heard rustlings and grunts and groans in the Jungle, and thinking it was some beast of prey began to throw stones: where-upon the Baron swore back at them in English broken by emotion! I would have given anything to see it! Williams and I laughed till we cried when he told us. The Baron is still quite weak today but as careless as ever, as he again was wearing only a shirt when he told us about the incident. And in a flash he fell asleep.[82]

Toshi and I walk down the pitch-black street to Hongpe Lenba's house without Peter, our torches lighting up the murky thatched roofs – electricity is not to be thought of in Changlangshu. This brings back memories of an experience way up north in the Konyak village of Longwa. I was in the chief's house, sitting near the central fireplace but otherwise in total darkness, when I was told that, not long before, a minister had come to the village and Longwa had been equipped with electricity. Masts were erected and cables mounted on each and every home. Thus, when the minister came, Longwa beamed. On the particular night I was there, sitting in the glow of the flickering firelight, I asked my hosts what had happened to the power at Longwa. The honest answer I got was: 'It came with the minister and it went with the minister.'

Inside the house of our artist we huddle up close around the fire. The foggy night is bitterly cold. With Toshi doing a fine job of translation, we get some remarkable information from Hongpe. He is a professional carver, taking his fees in kind from the villagers and, in addition, receiving extra labour for his fields, which are also maintained by family members, such as his sons, as his time is taken up with the responsibilities of maintaining all of the twelve *morungs* in Changlangshu. As such, Hongpe Lenba occupies an important and central position in the cultural life of the village, and is treated with considerable respect. We consider including Hongpe Lenba in the programme of our society and the possibility of supporting his work financially. However, we soon drop the idea, as here is a rare example of an artist whose work is appreciated and supported by the society in which he lives. This corresponds with traditional Naga values. Interference from outside might cause jealousy and do more damage than good by endangering his position within the community. Instead, we order some artworks from him and leave the appropriate payment.

The happy evening ends with a special treat. The lady of the house makes popcorn by dropping maize seeds into a basket and then adding red-hot pieces of wood from the fire, furiously shaking these around to prevent the basket catching fire but allowing the seeds to expand and pop. This delicious snack, liberally covered in a thick layer of ash, is passed around and enjoyed by all – despite the fact that in the dark I end up chewing on a couple of pieces of burnt wood.

82. Mills *The Pangsha Letters* 1936, various entries, n.p.

Opposite: Hongpe Lenba, Changlangshu's own artist, in front of one of his artworks and the very few tools he uses to create his extraordinary art.

Above: In 1936, Fürer-Haimendorf was amazed by the artistry of the Ang of Longkhai's deaf-mute brother and requested him to make him a copy of an erotic carving present in one of the village's morung. (CFH/MA/SPNH) This carving is now preserved at the Cambridge University Museum of Archaeology and Anthropology. (MA/SPNH) A similar carving denoting fertility and life force was seen in 2006 on one of the cross beams in a morung at the Lower Konyak village of Tang. (GG)

Beer from the Toilet

Menyakshu, 21 October 2005

Chingmak told us that Mom, a big village on the next range, renowned like Tobu for its daos, had told him to bring us a challenge from them, as they thought it a pity we should have come so far and go away without leaving them any of our heads.[83]

As morning breaks to wisps of cloud still hanging around the village, reducing the visibility considerably, Peter seems to be fine and cheerful again. Although neither Changlangshu nor Menyakshu had been visited by Hutton, Mills or Haimendorf, we had decided to include these on our trip, lured by photographs taken by Ganguli in 1971 showing huge soaring *morungs* and not a corrugated iron roof in sight, as well as her reports of seventy *khels*, each with its own *morung*.[84] It appears that Menyakshu is actually the same as the village known as Mom on all maps and reports. It is referred to as a huge village by Hutton and was known as Min to its inhabitants.[85]

Arriving in Menyakshu, this time after only an hour's drive, the place is again shrouded in mist. As usual, we go through the formalities of tea with the elders, explaining our purpose in being there. This results in accommodation in the church hall and permission to make a dash up into the village.

Opposite: A craftsman outside one of Menyakshu's morungs mounting a cylindrical brass collar imported from Wangti village on to a dao handle.

Above: Heavy rain clouds create a beautiful light setting on the hills beyond Menyakshu.

83. Hutton 1924, 18.
84. Ganguli 1993, 6.
85. I am not entirely sure, as in 1946 W. G. Archer, last British ADC of the Naga Hills, remarks in his notes (Archer 1946) that the Kangsho clan of Tuensang was hired by Mom to attack 'Monyakchi', which sounds more like 'Menyakshu' than Mom. However, he makes many mentions of fine weapons supposedly coming from Mom which we also see, that makes it highly likely that Mom is the present Menyakshu. To clarify this in the village itself proves futile as the villagers' pronunciation varies between 'Momyakshu' and 'Minyakshu'.

176

Menyakshu is an extremely industrious village. We watch blacksmiths at work in the *morungs*, the smithies set up just behind the porch. A speciality of the locally-made *daos* is the use of cylindrical brass collars to strengthen the point where the handle meets the enormous blade, lending a somewhat Burmese feel to these weapons. The finely incised collars made by the lost-wax casting method come from the smithies of Wangti, a village one mountain chain ahead. At one of the *morungs* an old man named Kangko is meticulously filing down and sewing cowries to one of the broad cloth and bamboo belts that are worn for ceremonial occasions here.[86]

It is raining heavily by now, so we spend the afternoon dodging in and out of various clan quarters and their respective *morungs*, all of which are adorned with magnificent carvings, but covered by corrugated iron roofs. Likewise in the Yongkhoang *morung*, the one photographed by Ganguli, what remains of the original carvings is virtually concealed behind a new subroof at the front, the original *morung* having been open at the front.[87] In the Yongkai *morung* the front of a drum includes a simplified version of the chest tattoo of the men, finishing in a design that we later see on a male shell earring representing the head of a man. In other *morungs* there are, among other spectacular sights: an unusual buffalo-headed drum; a beautifully executed carving of three seated

Village scenes from Menyakshu
Opposite: Despite the chilly and humid weather, the old village heroes gather on the stone settings in front of Changwei morung wearing nothing more than their loincloths and chest tattoos denoting their headhunter status. The same fountain of fertility pattern adorns a grave stone at Longching and communicates even to people incapable of reading the life-force and honourable deeds of the person buried here who, according to the inscription on the grave stone, had reached an age of 118 years. (GG)
Above left: An avenue of thatched houses with wide porches leading to the upper parts of Menyakshu.
Above right: Feastgiver status at Menyakshu is denoted by house planks painted in black and white with ornamental and figurative drawings of buffalo and lizards (centre), as well as dao sheaths (right). These planks are very similar to those with multi-symbolic depictions of the Southern Naga groups, where they represent 'enemy teeth' or are used as stools in feasts of merit.

86. Refer to DVD, track 15.
87. Ganguli 1993: opp p.22.

Above and right: At Menyakshu, the morung was traced in which, in the mid 1990s, a number of skulls were still displayed that had supposedly come out of the old conflict between the Upper Konyak of Tobu and the Chang (HS). Today only the cane strings from which the skulls dangled and the beautiful carvings of tigers remain.

Opposite top: Three stylised hornbills on a morung's central pillar in the upper part of the village. (GG)

Opposite bottom: Menyakshu's sacred 'rain stone'. (JS/SPNH)

88. I noted Yongkhoang, Yunjong, Hakjak, Yeangphea, Yongkai, Vhangpheang, Changwei, Janle, Shakhe and Shanyu before I lost track. Milada Ganguli had probably mistaken seventy for seventeen.

human figures, coloured black, and positioned over a buffalo head also painted black but with an ochre outline; a tiger drum; groups of expressive monkeys holding heads in their hands or grabbing a tiger by the tail; as well as artistically eloquent groups of hornbills – and we have seen only a fraction of the seventeen *morungs* to be found at Menyakshu.[88]

Thanks to Poangba's letter, we are invited for lunch in the house of the absent village chairman, where a relative of his, a young man stylishly dressed in matching windbreaker and trousers with designer glasses, has taken charge of us. Asked about his story, he tells us that he was educated in Delhi, returned to his village some time ago and was presently 'between jobs'. To me he seemed more 'between two stools'.

Due to the rains the village paths are as slippery as a skating rink. We slide on the stones on the steep paths, unlike the barefoot Naga who never miss a step, hopping nimbly from one stone to another. Talking about stones, Menyakshu also has its 'sacred stone'. We stop to view it in a hollow beside an open area, this one being capable of bringing on rain if moved to a certain spot with appropriate ceremony. With a bit of imagination, you can also see footprints set into the surface of the stone, and we are assured that this stone is a certain cure for drought.

Soaked, and with camera viewfinders fogged-up by the humidity, we return to the church hall where some people dressed in traditional costume want us to photograph them. This takes about half an hour and then things get a bit boring as the attendees, one after the other, leave. With rain thundering on the tin roof, Peter surreptitiously sips from his half 'unbreakable Canadian plastic bottle' of bourbon. He has fetched it from his backpack and, unnoticed by the crowd, stored it in the pocket of his jacket hanging over the back of the chair. But Naga eyes are attentive and soon Peter has to stand trial to a lecture from Toshi about the impropriety of guzzling in public without offering a round to one and all. However, Toshi ends his sermon abruptly when I tell him that a rather crusty *gaonbura* managed to creep over to Peter's jacket hanging on the chair and, in a moment when Peter had left the room for a short while, had helped himself to a generous slug, no doubt leaving a few bits of his own sediment in the bottle, before sneaking it back into its hiding place. 'That certainly is enough punishment,' says Toshi, and the trouble is over.

We want to make up for the oversight and decide to offer a round of rice beer to the local dignitaries. Our well-meant proposal is received by the crusty *gaonbura* with a deadpan expression – I suppose he would prefer some more slugs of Peter's Kentucky Straight – but he promises to get some of this contraband organised for the night. Eventually we make our way through the pounding rain to 'Mr Crusty's' house. We find him and the other elders sitting around the open fire, their mood hardly better than before. Still, we hope that the rare rice beer might help. After all, he has organised six bottles. 'Mr

As a wealthy man

1. HE HOSTED THRICE THE MOST PRESTIGIOUS TRADITIONAL FEAST KNOWN AS ENJAIHPUH. (A FEAST CELEBRATED FOR 3 DAYS WHEN ONES WEATH OVERFLOWS).
2. HE PURCHASED TWO FOREST AREA (JENH) VIZ YAHSEN & SANGYANG AND ALSO A FIELD AREA (HFH) YINGNEAU NGETJONG.
3. HE LEFT BEHIND 21 JHUM FIELDS AND OTHER PROPERTIES FOR HIS DESENDANTS. LEAVING BEHIND OLD CUSTOMS & TRADITIONS. HE WAS CONVERTED TO CHRISTIANITY IN 1994.

"Thought you perish your noble deeds and selfless service rendered to the people will be cherished forever".
"May your soul rest in peace".

By
Beloved wife and family.
...died and approved by vill elders.

BORN IN 1910. DIED ON 2ND.08.04.
HERE LIES THE HISTORY AND MEMORIES OF
Lt. Beyao Ngupu S/O LT. HONGPI PONGJAI OF ASHIAKSHU CLAN. THE GREATEST HEAD HUNTER AND WEALTHY MAN OF M/SHU VILL. A HERO AND A SAVIOUR OF NEPI LEYE AND EMPI SANGTI.

As a Warrior

1. TOBU & MOKA AREAS HIRED N.N.C. AND ATTACKED M/SHU TWICE IN 1955 LED BY KIYING & KAIBA RESPECTIVELY KILLING TWO OF M/SHU, BOTH WERE AVENGED AND SHOT BY HIM.
2. IN VENGEANCE FOR LT. SHIAKPONG KHETNYAK & SANGTI YENLONG M/SHU RAIDED KENJENSHU TWICE. HE KILLED TWO.
3. HIS ONSLAUGHT WRECKED THE IDEAS OF C/SHU WHO HIRED KHEANGSHU LOMAO(CHANG) TO ATTACK M/SHU AND WERE TAKING AN AMBUSH AT TESANG VALLEY.

4. AS A REVENGE FOR LANGPHONG HAPAO & HONGPI JADHFANG'S HEAD'D HE KILLED ONE WANGTI AND LATER TWO C/LOISO AT HAMTHAO YANNGO.
5. HE BEHEAD HENJAI & KHAIMAI OF C/LOISO TO AVENGE LT YEANGKAI'S HEAD.
6. IN RETALIATION FOR LT. KHENYAN NEANGPA & BUMANG PHAIPA'S SLAUGHTER, HE KILLED ONE CHANGNYU.
7. HE PLUNDER TWO BUFFALOES TO AVENGE A STOLEN MITHUN OF HIS KHEL BY C/SHU.
8. DURING THE RAID OF THROLO FIELD HE BEHEADED TWO.
9. PESAO SOUGHT M/SHU'S HELP AND ATTACKED ANGPHANG HE KILLED ONE. LATER TO AVENGE M/SHUS HELP TO PESAO, ANGPHANG HIRED INDIAN ARMIES OF WAKCHING CAMP AND ATTACKED M/SHU IN 1946. THEY KILLED SHEAKPONG YONGKHAP OF M/SHU HOWEVER, HE SHOT ONE ARMY.
10. HE KILLED A WILD BOAR AND A BEAR.

Graves among the Northern and Central Naga groups I

The many variations of grave constructions among the Naga all served the purpose of documenting the status the deceased had achieved during his lifetime, as this status was believed to continue in the world of the dead. Achievements in headhunting and feast-giving, which were desirable virtues demonstrating the deceased's connection with the essential life-force, were documented in a variety of symbolic and actual ways.

(Counter-clockwise from bottom left) Thus, the Chang placed painted planks with symbols such as the fountain-of-fertility tattoo marks, hoes to indicate agricultural prowess, and necklaces with (taken) heads along with the hats, body cloths and weapons on to the grave (VE/MA/SPNH); the Lower Konyak placed the skulls of deceased chiefs into large stone urns on which were chiselled out animal and human heads and beings, denoting the person's status (VE/MA/SPNH); presumably inspired by his forefathers' customs, Manwang Lowang, an artist of the Nocte (Naga group in Arunachal Pradesh), carved a huge log with similar symbols, possibly intended to eventually serve as a grave urn.

Opposite: Now that literacy has reached many of the Naga groups, symbolic depictions of status have been replaced by written equivalents. Thus, this grave at Menyakshu meticulously describes all the many achievements in agriculture and headhunting of one Beyao Nyeipa.

Graves among the Northern and Central Naga groups II

Grave effigies, not only of the deceased person but also of his family, lineage or the people he had killed, were often part of Naga graves.
(Clockwise from top left) A Konyak lifting his father's effigy, which, after the proper rituals have been performed, is no longer taboo (VE/MA/SPNH); Sketches by Hutton (1923) of effigies at Ukha (grave), Angphang (slain warrior) and Yonghong (genna figure) (JHH/MA/SPNH); Effigies of a chief holding a head in his hand (middle) and his wives photographed by Hutton at Angphang in 1923 (JHH/MA/SPNH), which are now at the Pitt Rivers Museum, Oxford (MA/SPNH, opposite); A Konyak coffin with a carved hornbill beak placed on a platform in a tree (VE/MA/SPNH); Lower Konyak soul effigies and grave goods at Totok in 1923 (JPM/MA/SPNH).

Graves among the Northern and Central Naga groups III
Opposite top left and right: Mauwang, the Ang of Longkhai, and his brother making two grave effigies with all miniature adornments such as hats, cloths, baskets and weapons for C. v. Fürer-Haimendorf and H.E. Kauffmann in 1937 (CFH/MA/SPNH), one of which is now at the Ethnological Museum of Zurich University.
Middle left: Soul effigies at Mon in 1923. (JHH/MA/SPNH)
Middle right: Decorated chief's skull taken out of its urn at Mon. (Both: JHH/MA/SPNH)
Bottom: Skull cists at Wanching in 1937 (CFH/MA/SPNH) and 2006. (RK/MKB (F) IIb 5231)

Above: Watercolour painting by R.G.Woodthorpe (1875) of a Phom or Konyak grave and a photograph of the same grave (unknown photographer; both MA/SPNH).
Left: Remnants of traditional Phom burial practices are still to be found even in modern Christian graves (Pongo, 2002).

185

Crusty' emits a seemingly inhuman sound, which makes a servant run to a side room to produce a 20-litre bucket made from white and pink plastic. From the edge of the bucket hangs a dark blue beaker. Everybody who has travelled in India will probably be aware by now what these two vessels represent, where they are normally placed, and what they are normally used for. Yes, it's the bucket from the toilet in which water is stored that is poured over the hand with the little beaker while wiping your backside. My worst fears are realised as the servant pours the remains of the water from the bucket on to the clay floor and one bottle of rice beer after another into the bucket.

So it is really us paying a round to the locals (and Toshi) tonight, since neither stomach-troubled Peter nor myself are willing to take more than one or two sips out of courtesy, as we see how the rice beer, dull anyhow, mixes with the dull remains inside the bucket to an even duller monotony. We content ourselves with listening to what the elders have to say. Unfortunately this is not very enjoyable either because 'Mr Crusty' lapses into a lament about the inequities of the Brits and everyone else who has not given due credit to his village in the last hundred years. I know such speeches all too well from other journeys and know that the one lamenting will only terminate the speech once the person it is directed at is willing to (financially) compensate the lamenting person for the (questionable) content of the lament. For the recipient of the lament, the only way to stop is by escaping. Peter tries his luck by turning the attention to the profit made by the blacksmith in selling *daos* to us, the food and lodging we are paying for, and the (toilet) rice beer. With little success – 'Mr Crusty' himself wants some of the action and is making it clear. We continue to listen to him for quite some time until in a short pause, when our quasi-host seems increasingly drunk, we politely say goodbye and run for shelter to our quarters.

Here we discuss the matter with Toshi. His position is complicated as he speaks for us and at the same time has to face his discontented brethren. We make it clear that we sympathise with the view that says strangers should always visit with the necessary respect and sensitivity. Villagers, especially those in poor circumstances, should benefit from such visits. Under no circumstances should they be left with the feeling of having been used. Fortunately, though, Toshi is aware that we have always operated with the approval of the various village councils as well as individual village members, and have been accompanied by them during our visits, in addition to making donations to the requisite councils for maintaining their traditional culture – something we, of course, may never control. Nevertheless, I am left with a distinct feeling of discomfort which, like the rain that continues to pound all night on the tin roof over our heads, does nothing to lift my spirits.

Opposite: A recently built morung with a curious wooden impression of how the local artist seems to imagine a constable.
Above: "Mr. Crusty" in festive gear.

Examples of the extraordinarily diverse and artistic morung carvings at Menyakshu.
Opposite: A monkey holding a human head (Kailuhu morung).
Above: A rare find of a Y-post denoting fertility erected inside Yongkai morung after a feast of merit had been given.
Left (clockwise from top left): A warrior standing on a buffalo head; Human heads on rows of hornbills approaching a buffalo head (Yongkai m.); three warriors crouching on a buffalo head (Yeangphea m.); a monkey holding a buffalo by the horns (Hakjak m.).

Footsteps in the Fog

Menyakshu – Yonghong, 22 October 2005

When we wake the next day there is only a glimmer of light in the sky, not enough to pierce the clouds and walls of mist which have settled all around us. After breakfast we are again in a meeting with the elders, now in an even more uncomfortable atmosphere than before. No doubt, Mr Crusty has done the rounds spreading his views and is now glowering at us in the background. Toshi comes in from somewhere and whispers that a sum of 5,000 rupees for last night's room and board would be appropriate. I cannot believe my ears. Not only is this equivalent to a luxury hotel in Calcutta, but I am astonished by the brusque way the locals here try to reach their goals. 'Quiet action is the best diplomacy' is probably on Peter's mind as, with a smiling 'Thank you', he shakes the pastor's hand and leaves him the same amount we have always paid before in all the villages, plus an appropriate extra for the rice beer. Besides the pastor, I think nobody is really sorry to see us go. Under 'Menyakshu', I file: 'Fantastic *morungs*, but a strange village none of us are sorry to leave.' Our young dandy from yesterday does not show up either.

Opposite: Leaving Menyakshu's Yongkai morung in the rain.

Above: Treacherous, muddy paths towards the North.

Above: A carving of a monkey grabbing a tiger by the tail at a morung in Ukha. (GG)

On the way back to Changlangshu we again make it up to the Assam Rifles camp and this time are ushered into a very nice open rest hut with great views. The army has certainly picked the best place to keep a check on Menyakshu and Changlangshu. After the waiting period so typical of the bureaucratic world, which serves to increase the status of the one waited for, the camp commander appears: a tall Indian from Uttar Pradesh, dressed in military tracksuit with knife-edge creases on the pants, and looking freshly scrubbed. Tea and (way too sweet) biscuits are served, followed by a nice, albeit trivial conversation with not a word about political subjects or the reasons for our being here. After half an hour we take our leave and are back in the Jeep on the road to Tobu, where we have to organise diesel for our onward journey towards the North. By this time the clouds have started to descend into the valleys and the tops of the mountains with villages perched on the ridges are starting to appear, some bathed in sunlight through gaps in the cloud cover and giving me the feeling of being transported into a biblical illustration by Gustave Doré.

We lunch again with the eminently hospitable Poangba, with much to narrate and give thanks for. The situation in Tobu has remained calm – at least that is what we are told – and something very extraordinary is about to take place at the village of Yonghong, our next destination – what exactly, Poangba may not say.

After all the rain, the road up to the Hongkhong ridge where Yonghong lies is very muddy and treacherous. Fortunately, we are forced to stop only a few times and these are soon overcome. But as dusk falls the threatening clouds open and rain lashes down on the mountains, forests and us. We sweep past Ukha, crawl through Yakshu and finally arrive in a mass of dark clouds and mist at Yonghong. While parking on the village's outskirts and wondering where to go, visibility being virtually nil by now and the only sounds those of other footsteps in the fog, a young woman appears and, in excellent English, invites us to come into her warm house for a cup of tea. It is Ejie, wife of P. L. Wanmei, a village council member, and she despatches someone to come and guide us to our quarters.

As we are soon to find out, Yonghong is the climax of our tour, not only because of the experiences we have there, but also with regard to the friendliness, support and interest of the local people. Unlike Menyakshu, they are delighted to have us in the village helping to record their culture. This becomes clear especially in a wonderfully emotional speech given by the village chairman in which we are welcomed into the village community. Outer signs of this welcome are the valuable presents we receive. As the oldest, wisest and most venerable visitor, I am presented with a length of Upper Konyak national cloth – black, with green border stripes symbolising the number of successful headhunts and red squares signifying raided villages – while my juniors are handed *daos* with which to protect my old bones in

At the Konyak village of Angphang, located northwest of Ukha and Yonghong, the villagers are engaged in constructing a new morung, following the age-old patterns of architectural design: the traditional symbols of wealth, fertility and prowess are depicted as carvings on the pillars and cross-beams. The tasks are shared among all male members of the clan. Formerly the inauguration of a morung was celebrated with a raid for a human head; this has now been replaced with the sacrifice of a mithun or a chicken on the joyous occasion of getting together and celebrating the strength and unity of the clan. Possibly a new log drum will also be pulled in the near future. (All photographs: GG)

Above left: Line drawing by Hutton (1923) of a wooden "menhir" carved with a buffalo head at Yakshu village. (JHH/MA/SPNH)

Above right: Yonghong's villagers receive Hutton's old photographs with curiosity and gratitude and excitedly recall the depicted people.

the event of an attack. In such a way appropriately equipped, we are introduced to the village elders and *gaonburas* one by one. Most impressive is the statuesque figure of a warrior, complete with hair knot and encased in a red blanket, who strides in, ignoring our presence as is fits his position. This, we are told in hushed tones is Yangang, the village hero, and, looking at him, it is easy to imagine him out there lopping off heads with abandon.

Peter pulls out the old photographs of Hutton's trip, which invoke lively memories as they pass from one gnarled hand to another. We even find out the names of the village headman and his wife in two of the pictures from 1923 – Panglem and Hungkai. Then we are presented with the greatest prize imaginable. We find we have arrived in time to witness a spectacle, which, to our knowledge, no foreigner has ever been privileged to record in depth. Yonghong is about to pull a new log drum up from the jungle for installation in the Yinkong *morung*. Considering the enormous tree trunks I have seen as log drums in the *morungs*, I imagine a breathtaking spectacle – the entire village, a crowd of 900 people, will participate in the pulling. We are invited to take part in the ritual and to document it. At present, however, only the shaman and his helpers are allowed near the drum – the sacred ritual may not be disturbed by anybody. I can hardly believe my ears, hearing about these traditional customs and am beside myself with joy and anticipation.

Panglem, village headman of Yonghong in 1923, wearing a brass disk as a headdress reserved for chiefs. (JHH/MA/SPNH) Headdresses such as this, which in their form remind one of the Chang hoe symbol or certain chiefs' field huts among the Phom (see page 214), have become rare among the Naga. In 2002, however, one of the clan chiefs of Yongnyah was wearing one.

Down a Good Road

Longching – Chen Wetnyu, 23 October 2005

We have to wait for two more days to participate in pulling the log drum at Yonghong, so we discuss what to do in the meantime and decide to drive via Changlang and Longching to Aboi, from where we will try to reach the giant village of Chen, closest to the Myanmar border. The name 'Chen' has filled Peter and me with longing ever since we heard it. Only three explorers have been there before us – Woodthorpe 1876, Lambert 1936, and Elwin, together with the last British Additional Deputy Commissioner of the Naga Hills, W. G. Archer, in the late 1940s. Shortly before their visit there had been dramatic incidents at Chen which are described by Archer:

> *Memo. no. 3662G. dated Mokokchung 30/3/1947 – Chen and Mon are still in a latent state of war. Mon told me they would take a head from Chen in 1948, when the chief's eldest son is married. At that time a new log-drum will be brought to the chief's house and a fresh head will be necessary for offering to the drum. Furthermore Sengha took 10 heads from Chen in 1945 and a further 4 in 1946. Chen took 1 from Sengha in 1945, 2 in 1946 and they have just taken another this March. At present they are at war with about 12 villages.*[89]

Opposite: Clan elders outside of Hongkhong Ahng morung at Longching, a village on the border of Upper and Lower Konyak influences – the former may be seen by the Tobu-style tattoo mark, the latter in the architecture of residential houses (overleaf).

Above: A rare carving of a man holding a tiger by the tail at the same morung. An equivalent was photographed by Fürer-Haimendorf at the Konyak village of Anaki in 1936. (CFH/MA/SPNH)

89. Archer 1947, n.p.

After slipping and sliding down the mountain track to the main road, getting stuck in the mud and hacking our way out with a *dao*, we make good time to Longching, but arrive at an inauspicious moment, a young village guard having died and his funeral rites taking place today. Eventually, having found someone in a position of responsibility, we tour the parts of the village still accessible to us. Here, the influence of the Lower Konyak is to be felt clearly, both in terms of architecture and people's tattoos. We discover the *morung* depicted in Sardeshpande's book,[90] and find out that in Longching all the young men still seem to sleep in the bachelors' dormitory – in the truest sense of the word, because as we enter the house we hear the snoring of about fifty men coming from just as many hammocks criss-crossing the interior.

The villages along the way are Anjangyang and Changlang, where we can order diesel for our onward journey in four days. This will be brought by bus all the way down from Mon high up in the north of Nagaland. Finally we reach Aboi, an ugly little crossroads where the roads go eastward to Chen, westward to Aopao and Wakching, southward to Tobu and northward via Longmein to Mon. We treat ourselves to some packets of outdated masala chips and pay a courtesy visit to the Extra Assistant Commissioner, a

90. Sardeshpande 1987, Plates 23 and 24.

Konyak and Phom have a distinctly fantastic style of carving elephants. Opposite bottom: Onyeang morung, Longching; opposite top: grotesque carvings of a being half man/half elephant and half man/half snake at Sowa (both: GG); above and right: carvings of a family which seems to be nurtured by an elephant through its tusks, photographed in 1936 at Kongan (CFH/MA/SPNH) and in 2006 at Wakching (GG).

middle-aged Chakhesang Naga. While wolfing down his biscuits and tea, he assures us that we are in for a 'good road' up to Chen, which just yesterday has been newly flattened by bulldozers, both from the Aboi and the Chen side. We pass the first of the promised bulldozers just a few kilometres outside Aboi, resting at an acute angle to the road. I think to myself that this is due to the work on this part of the road being finished. However, when we have to get out for the tenth time to dig the car out, push it and cart stones, I know that the road construction company has simply given up.

It is about to turn dark when shortly before the first Chen – altogether there are three Chen villages – we end up with the differential jammed firmly on top of a stone, which has to be chipped out with an iron bar borrowed from one of the local villagers. The next obstacle looms in the shape of a deep trench across the road, which has to be partially filled where the wheels would go before we can drive over it. In moments like these, of which even more dramatic ones are soon to follow, we regret not choosing the less comfortable four-wheel drive vehicle at Jorhat when we still had the chance to do so. Finally, it is already late in the evening, we grind to a halt in a mud pit at the foot of a steep hill above which, as the dull gleam of a lantern tells, is Chen Wetnyu, where we are to spend the night. Instantly the Jeep is surrounded by curious eyes whose owners are ready to help us with the many loads we have to carry uphill to the local church and meeting hall. Here we are met by Sheiya Konyak, a teacher from the village, who makes us welcome and provides shelter in the small guest quarters behind the pastor's residence. We settle in, Peter taking the opportunity to observe a service in the church next to our rooms from where some interesting harmonies are reaching us. When he returns – I'm not really in the mood for a service tonight – he is enthusiastic about the many old headhunters with shaved heads, all with full facial tattoos of the spectacle design typical of the Lower Konyak, who quietly slumbered through most of the service. Together we take a short walk in the cool evening breeze. We feel the same about seeing sharply pointed *morung* roofs silhouetted against bright stars and the view from the steep mountainside into the valley – simply happy.

Top: One part of the vast Chen villages is Chen Loisho, remotely set apart from the other Chens on top of a ridge. Middle: The village of Sheangha Chingnyu (Archer's "Sengha"), which used to be at constant war with Chen. Its Ang's house is one of the largest in the whole of Nagaland. Bottom: Inside a stone and a spearhead are preserved as signs of a peace treaty with Chen. (All: GG)

Opposite: Yohon, a face-tattooed warrior, is now the fervent preacher of Longwa village (TF). A similarly strange and almost absurd impression of incongruence between war-like traditions and Christianity arose during the evening service at Chen.

201

The 'Sub Ang', Bamboo Tow Ropes and a Man from Benares

Chen Wetnyu – Yonghong, 24 October 2005

The next morning there is no obvious water for washing and the toilet is at the bottom of the pastor's garden, so I wander down there to steal some of the water in the bucket for a quick scrub. I am in for a shock: an enormous pig in a small sty next to the toilet wakes up with a tremendous snort just as I am tip-toeing past. After breakfast at the pastor's, Sheiya Konyak takes us in hand to see round Chen Wetnyu. The three villages combined are enormous. Today they are encircled by a sea of fog, making the lowlands disappear completely. In a later diary Hutton writes about Chen:

> *December 4th, 1926 – Chen is probably by far the largest village in the Naga Hills or the coasts thereof. It appears to cover about two miles of ridge and is said to have over 100 morungs. It is a village of recent foundation having come over the Patkai range from the Burma side a generation ago. The founder of it only died three years ago. His name was Panglem.*[91]

Our first stop is the enormous house of Chenhoo, sub *Ang* of Chen Wetnyu. *Ang* is the term used in the Lower Konyak for the great, strict and autocratic rulers, to whom are

Opposite: Morning mists cover the valleys below Chen.

Above: Chenhoo, sub Ang of Chen Wetnyu in polyester fur coat and hat on a plastic chair in front of his enormous traditional house.

91. Hutton *Tour Diaries* 1926, n.p.

*Details of Chenhoo's house (top right).
Left: The beautifully carved house planks, the central ornamental lizards being similar in style to those Hutton noted at Yonghong (see page 161); middle: carved pillar indicating heads taken; right: canework "knot" at the house's main threshold; opposite top: the elaborate front porch roof construction as viewed from below; bottom: locally manufactured clay pots used as storage vessels.*

extended king-like virtues and who, in certain cases, rule over dozens of subordinate villages. Chenhoo, although only second in local rank, exudes some of that dignity as he sits in front of us in the low morning light, robed in a black-tufted polyester coat (I wonder where he got it?) with matching Russian cap, his face marked with the black tattoo of his culture, his palace in the background. We are allowed to see his house. We are especially fascinated by the carvings on the front, one panel depicting lizards in low relief created with a skill the like of which we have seen nowhere else in the Naga Hills. The architecture of the giant hut shows definite links to northern Konyak architecture, the main structural poles jutting high above the roof and wrapped in thatching grass, reminding one of fertility poles. However, on the main threshold a top section decorated with canework leads back to Upper Konyak custom,

Above: Tolei, Ang of Chen Wetnyu, hears himself singing for the first time. (JS/SPNH)

Opposite right: Tolei (second from left) with the clan elders dancing in front of the enormous Wangpa morung; top left: his back is decorated with a distinct tattoo associating him with a certain animal familiar, presumably a tiger or a leopard; bottom left: also other tattoos at Chen bear significant meanings, such as this one indicating that the person has taken ten heads. (GG)

92. E. T. D. Lambert was a Police Officer in Political Service in India who accompanied a Survey of India party from the Brahmaputra in Assam to the Chindwin in Burma.
93. Fürer-Haimendorf *Naga Notebook 4*, n.p.
94. The Naga believe in a kinship between man and certain animals, especially carnivores.

this being the mark of a wealthy person and defining his house. Compared to ordinary houses, the space and height inside is amazing, the layout of the house being closer to Lower Konyak than Upper with a series of interconnecting rooms and a reception area for guests. After a short visit to the Hoyang *morung*, locally called *pa*, we return to Chenhoo for tea and biscuits, and questions and answers. I think of Lambert, who in 1935 wrote:[92]

> *Chen – Tea drinking up to a few years ago was forbidden in Chen under punishment of a heavy fine. It has been finding its way in now but it still used more as a medicine than as a drink. It is used both externally and internally. Opium in Chen is unknown. Chen grows no rice but taro and millet. They are fond of eating snakes, especially vipers.*[93]

The conversation about the circumstances that have led to the carvings at Chenhoo's house naturally turns to headhunting and our teacher-cum-guide becomes increasingly nervous. He soon takes his leave, saying that his students are waiting (otherwise he would have certainly skipped classes for today, I'm sure). However, with a distinct gleam in his eye, Chenhoo, while reiterating that he is now a good Christian, recounts in graphic detail his earlier exploits while lopping off enemy heads, a misty faraway look indicating how much he misses those exciting far off days. He then proudly removes his coat and shirt and displays an intricate tattoo in addition to the spectacle design on his face, which, unlike those of the villages to the south, is on his back. He explains that the pattern is an animal familiar – a tiger – and that each tattoo differs according to the individual and his respective animal familiar, which may be mithun, lizard, leopard or tiger.[94] He refers us to the *Ang* of Chen in this regard – an invitation we happily accept.

The old *Ang*, Tolei by name, is an extremely dignified old man but with a sadness about him, as he recently lost not only his *morung* but also his house to a devastating fire. He is living in temporary accommodation while the *morung* is being rebuilt – it is almost finished and just awaits the installation of the ancient log drum and stamping board adorned with hornbill heads that lie to one side of the main square under a temporary roof. We are allowed to photograph Tolei and a couple of the village council members and their tattoos in detail, the *Ang* proudly showing us his back tattoo, which differs considerably from that of Chenhoo. When Tolei's wife, a lovely old woman with a great sense of humour, sees our interest, she comes out and, with equal pride, shows us all her own tattoos, the patterns of which, as she lets us know, are reserved to the *Ang* clan. This may be verified from the patterns of the other tattooed women all dropping by to be photographed. The order in which the tattoos had been applied is as follows:

i. under the knee; ii. on the back of the hand; iii. underarm; iv. shoulder; v. above the knee.

Female tattoo patterns of Tuensang, Longleng and Mon I

(Clockwise from left) Phom, Yungphong (GG); Phom, Pongo; Upper Konyak, Tobu; Chang, Tuensang; Lower Konyak, Wanching; Lower Konyak, Chen.

Opposite (from left): Top: Phom, Yongshe, sketch by H. Balfour (1922) (MA/SPNH); the same patterns seen at Yongnyah in 2004; Upper Konyak, Longching (GG).
Middle: Ao, Changtongnya; Lower Konyak, Chen (both);
Bottom: Upper Konyak, Longching; Khiamniungan, Nokyan; Upper Konyak, Tobu; Upper Konyak, Yonghong, Phom, Yangching.

The continuation of the pattern round the knee has been shown outside the outline of the leg.

Tattoos—
1. Pongu ♂ arm.
2. do. ♀ face.
3. do. breast.
4. do. leg.
5. do. ♂ face.
6. Angfang ♂ arm.
7. Chingtang ♀ navel.
8. do. shoulder.
9. do. below throat.

Female tattoo patterns of Tuensang, Longleng and Mon II

Hutton was especially fascinated by the variety of female tattoo patterns and hairstyles of the Konyak and Phom, denoting clan origin and virtues, and meticulously sketched and photographed them on his tour in 1923. (JHH/MA/SPNH)

In 2002 a woman similar to that in Hutton's photograph taken at Yungphong could be recorded at the Phom village of Sakchi.

Rice terraces and a field hut in the lowlands north of Chen.

The mood becomes so jolly that neither the men nor the women can refuse to sing a local tune for us to record. As dignified headhunters, the men dance in discreet and slow moves in a circle with bent knees and raised *daos*, their voices low. Six women assemble at the huge mortar table and start husking rice while singing intricate melody lines, which, in order to reach a continuous sound wall, skilfully use each other's breath pauses for filling in. Everybody is happy that Peter is recording their performances on the minidisk player

and may play them back to the performers right after they are finished. None of them has ever heard him- or herself on tape before. The excitement knows no bounds.

As usual, time is our enemy also at Chen, as we have to make it back to Yonghong today. So we soon say goodbye to these great people and, having learnt our lesson from yesterday's bad road experience, we take the road via Tang on our way back – especially as this passes through the second Chen village, Chen Moho. A fatal mistake, as we are soon to find out.

No sooner have we left the village than we are stuck with the differential on a rock once again and have to be lifted off, which takes about twenty minutes. Almost immediately afterwards we hit a particularly horrendous corner where the ruts are deeper than our wheels and the central island is a sea of slush. We pile out once again and eventually manage to push the vehicle back up the slope. Hilary then decides to make a run for it and the car careers round the corner, lurching all over the place and losing bits in the process. There is no turning back now and we can only hope this was a one-off and the promised good road lies ahead. Of course, we are wrong, and are soon stuck in soft clay on yet another downhill slope. This time all our efforts to move the beast are in vain and it just sinks further and further into the mud, as the wheels spin round showering everything in sight with lumps of clay.

Fortunately, and as is the case so often in India, help is at hand, coming from somewhere entirely unexpected. A Border Roads truck lurches round the corner behind us, screeching to a halt just metres from our vehicle. The driver is a small Indian man from Benares (Varanasi) and an expert in all things. He announces we are stuck. We agree and ask for his help in getting us out. No one has a towrope. Toshi sets off to find some local inhabitants who can let us have some bamboo to use as a towrope – all bamboo in these parts is owned by someone and cannot just be hacked from the forest. Peter and I use the enforced break to take some photographs while there is still a bit of light – the sun is about to set. We wander down a field track towards a place where, as we had seen through our car windows while lurching down the road, we suspect a nice, specially-shaped *Ang's* field house to be located. We take some pictures and head back. Some time later Toshi returns with some local worthies and a couple of lengths of bamboo. The bamboo is immediately split at the ends, the individual splints twisted to render them more pliable, and woven round the towing stanchions of the Bolero and the truck, our man from Benares offering unsolicited advice to the Nagas – who promptly ignore him. After the second attempt, and to all our amazement, the bamboo towrope holds and the vehicle is dragged clear of the mud. Hilary makes a mad dash at the mud pit, and slips and slides round the corner, reaching higher, dry ground to the relief of one and all. Benares passes by waving at us and vanishes in the twilight ahead.

Deep ruts caused by army and logging trucks on the "highway to hell" between Chen Moho and Aboi take our Jeep to its absolute limits.

Konyak and Phom chief's field huts are built in unique architectural styles.
Above: Jakphang (GG). Left: Sketches by Hutton of Yongnyah, Yonghong and Longmein. (JHH/MA/SPNH)
Opposite (from top): Mon; Chen; Menyakshu (all GG); Chen (JS/SPNH).

Our troubles are not over. About 5km (3 miles) down the road, despite the assurances of better roads ahead, we hit an even worse stretch of mud and deep ruts. This time nothing we do is to any avail, even the help of more Nagas who are passing by fails to get the brute moving. To make matters worse, we are assaulted by clouds of mosquitoes as it is getting dark and this is supper time for them. We sweat, strain, try digging into the ruts but cannot budge the vehicle. But again there are guardian angels. Two more Border Roads trucks arrive, this time containing the supervisor for this stretch. He assesses the situation with an expert eye, a man is despatched with one of the trucks back to their camp, only about another 5km (3 miles) down the road, to fetch a steel towrope. Half an hour later, the towrope arrives, brought by Benares again, and we are informed that we will have to be towed at least another two to three kilometres before a reasonable surface can be reached, after that it would be plain sailing to Tang. (Hadn't we heard this before?) Hilary is on the edge of a nervous breakdown, the vehicle is no longer intact, pieces being strewn along the roadside at our many brushes with the spirit of the roads. We all pile back into the Bolero and set off on a hair-raising trip, being literally dragged down the road, sometimes sideways, sometimes facing straight ahead, Hilary manfully wrestling with an unresponsive steering wheel. The fender falls off and is fixed up again before we finally reach the homely barracks of the street workers where we are cordially invited for tea and biscuits.

As we sit sipping tea and nibbling soggy biscuits Peter all of a sudden turns pale. 'Careful,' he whispers in my direction. 'Slowly get up and come to me.' I follow my friend's advice and, as soon as I am at a safe distance, turn around. Good grief! On the wall right next to where my head had been sits an enormous hairy monster the size of a saucer, with eight long, narrow legs. Our hosts seem amused, shrug their shoulders, say, 'Just a little jungle creature which will find its way back to the forest,' and carry on with their conversation about the beauties of India. That spider is surely not one of them. But our supervisor does not mind anymore. His service here ends tomorrow. He will rush off to Delhi in a single drive.

Bidding farewell, we once more set out on what we are assured is a good road. Hitting the Tang junction, however, we are again ensnared in the mud. Fortunately, we manage to push the car out, but by this time our shoes and trousers are ankle deep in slippery grey mud and Toshi wants a photograph. I think Peter is about to give him a layer of mud on the seat of his pants.

We have four more hours to go till Yonghong – four hours which, fortunately, pass quickly under the stars with no other terrible situation ahead of us. At 3.30 in the morning we reach our destination and fall into our sleeping bags. This has been the worst drive of our entire journey.

DAYS OF THE DRUM 1: FAILED FLYING LESSONS

Yonghong, 25 October 2005

April 17th, 1923 — Yonghong is not only the biggest Naga village I have been into, but also one of the most interesting I have seen.[95]

Next day, the sun is finally shining. The air being crisp and clean, there are amazing views of Changlangshu and Menyakshu on the opposite ridge and as far as the hill ranges in the Yimchungrü country. Although my legs and arms ache from yesterday's pulling and pushing of the car, I am very excited. After breakfast and packing the equipment for recording the special day ahead, we are taken along a path beside thatched houses built half on stilts down to a kind of central village square in front of the Changnhe *morung*. Everyone at Yonghong knows this little traditional building by the name of 'Hootton *morung*' ('Hutton' being unpronounceable). This is the place Hutton had as his base in 1923 and, because he lavishes praise on Yonghong in his diary, he has reached heroic proportions here. How the villagers have managed to get a copy of the first reprint of his diaries remains a mystery to me.

As we reach the square all the heroes have already gathered – old ones such as Yangang and also young ones, clothed in as traditional attire as possible, with full weaponry ranging from

Opposite: Thick tropical forest on the edge of Yonghong village

Above: Yonghong in 1923. When Hutton first came here, the villagers denied him passage through their country and into their village, but later the conflict was resolved and he could explore the village, which turned out to be one of the most interesting he had seen.

95. Hutton 1924, 21.

shields of mithun hide over muzzle guns, *daos* and red-haired spears. We take our position at the edge of the gathering and Shamlau Konyak, the village chief, mounts the pile of stones in front of the *morung*. Gazing at the mountains across the gorge that mark the border with Myanmar, he shouts at the heroic assembly, 'Yonghong needs a new sign of its strength.' Shamlau speaks of the tree that has become Yonghong's new *kham*, their new log drum. 'Months ago,' he continues, 'our seers found *the* tree in their dreams and visions. Together they set out to find it and after three days of marching through the eastern forests, they stood in front of it. The omens were favourable – a hornbill arose from its crown, a monkey jumped from its branches and a snake came crawling through its foliage. They say it was as if the tree had been waiting for them.' He goes on to explain how it took the carefully selected young men from the village a whole two months to fell the 30m/100ft-high tree, strip its bark and hollow out the appropriate section. While doing so they had to be extremely cautious about reading the signs around them – it was a dangerous time, Shamlau recounts – a single unfavourable omen and all of their work would have been futile. But the young men had heeded all taboos, positioned guards and, together with the seers who had requested the tree to come with them, they had offered the right sacrifices. All went well. And now joy is overflowing, because today's the day: the log drum may be pulled.

In addition, the foreigners are here – like a gift from heaven, shouts Shamlau – in time to witness the greatest event in a Naga's life and to document it. This must mean luck for this day and for the future represented by the log drum. Life will be happy, unified, strong and fertile. This much is certain to the people of Yonghong. Again and again I look into faces which stare at me in awe. When I counter their gaze, the people laugh, hands held shyly in front, and look away, only to look at me again a few seconds later and to watch my every move and word. I listen to Shamlau and to Toshi's translations and feel overwhelmed by what I hear. Shamlau speaks of meanings connected with the log drum that I thought would have ceased to exist at least fifty years ago.

The chief orders us to go ahead together with a couple of guides so that we may document the warriors' approach along the village track and towards the place where their new symbol of identity rests. We are happy to do as he suggests and position ourselves in a curve below the village – Peter with camera and sound equipment and I with my wobbly video. It does not take long till we hear the deep-throated calls of the crowd as they leap along the path towards us, finally coming into view, brandishing weapons, shooting off ancient but still serviceable flintlock rifles with deafening cracks, and shouting war cries; some break out from the column as they hop around, screaming challenges and shaking their *daos*. It is a truly awe-inspiring sight that would have struck terror into the heart of any enemy crossing their path and would certainly have had me dashing for the hills screeching with fear. Yangang, the village hero, comes second

Opposite top: During his stay at Yonghong, Hutton stayed at the Changnhe morung. After its recent rebuilding, the villagers respectfully refer to this dormitory also as 'Hootton's morung'. Below: After days of heavy rain, the air is clear on the morning of the great day when all the villagers of Yonghong are to join in the giant log drum pulling ceremony.

Above: The traditional part of Yonghong consisting of long thatched houses with back terraces built on stilts.

Above: The warriors of Yonghong approach the site of the log drum, shouting, waving their weapons and jumping back and forth to safeguard the passage against enemies and evil spirits. As the most honourable person of the village, Yangang takes the second position, guarded by another warrior.

Opposite: The procession of warriors nearly vanishes amidst the giant and steep hills which will be their field of action when pulling the log drum.

in the seemingly endless column, which puzzles us. But our guides explain that, as the most honourable member of the community, he has extra protection, which he gets from a man with raised *dao* and shield, jumping around wildly and challenging an invisible enemy by shouting at the top of his voice. The procession sweeps past us and we follow. But they are too fast for us – as sure-footed as rabbits they race along the narrow path and are soon out of sight. This, however, is not a disaster, as they will start by performing a ritual at the drum that we are not allowed to witness. We have some time to marvel at the magnificent landscape we are walking through.

April 18th, 1923 – Indeed, the jhuming system of the villages round here is about the finest I have seen. Only millet and Job's tears are grown, but the whole hillside, and very steep it is, is most elaborately laid out in ridges and quasi-terraces with logs cut from the pollard alders growing all over the slopes and everywhere most carefully preserved. Unlike the jhums of other tribes, which are used for at least two successive years, the ground is sown for one year only, and, then allowed to stay fallow again for three or four years, instead of the more usual ten, and this rotation is continued with apparently admirable results, showing what really can be done with steep and unpromising land by careful preservation of the alder and precautions against denudation.[96]

I cannot get enough of the magnificent view. My eyes range from one sight to another and I stop watching my step. All of a sudden, I feel sharp pain in my back and moisture creeping up my sleeves. It seems that I have tried my hand at flying and have launched myself off the side of the path, dropping like a stone into a small brook 2m/6ft below, where a pile of pointed rocks has been artfully positioned to break my fall. I find myself lying helplessly on my back like a dizzy beetle. In a flash, two of our faithful Naga companions are by my side, unwrapping me from the rocks and checking that most of the bits still work. My right leg hurts a bit and I feel a piercing pain in my shoulder. Fortunately, both my cameras, which had been swinging from my neck, are undamaged, having been protected from the rocks by my body. As I make it back to the path and look into the surprised, shocked and compassionate faces of my companions, I realise that my attempt at demonstrating a technically sound flying lesson has been more of a crash course.[97]

Keeping my eyes firmly on the heels of our Naga leaders from now on and stepping only where he puts his feet, we soon reach a field hut with a lookout platform that juts out over the landscape's steep drop. I'm not in the mood for more flying exercises and decide against sitting there. A few men have just slaughtered an enormous pig, whose meat is still steaming while being distributed. Here we also meet the sponsor of the drum, Wennyei Konyak, an elderly man, dressed in village guard khaki uniform à la British army circa 1942, knife-edge

96. Hutton 1924, 28-9.
97. Peter van Ham adds that Jamie's first words, shouted once he was standing again, were: 'Peter, you got any of that on film?!'.

Above: Wennyei Konyak, sponsor of the log drum pulling, proclaims his clan's virtues on top of the drum. (JS/SPNH)

Opposite: The lookout platform, where meat is being cooked and distributed, juts out dramatically over the steep hillside. Jamie Saul sits filming next to Wennyei Konyak and Toshi Wungtung, and Peter van Ham can be seen standing on the left of the photograph. (RK/MKB (F) IIb 4962)

creases in the trousers and shoes so highly polished you can see your face in them. He will be the only one entitled to 'ride' the log drum on the last section of its journey into the village. From now on his name is inseparably connected to the drum as well as to the whole ritual and festivities, and he will be treated as a hero as he has used his wealth to feed the villagers for the entire time needed to pull the drum to its new destination. This is a typical custom for most Naga societies and is known as a 'feast of merit': someone who has gained a surplus from his fields gives this surplus back to his community. By this he gains status and prestige and the beneficiaries are less likely to feel envious. Overall the community is strengthened in a sensible way by the system of such feasts of merit.

Soon loud singing and calls in the distance draw us on and, as we turn the corner of the next gorge, I cannot believe my eyes: approximately 500 people have gathered on the steep hill and are struggling to pull a monstrous log up the almost vertical slope. Already the log drum has left a deep rut in the damp soil. I see the enormous distance the tree has already covered from the forests in the east up to here. But that was downhill. There now follow dozens of bluffs and gorges until the village boundaries are finally reached.

The Naga are well organised. In front of the drum, a bamboo frame manned by four men across each section bears the brunt of the pulling. A series of creepers lashed together in a thickness of up to four creepers snakes out ahead of the drum, disappearing up the hillside. Old and young men are positioned by the creepers next to the drum. Women and children will be taking positions at the sections of rope further to the front, but at present the pulling is men's business and, far from being haphazard, it is well orchestrated by a team of older men and leaders who stand on the hillside waving *daos*, spears and bunches of leaves and chanting a song, extolling the virtues of the men and the village. The pullers take up the refrain in a swelling chorus and raise the one rope above them before pulling in unison and in time to the chant. Centimetre by centimetre the drum moves up the hill in a steady rhythm, and we stand mesmerised. If 900 participants work like this for ten or twelve hours each day, I estimate that it will take the villagers a further two weeks at least to get their monster home. The sheer imagination of this, combined with the effort I am making myself, takes my breath away. Because, much to the amusement of the people, Peter and I have joined in the pulling fun and thus get an idea of the enormous show of strength undertaken here. I cannot help being reminded of the forced labour of Egyptian slaves. But the people here do this voluntarily and in their leisure time. This is even more astonishing considering they have just finished harvesting these same extremely steep hills, which must have taken weeks of hard labour in heat and rain.

As well as those pulling, there are men busy hacking away at vegetation and preparing the route for the drum, while others have the job of pushing wooden rollers under it to ease the

Scenes from the log drum pulling I.
Opposite: Having reached a certain height the pullers have decided to build a traverse into the extraordinarily steep hill. They have rammed supportive poles into the hillside over which the drum will be pulled. At the same time people will hold the drum by thick cane ropes from above in order to balance it and keep it from rolling over down the hill.

Above, from left to right: Once in a while, especially when it seems the drum is about to get stuck, one of the commanders climbs the log and beats it, as if he was trying to convince the drum to comply with the pullers' will; Sheer physical strain is written in the facial expression of this young puller; Yangang, in his coarse voice, screams at the villagers to give their best.

Scenes from the log drum pulling II
Various dignitaries in command of the log drum pulling spectacle are strategically positioned along the rope made of cane creepers twisted together. Mangyang and the other successful warriors of the village as well as their wives shout at the pullers, instructing them about the necessary moves and motivating them for their superhuman efforts through constant dancing and waving their arms in the rhythm of the pull. (Top right – RK/MKB (F) IIb 4974)

Right: The women of Yonghong wearing their finest clothes and jewellery – conch shell necklaces and black dresses with a skirt woven with stripes in the Upper Konyak's 'national' colours of red, yellow, green and blue.

Opposite: Along the hills the pulling procession takes on various forms, at times looking like a giant human snake singing and leaping through the grass. At the log drum itself, only men are positioned. (Left – RK/MKB (F) IIb 4972)

Scenes from the log drum pulling III.
The pulling of a log for the rebuilding of the Thepong morung at Wakching in 1936, as witnessed by Fürer-Haimendorf. (CFH/MA/SPNH) The operation is very similar to the one at Yonghong in 2005: there are separate pulling sections for men, women, boys and girls and various people of rank act as commanders.

passage or wedging up the drum at the side with angled poles, preventing it from rolling off the path, which would certainly lead to fatal accidents. Yet more men hold long ropes that angle out from the drum, preferably anchored around a convenient tree, again giving direction to the drum by steering it in the right direction. Sweaty faces wreathed in pain from the exertion, muscular bodies glistening with sweat, the thick veins protruding, and a wall of sound from hundreds of voices echoed by dozens of steep hills – all these images burn into my mind. But at that moment I am not sure if these are the most impressive sights or whether the laughter coming from hundreds of weather-beaten faces is even more memorable. The unbelievable cheerfulness and boundless enthusiasm of everyone present gives them a strength that unifies them – the same strength Shamlau had referred to. In a few weeks they will stand in front of their log drum, the symbol of this unity and strength, and will remember these weeks for their whole life. No wonder that to the Naga log drums are living beings with a sex and names. At this very moment the drum also appears to me to be spiritually loaded and able to come to life – and this will be especially so when the warriors play their steaming rhythms on it, which may be heard for miles and will make shivers of fear run down the backs of their enemies.

After two hours of jumping up and down the steep gorge recording visions and sound of this amazing event, laughing, pulling and trying not to slip a second time, a rest at the field hut is called for, and to watch the women bringing the food and later joining in the pulling. Soon about 400 women come down the slope that we have already taken, all dressed in black, waving branches to chase away any evil spirit and singing with light, clear voices – a magnificent contrast to the dark male voices, which let the mountains ring. One after the other, they unload their baskets of rice, meat and vegetables carried by a strap on their foreheads. Their food is well wrapped in banana leaves. Even so, the pleasant smell of cereal and vegetables is already escaping. The baskets are received by men who carry them up the slope to another hut – the destination of the log drum by noon. In order to reach this aim the women immediately join in the pulling. They are a great sight as they move eagerly towards the log drum in their black dresses and necklaces of white seashells.

We follow and listen to their songs, which sound like challenges to their husbands or to the men whose attention they want to attract. Laughingly, the men reply in song. It is difficult to describe the feeling of awe that courses through my body, the hairs on the back of my neck standing up as the chorus thunders out across the rolling hills, the deep voices of the men thoroughly complemented by the trilling of the women. The women then join the fray, the first day that they are allowed according to tradition, and take up position at the head of the creeper, a long line now stretching out of sight like a huge snake winding its way up the hill. The pulling starts again, this time with selected women cheerleaders joining in, some dressed

in warriors' hats, swinging *daos* and sticks and screaming and singing at the tops of their voices.

Much to my surprise, after another hour, the place where the drum was supposed to be at that time is reached and lunch may be taken – but not in the immediate vicinity of the drum. Everybody streams to a remote field hut halfway up the next steep hill. Special precautions have to be taken with the cane rope, as it may not touch the ground and people are not to cross over it but just underneath it. 'It always was that way,' is the typical explanation. I suspect some taboos associated with cleanliness, possibly also concerning women menstruating.

Unlike Toshi, Peter and I cannot finish the enormous portions of still hot Job's tears seeds, pork and jungle leaves, which have been ladled on to a plate formed from a banana leaf for us, and, after consultation with Toshi, request that it be parcelled up for later enjoyment back at our quarters. The food is wrapped up in a kind of 'doggy bag' made out of the banana leaf plate, and stored underneath the body cloth. As a real Naga, Toshi has no such problem. After half an hour Shamlau calls for departure and willingly everybody follows. Before starting the pull again, the men line up on either side of the drum, turn it round until the slit faces up, remove the bamboo protection and belt out a few rhythms on the drum. Then the drum is re-protected, turned sideways and again prepared for pulling, which starts with a threefold bloodcurdling 'Amaaaaaah Shuaaaaaaa! – Hey!' Again we stand aside, marvelling, unable to let go of these sights and the thoughts about what it might mean to the villagers to pull such an extraordinarily heavy monster up such an extraordinarily steep hill. This will continue till late tonight and similarly for the next weeks.[98]

In order to get to know the village so much appreciated by Hutton – there is a ritual planned for tomorrow in which we also may participate – we take our leave. Our guides follow a shorter, steeper path up the hill, which eventually comes out into the jungle just short of the village of Yei, an offshoot of Yonghong. There we are confronted with an all too familiar sight: our trusty vehicle hub-deep in mud and listing to one side. Hilary had decided to meet us and became bogged down in the process. We all set about trying the usual tactics of digging, shoving stones under the wheels and other time-wasting procedures, while the wheels spin furiously, throwing out great clods of mud at anyone standing behind. We try pushing, but do not have enough people: the vehicle is stuck fast. Peter has had enough and sets out to walk back to Yonghong. I hang around to wait for the others. In the meantime some more able bodies arrive and Hilary persuades them to help. Strategically positioning myself in the centre of the vehicle, we all give an almighty shove and, just as Toshi appears on the horizon, free the car from its muddy grave; it hurtles off down the road towards solid ground, throwing out clods of slimy earth as it thunders off. It is well into the night that we finally hear the men and women returning, singing and joking, from their mighty task of pulling their symbol of identity up the Naga Hills.

Opposite: The women, led by the eldest woman of the village (who is displaying a facial tattoo), descend the hillside to join in the pulling. Singing and waving branches, they chase away evil spirits and from a distance make the men of the village aware of their presence. (RK/MKB (F) IIb 4964)

Above: The pulling of the log drum goes on into the night and will continue to do so for three weeks. (RK/MKB (F) IIb 4977)

98. For a film of this day of the log drum pulling refer to DVD, track 16.

DAYS OF THE DRUM 2: THE RITUAL

Yonghong, 26 October 2005

The next day breaks at 6am when a group of girls wants to sing some songs for us. They have picked what they feel is the perfect background for their performance – the soccer field in front of the church. All dressed in black with the body cloths that carry the yellow, red and blue stripes so characteristic for the Upper Konyak, their seashell necklaces reflect the first rays of sunlight. After a few attempts ending in giggling and whispering, the Yonghong Shekokhong troupe gets into the swing of things and gives three separate performances of the same two songs, an ancestral ditty known as Pouchou and a new song, which covers the period after the introduction of Christianity. In order to save time, Hilary gives us, along with our Naga mentors, a lift to Yei, where he does his party trick and, incredibly, manages to get us stuck in the mud just short of the place he had reached the previous afternoon. We manage to dig ourselves out fairly quickly with the help of our guides and Hilary decides to join us on the path downhill through the jungle. It seems he has caught Naga fever too.

Opposite: Yangang, the village hero of Yonghong, has mounted the log drum and, at the start of another day, is inspiring his fellow clansmen to continue their superhuman effort in pulling the drum up the steep hills.

Above: A log drum overlooking an Ao village photographed by W.G. Archer in 1947. (MA/SPNH)

From quite a distance we can see that the drum is on a small knoll way above where we thought it could have reached, the cane rope being hung in the trees again. When we arrive at the spot we watch some men renewing the cane binding on the back of the drum, pounding, splitting and twisting the creeper until it is malleable enough to be taken through the wooden loop at the end of the drum and wound together. Peter fixes his microphone to a tree – we had been told that we may not be in the immediate proximity of the drum when the warriors perform their ritual – as we hear them arriving in a flurry of shouts, rifle shots and war-like posturing. We are ushered away from the drum and told to go higher up the hill where we can witness the ceremony to be performed.

The purpose of the ritual, according to Toshi's translation, is to convince the log drum to follow the people for another day towards their village. It starts by the men walking around the drum. Yangang, the village hero, overtakes his guardian and now leads the procession. Today he has brought out everything that records his headhunter status: loincloth with cowrie shells, arm rings from elephant tusks, basket for the loot with attached monkey skulls, helmet from red-dyed cane with boars' tusks, bear's fur and hornbill feathers. A chain of brass heads dangles from his neck. In his hands he holds a long *dao* and a shield of mithun hide. In a deep coarse voice he prompts his comrades, who are similarly richly adorned, to form a circle around the log drum – which they willingly do,

The warriors prove their strength to the log drum, sneaking up to it through the long grass (opposite) and with shield and dao raised (above left) as if attacking an enemy. This symbolic overthrow of the drum convinces it of their worthiness to adopt it as their clan symbol. The photo above, taken in the mid-twentieth century, implies that these forms of ritual attack have not changed over the years. (Unknown photographer, VH)

Scenes from the second day of log drum pulling at Yonghong.
Above: A man up an alder tree, his lookout high above the fields. Above right: The monkey skulls on a warrior's basket indicate his headhunter status. Opposite left: A plastic children's mask is as good a symbol for headhunting success as a monkey skull. Opposite right: One of the pullers has proudly attached a shiny CD to his bear's fur cap, thus continuing the Konyak practice of attaching all kinds of shiny objects, such as Burmese brass disks or mirrors, to their hats in his own special way.

chanting, waving *daos* and firing guns. At times the Konyak wish for adornment takes rather peculiar forms. Thus, in the crowd, I find a man who, instead of the typical brass disks imported from Myanmar, has attached a shiny silver CD to his bear's fur hat. Furthermore, on one of the head-taker's baskets, instead of the monkey skulls denoting status, I discover a plastic children's mask, which looks as if it comes from an ancient Greek play.

Then the village hero mounts the drum and screams at his comrades, beating the shield against his thighs and inspiring them Naga-style to use all their powers for another day of superhuman effort. With screams, chants, raised *daos* and fired guns, they indicate their approval. When Yangang has finished, all the men storm towards the log drum and try to get hold of one of the beaters. Then the tree for the first time on this day reveals its new role as a dull, booming and deafening sound rings out, symbolising the prowess of the people of Yonghong, their unity and identity. The warriors are content with the sound of the drum – one can see it on their faces as they leave to take up their positions at the cane creepers. Finally, the women also come down the hill, dressed as yesterday, singing, dancing and waving branches. They hail their men, cheerfully position themselves at the ropes and on their command begin to pull.

Their successes in warfare have entitled Yangang and his senior clansman to position themselves on top, directly next to the drum for their efforts in convincing it to join the Yonghong villagers. After this ritual is over the women are again permitted to join in the pulling, fervently motivated by the chief's and the elders' wives.

Log drums carved and painted in different styles I.
Opposite: Upper Konyak, Changlangshu.
Top row: Upper Konyak, Menyakshu; Lower Konyak, Chen Moho; Lower Konyak, Mon.
Middle row: Lower Konyak, Longching; Chang, Tuensang; Lower Konyak, Chen Wetnyu.
Lower row: Lower Konyak, Wanching; Ao, Mopungchukit.

Log drums carved and painted in different styles II.
Right: A Lower Konyak log drum at Wakching in 1937. (CFH/MA/SPNH)
Below: Nagaland's most ancient log drum from 1725 at the Ao village of Changtongnya.

The Naga concept of the drums being a spiritual entity may be clearly perceived in Ao log drums where the head sections are often equipped with human features such as faces or eyes and sometimes arms (see also preceding page), which give the drum a figurehead-like impression as on ancient sailing ships. Clockwise: Ao drum photographed by Archer 1947 (MA/SPNH); a similar drum photographed at Mopungchukit in 2002; detail of the eye of Nagaland's second most ancient log drum (1740) at Changtongnya.

Lunchtime on the second day of the log drum pulling at Yonghong. In their baskets the women have brought huge quantities of food – Job's tears, potatoes, leafy vegetables and pork – to be distributed among the nine hundred hungry pullers.

99. For a film of this day of the log drum pulling refer to DVD, track 17.

After five hours of superhuman but happy pulling, the log drum has reached a secure place halfway up the hill and it is time for the lunch break. The 'kitchen crew' has slaughtered twenty pigs that morning and left hundreds of baskets filled with boiled Job's tears seeds at the field huts. Exultant and joyfully chattering, the people sit comfortably in the shade of a jungle clearing at the top of the hill. The crew attends the pullers and pours spring water brought in bamboo tubes on to their hands, which have turned black from sweat and dust. Then a great broad leaf is spread out on the ground for each group of feasters, and a huge dollop of a tasty mixture of millet, Job's tears seeds and rice is placed in the centre and everyone helps themselves in a sea of flashing hands diving in and out of the mix. Around the edges, the women dole out the rest of the food. We are still new enough to remain the main object of curiosity as regards our eating and other habits, but this soon dies down and everyone tucks into their own communal pot. There is so much to eat that towards the end of the break people start a friendly fight with it. Happy about the surplus, they laugh as they throw handfuls of sticky Job's tears mash into each other's faces. They are following an age-old fertility ritual, which in this or similar ways is performed among many peoples of the world, be it the water festivals of Southeast Asia, the Indian *Holi* or the rice-flour festivals of the Himalaya.

Thoroughly fed, the massive troupe follows the chief's commands and happily sets off down the trail again. Soon I hear chanting and screaming again – this time, however, from a distance, echoing in the surrounding green hills. We may not follow our new friends again as our time in Nagaland is drawing to a close. Tomorrow we will make a move towards Mon from where it is not far to Assam. Upon my return to South Africa I will discover the headlines that coincide with the dates of our amazing experience at Yonghong: 'Hurricane Wilma reaches Mexico'; 'Man dies during upheavals in Birmingham'; and 'Sunni province rejects Iraqi constitution'. The most important experiences in life are probably not to be shared."

Before we leave, however, we do not want to miss exploring some of the locally important places, the first one being *Aoyangyong Kang*, an enormous stone marking the site where an ancient flood had reached before being turned back. Naturally, to see it involves a breathtaking ascent, higher and higher, till one arrives at the top of the hill. Naga paths make no concession to easy routing and, like Roman roads, normally follow the straightest line from A to B, which can be more than a little exhausting for some of us. Once at the top of the ridge, we follow the click clacking of the *daos* in the sheaths of our Naga guides through an endless series of ups and downs, over open clearings and through dark stretches of jungle, until we reach a truly enormous stone. For our Naga companions this means photo-session time and they come up with ever-new combinations of people to pose

Left: An Upper Konyak woman's adornments. The white conch shell halves and yellow and red glass bead necklaces appear to glow against her black dress. On the upper edge her facial tattoo can be made out.

Above: In a joyful mood and joking loudly, the villagers of Yonghong eat their lunch; they are also divided into male and female sections during their break.

with. Peter has become the favourite of Lamphong, one of the younger members of the village council, who has helped Peter during his remarkable photo work along the steep ridges and has prevented him from coming into serious trouble more than once. Peter has told me that when he did eventually slide and fall and was stung in the hand by a black, hairy caterpillar, Lamphong, immediately alert to the possible danger of such a sting, selected in a most expert way a certain leaf, picked it and rubbed it on to the painful puncture, around which an oedema had already formed. Shortly afterwards both the swelling and the itching were gone.

For our way back, our Konyak friends select a path they call a 'short cut'. However, in order for us to enjoy it as much as possible, they give each one of us a *dao* so that we can help them with clearing the path of thick undergrowth. The mithun, whose faeces everywhere turn the track into a slalom course, have merely nibbled at brush and bushes and not trampled them aside. Now I can understand why the Brits had developed a system of 'control' in the regions adjacent to their administered zone by which it was compulsory for villagers not only to carry loads but also to clear the paths to their villages, should an official visit be announced. Otherwise efforts of making contact of any kind most probably would have been completely futile.

Hacking away thorny creepers and skipping over branches and slippery leaves, we stumble through the thicket, when all of a sudden we find ourselves back at the same access path to Yei where we had been yesterday evening. Naturally, we ask our guides if we may pass through the village. They justify their hesitation by telling us that Yei at present is pulling a stone and therefore is *genna* – taboo. 'It's party time in the Naga Hills!' I think to myself – this is fantastic. What else will Nagaland hold in stock for us to witness? But we are requested not to remain for long in the village so that no evil may come upon us. Somehow, however, I have the feeling that some sort of clan-related conceit is the reason for our friends' attitude, but accept that presumably it would not be advisable for us to participate in yet another extraordinary event among possible enemies. This would certainly hurt the feelings of our hosts. We do not linger and go straight through the village in frosty silence – presumably the stone pulled is a gravestone. Yei, however, is a village that would repay time spent there, as it has a series of stone paths, very well laid, that wind their way around the village like miniature Roman roads.

Unfortunately, this last night I inadvertently cause a major political gaffe by checking on some information that I had been given the night before, according to which there are two clans in Yonghong. This, however, differs considerably from the information in Sardeshpande's book.[100] Therefore, I ask some of the elders if they can verify it. At first they look at the names, make a few corrections and agree that the list is essentially correct, one even writing down the names of four sub clans. I go off to bed quite happy and oblivious

At the end of the lunch break the villagers start throwing Job's tears seeds at each other in a playful re-enactment of an ancient fertility ritual.

100. Sardeshpande 1987, 129-30.

of the furore that is to follow. Somehow my rough outline notes end up with other elders who overturn everything that had been said earlier, and pull poor old Toshi out of his bed to explain why I am causing problems with their clan information. For some reason that I do not find out, this is a local hot potato and even after explaining that these are preliminary notes based on information from others, Toshi is again hauled out of his slumbers to explain this. After again attempting to explain that these notes are based on existing writings not of my making, Toshi then, again for some unfathomable reason, launches into a rendition of a Yimchungrü song, which tells that all Naga groups have sprung from the same source. This song seems to smooth ruffled feathers and finally everyone involved in the unrest may find a few hours of sleep. Anyway, I first find out about this when I wake up next morning and am given a long lecture by Toshi about the seriousness of the matter. Three times I listen to the repetitions, then I have had enough and leave the house to make a few sketches of carvings nearby. I hate being preached at, especially repeatedly and especially if I am not really to blame.

Opposite: At the end of a glorious day the sunlight breaks through the thick foliage in the jungle en route to Yonghong's 'flood stone'.

Left: Lamphong and another new friend from Yonghong have their photograph taken on top of Aoyangyong Kang.

The Skulls of Longmein

Yonghong – Longmein – Mon, 27 October 2005

Up in the village I notice the platform that has been erected in preparation for dragging the log drum up to its new home in the *morung*, and see some new carvings, which cheer me up. While sketching I am collected by the friendly Shamlau and we return for breakfast. Then we assemble in the main room for the goodbyes, and are again in the thick of the clan story. After once more explaining that the notes are not written in blood and that the point of raising them was to get the correct information that I would accept no matter what the people tell me, the guys' looks are slightly less grumpy. It is time for some last snapshots together, affectionate thank-yous and handshaking. Lamphong, Peter's friend, has tears in his eyes and uncontrolled sobbing makes a bit of betel juice drop from the corner of his mouth. The Jeep is packed and we are on our way. We see our guides, Shamlau, the elders, Yangang and others standing in the morning sun waving at us for a long time, as we do too. I certainly feel sad that this wonderful visit has turned a bit sour by a misunderstanding. But considering Hutton's many remarks about the chaotic clan relations reigning everywhere in the Naga Hills, I can imagine that some things have happened here that the villagers have not coped with completely as yet, or at least do not want to have raised to public level.

Opposite: The enormous field hut of the Ang of Longmein.
Above: A first view of the skulls of Longmein stored inside the morung's log drum.

Top: Inside 'Hootton's morung' – a "Naga cherubim" as Hutton used to call these carvings of heads adorned with buffalo horns.

Bottom: Low-relief carvings at a feastgiver's house at Yonghong, possibly those Hutton had recorded in 1923 (see page 161) and similar to what we saw at Chen Wetnyu.

101. An old spelling of Longmein.
102. Hutton 1924, 31-2.

Upon reaching the next village, Kenchenshu, we are immediately made to think of other issues, as here stands a truly magnificent *morung*. It is still thatched with palm leaves and the roof juts steeply, cane balls at its ridge and bizarre bamboo roots sticking out from the front. Naturally, we get out of the car when stopped by a young boy letting out a piercing scream and starting to bawl uncontrollably, obviously unused to foreigners. Eventually he is brought to a stop and, still sobbing and glancing fearfully in our direction, is led away by his mother. Peter is heading our group so I can sympathise with the boy.

Via Changlang, where we can buy gas for the Jeep, we reach Aboi in 2½ hours without incident, from where we take the northern route to Mon. This road is much better than the nightmare track towards Chen, and we soon see a village located on top of a gentle hill in the midst of a vast plain east of us. The fields in its vicinity are barren from the last harvest, as Peter's heart and mine start bumping almost at the same time: on one of the fields we spot one of the strangest huts we have ever seen. Of course we have to get closer to it. The *cacha* road towards the village is reasonably dry but sometimes loses its contours in the wide surroundings, at times leaving us directionless in the middle of a barren field. But finally the hut comes into view, an approximately 25m/82ft-long bamboo monster, consisting of a roundly-domed main building with an extremely long annex, topped by two bamboo sticks with long tassels. Peter and I disagree about which is the beast's front and which its back and, thus, come to different conclusions as to what this building is supposed to signify. Peter says it is a turtle with a long neck, I say it is a frog with a long tail. We agree, however, that it is a traditional field hut of an *Ang*, as mentioned and drawn already by Hutton in 1923 (see page 214). The building indicates the absolute power of the *Ang* and serves as a resting place for his servants when they labour on his fields. We are fascinated by this unique form of indigenous architecture, shoot pictures and continue our journey to the village. We are excited to get to know the man whose status is testified by such an amazing construction.

20. April 1923 — To Longmien,[101] visited by Mr. Webster in 1913, dropping down on the way exactly 3,000 ft. in about six miles, before the ascent to the village and the path a mere mud slide. At Longmien we were among the naked Konyaks, again as at Yungya. I noticed dolmens, and the approach to one morung consisted of a long raised stone path paved with flat stones. In front of this morung there were high dolmens and one tallish menhir. In some of the Angs' houses I noticed a large number of basket-work objects hanging in the roof. Some were figures of men, one, for instance, carrying a gun. Others reminded me of some sort of branching fungus or seaweed in shape, hung upside down, but were possibly merely the result of trying to combine many human shapes into one basket.[102]

Various perspectives of the beautiful, fully-thatched morung of Kenchenshu.

254

Our bumpy entry into Longmein is accompanied by the shouting of hundreds of children who try to get a hold of the Jeep so that Hilary has to lay down the law many a time. Passing by compact huts with round roofs and huge pounding tables in front, we stop at the *Ang's* house. He is at home and cordially welcomes us. At first his presence is not very commanding, but his importance is indicated by a guard who paces behind him at a respectful distance with a pulled-out rifle. The approximately sixty-year-old *Ang* invites us inside his large, dark house and offers us – for the first time on our journey – rice beer, poured into bamboo mugs by his wife. I instantly feel at home and marvel at the stuffed bearskin eaten away by moths and other nasty bugs and hung from the eaves. Basketwork figures, however, I am not able to spot anymore.

The *Ang* is willing to take us around his village and to show us the places described by Hutton. We are soon on our way along the ancient stone paths of Longmein, surrounded by the hordes of kids who had welcomed us here. Indeed, there has not been much change here. But what had escaped Hutton's view – probably it had been hidden from him – is revealed when we ask for it: Longmein still owns a collection of twenty enemy's skulls. They are stored inside the log drum of the *morung*. In our honour, they are brought from the drum and placed upon the huge stone table, which still serves the *Ang* and his council for speaking the law. An old warrior with face

Impressions from Longmein.
*Opposite: A portrait of the Ang; the Ang with his wife and daughter inside his house, protected by an armed guard behind him (AS/SVH); an avenue of tidy houses.
Above: The peculiar canework figures noted and drawn by Hutton are now at the Pitt Rivers Museum in Oxford (all: MA/SPNH). What remains is the stuffed bear, which hopelessly rots away, being eaten by moths and other insects.*

255

tattoo and robed in an ancient and dirty army jacket watches us from the terrace of the *morung*. He gets up, leaning on his spear, scuffles towards the skulls and in a croaking voice starts to explain the origin of each: 'This one is from Aopao, that one from Chongwe, this one should be from Lekhang and those from Totok.'[103] True, I think to myself – one can see it from the lines subsequently painted around the eye-sockets indicating the old spectacle tattoos so typical for the Lower Konyak. I am reminded of the immense respect which the Naga used to extend to their enemies and the many taboos and laws involved in headhunting. Peter's question whether the people of Longmein also used to name their children after the beheaded enemies is unanimously affirmed. Then the skulls are stored back in the drum and the children, who are present at all this, grab the drum beaters and begin one of the most amazing drum performances I have ever heard in the Naga Hills. They are playing real melodies – caused by the different sizes of the beaters which bring out different frequencies from the wood. Towards its rear the log drum features a narrow tail. This especially

256

sonorous part is banged on by one boy with a huge stone, thus creating an especially low sound, serving as the base for all frequencies on top of that. We are totally thrilled. Unfortunately, Peter has left his recording device in the car, so we will have to return to Longmein one day.

There is still quite a distance to cover until we reach Mon so, unfortunately, a timely departure is necessary. The mood in the car is a bit low as we all know that the end of our journey is drawing nearer and nearer; we all press our noses against the window and follow our own thoughts. The road leads through increasingly flatter terrain, this being the cause for the term of the local population 'Lower Konyak'. But this would not be Nagaland had not the villages here also been built on the hilltops. Thus, the road has to again ascend gradually and in serpentines in order to reach both the final remaining villages before Mon – Totok Chingnyu and Chui. Peter and I have visited both of them already, Peter having reported about Chui on another occasion,[104] and Totok Chingnyu being perceived by both of us as not very interesting, taking into account, however, that our visits here were short.

It is already dark when we reach the town of Mon and we can feel clearly that the scope of our valued guide Toshi starts to wane here. His connections up here are few and, therefore, it takes a while to find accommodation for the night – at the guesthouse of the police church.

Opposite: The skull collection at the morung of Longmein. (Top: TM, bottom: VD)
Above left: The old warrior who was so firm in naming the places from which the skulls were taken.
Above right: Longmein's children having a ball at performing a tune on the log drum, which involves drum beaters of various sizes – and even stones – thus creating melodically appearing rhythms.

103. For an historical film showing the identification of skulls taken in raids refer to DVD, section "Return to the Naked Nagas", track 1.
104. van Ham 2006, 171-3.

Farewell and Death in the Naga Hills

Mon, 28 and 29 October 2005

October 21st, 1923 —To Mon, home of the mightiest of all Angs – chiefs of great personal power and sanctity. Their authority is unquestioned, and their persons are taboo very much like those of a Samoan or a Maori chief. The Ang of Mon has a fine house 120 paces long— long paces too— and the village was most friendly, and presented us with a mithun. There are stone sitting-out places here, and, in front of the Ang's house, a huge pile of stones to which a small erect stone is added for each enemy head brought in, the head being first exposed on a high stone table, which forms part of the pile, and ultimately housed in the morung, not apparently in the Ang's house. A bush of euphorbia grows at the top of the pile. The village contained an enormous number of elephant skulls.[105]

Peter had been to Mon in 2002 and made a lot of friends there, especially with the *Ang* and a grumpy older fellow called Longsha, who in the mid-1990s starred in Pan Nalin's documentary about the Konyak.[106] He is excited to meet them again and also I am looking

Two generations of the Ang of Mon at their village's stone settings.
Opposite: The late substitute Ang Yangbong together with two of his wives and a relative in 2002. (JHH/MA/SPNH) Above: One of the last "true" Angs photographed by Hutton in 1923.

105. Hutton 1924, 41.
106. Nalin 1995.

Compared to what Hutton saw in 1923 (above), the Ang's quarters and the village's stone settings had changed only marginally in 2002 (right). It was only in 2005 that a concrete staircase had been laid into the sacred monument, in order to "facilitate the tourists' needs", as Toongnam, the late Ang's son, explained. (right and top right: JHH/MA/SPNH)

forward to seeing this ancient, powerful village Peter so adores, which I had to pass on during my journey in 2002 when I could visit only Shangnyu, Wakching, Chui and Totok.

Mon village lies approximately 3 km/2 miles outside and above the township, and driving there really seems to take one back in time. Upon passing through the village gate and ascending the curving track, one gets to see open fields and thatched houses, old men with spectacle tattoos and women with colourful beaded necklaces crossing the road. Passing by the big church we arrive at the *Ang's* house. There we are in for quite some surprises. At first, no one is in sight and Peter is shocked that a concrete stairway has been built into the extraordinarily huge stone pile in front of the *Ang's* house. This giant mushroom-like building with six main pillars jutting out of the thatch roof, fortunately, has not changed at all. We call in to the house for someone to attend us and then have a look into the modern structure next door, where we are more successful. It does not take long until three women wearing heavy glass bead necklaces and porcupine quills through the upper ear cartilage appear. Peter instantly recognises them as the wives of the *Ang* and the women also seem to recognise him. He distributes the photos he took in 2002 and jokingly relives episodes from those days, including how they had tried to bring a smile to one of the *Ang's* wives, which proved to be futile. Even today only a fleeting smile touches the queen's face – not because the woman fears to appear less royal when doing so but because the news she is waiting to

Yangbong, the late Ang, in 2002 and a picture of him being laid-out for his friends and subordinates to pay final reverence to him. The cloth covering the corpse comes from Maram in Manipur and was given to the Ang by filmmaker Pan Nalin during the shooting of his documentary in 1994.

tell is so bad: the *Ang* is dead. Last spring he suddenly died of a heart attack. The shock not only still lies deep with the queens but I can see in his eyes that Peter is also devastated.

Wakching, August 24th, 1936 – Mon and Chi beyond the administered zone seem to have an endless supply of blue-blooded Angs which they pass on to other villages.[107]

All of a sudden a young man of about twenty-five emerges from the house, dressed in a polo shirt and shorts and with gel in his hair. But below his knees he displays the signs of royal origin – two strings of blue glass beads. He introduces himself as Toongnam, first-born son of the late *Ang*. He, too, is grieving, but is happy to receive photographs of his father, which are probably the last ones taken before his death. Toongnam takes us to his father's grave – a monument that is a mixture of traditional burial practices and Christian influences, with a replica of the *Ang's* impressive tiger-teeth necklace and a gong worked into the concrete and marble of the gravestone. As Toongnam recounts, it seems more and more likely that he will inherit the real necklace. We ask him to explain the complicated connections between *Ang* status and succession.

The deceased *Ang* had been a substitute or Deputy *Ang* since the original *Ang* was shot by the underground in the 1970s when he was unwilling to support them, and his true heir, a son living in Mon Town, was not willing to give up his 'modern' lifestyle with all its (questionable) amenities – especially his opium addiction – to fulfil his duty up in the poverty-stricken village of his ancestors. After the Deputy *Ang's* death, Toongnam tells us, the villagers had again asked the original *Ang's* son to come up to the village, but the answer was still negative. Therefore, Toongnam will follow in his father's footsteps. This, apparently, causes him some problems as he has been married to Chahlim for two years, a love marriage indeed, but with a girl of 'commoner' status. Should Toongnam be installed as *Ang*, the villagers would have to select a wife for him of the noble or *Ang* class from a neighbouring village, who would be able to bear a new *Ang* with the correct 'breeding credentials'. Chahlim would then become a skivvy for the royal wife who, not being allowed to do housework or work in the fields, could only cheer on the gangs working in her fields while reposing on the sidelines. The beautiful Chahlim, busy weaving a complicated weft pattern on a small loom, does not look the type who would take cheerfully to her new role.

I am astonished how important the *Ang* institution seems to be to the people here still – or rather again – since this is in complete contrast to what Fürer-Haimendorf had described in the 1930s, and also in the 1960s when he returned briefly to Nagaland. Presumably this is a further sign of the revival movement taking place everywhere in the Naga Hills:

Wakching, July 12th, 1936 – The present Ang of Wakching is a pathetic figure. Actually he is not a proper Ang as his mother did not come from the Ang clan. The old Ang's two sons

from his first blue-blooded marriage had both died young so that another son of a secondary wife became his successor. He soon wasted the entire fortune inherited from his father, especially on opium, and he allowed the house on the old Ang ground to fall apart. Nowadays he lives in the poor half-dilapidated house of a man who died some time ago. Because he had sold his own fields the village gave him some land and they still work one field for him, but he is so lazy that he does not even bother to look at his own fields. His influence and power naturally enough is nil. An interesting example for the decline of an institution.[108]

Peter asks Toongnam for the marriage date. Looking for a wife will start in the spring, answers the young *Ang*-to-be. We would be thrilled to take part in this event, which, as it means that the future *Ang* of the mightiest of all Konyak villages will introduce himself to his vassals for the first time, will surely be unique.

Wakching, September 12th, 1936 – When Mewang married an Ang daughter of Mon she was brought by her relatives to Chi and he paid a bride price of three mithun, three buffalo, 100 daos and 300 spears. For that the bride brought with her six long necklaces of spirit money each worth Rs. 100 to 200. For the wedding people had come from eight villages dependent on Mon and twelve 'sons of Chi' had come.[109]

Opposite top: Toongnam at his father's grave made from marble and glazed tiles and sheltered by a tin roof, also involving, however, traditional aspects of Konyak burial in that some of the Ang's personal belongings are hung at a fence next to it.
Opposite bottom: As a sign of their status all Angs in Nagaland are solely entitled to wear strings of blue glass beads below the knee.

Above: The present Ang of Longkhai and one of the wives of the Ang of Leangha in 2006. (Both: GG)

107. Fürer-Haimendorf *Tour Diaries* 1936/1937, n.p.
108. op. cit., n.p.
109. op. cit., n.p.

Toongrum gives us the royal tour of the house of the *Ang* which is bigger and longer than any other house in the village, including the *morung*. Proudly he tells us that the house was built without a single nail. Inside are various rooms on the unlevelled clay ground, each with its own fireplace, occupied by different family members. Each wife – the deceased *Ang* had six, three still being alive – would have had her own room. The front part of the building is the reception hall where the throne is standing, a bench made from a single log with carved hornbill beaks as side adornments. On the walls are stored an amazing *dao* collection as well as further insignia of royal status. In the rearmost room leading towards the terrace are stored the pottery items and the massive pounding table where each wife would have her own position according to her rank (see page 73). For a number of reasons, including the fact that the *Ang* had more wives than anyone else, no one was allowed to have a bigger pounding table than the *Ang* and should such a situation ever occur, then the person concerned would be exiled and his fields confiscated. We discover a relic of Hutton's day – one of the large hollowed-out dishes on which the rice is dried by adding hot stones to the grain:

264

Mon, October 21st, 1923 – We noticed again here the dodge of drying paddy before use by putting it into a long wooden trough and pouring in hot stones. It gives it a slightly burnt taste which is perceivable in the rice beer brewed from it, and which is said to improve the taste of rice which has been dried in the sun, merely, before husking. Can it be an adapted survival of the pre-pottery age, when cooking was done this way with hot stones?[110]

Then it is time to visit the old honourable headhunters of Mon to give them their photographs taken two years ago. Unfortunately, Peter's most impressive first contact in Mon is no longer alive, but his widow is overjoyed to receive a photograph to keep her memory alive.[111] There are tears in her eyes as we leave to take the path towards Longsha's house. The track takes us through the cemetery built around the old head tree, where in the olden days the enemy heads were hung until they were dry enough to take their final place inside the *morung*. Graves here are again a mixture of old and new, the deceased now being buried but grave goods still left in some places, such as an umbrella mounted to

Views of the reception room inside the Ang's domicile.
Above: The Ang with two of his wives behind the fireplace for guests.
Opposite: The Ang's throne and dao collection. Most Angs' thrones have hornbills carved at their ends – as at Chui, where it is furthermore compulsory to present the beaks of hunted hornbills to the Ang, which he hangs from his ceiling, thus raising the mere trophy to a symbolic level, that of beauty and power. Other symbols for the power of the Ang are the gongs presented to him by subordinate villages and the monkey skulls attached to baskets signifying headhunting prowess.

110. Hutton 1924, 41.
111. van Ham 2006, 167.

There are nine "Great" and twenty-eight "regular" Angs in Nagaland's Mon district who hold influence over 113 villages. In 1936 the Ang of Wakching already held a rather minor position, as Fürer-Haimendorf recounts, which was not only due to Wakching having come under British administration, but moreover the Ang's addiction to opium (which again was a colonial way of slowly breaking the power of rulers). Seen here is a portrait of the last "proper" Ang of Wakching (left), taken by Mills in 1921 (JPM/GH). Next to Mon and Chui, the Angship of Tang is still one of the most powerful in Mon district. Pictured here are portraits of the Ang of Tang in 1923 (right – JHH/MA/SPNH) and of Lemwang, a direct successor, in 2003 (opposite – ML).

The Ang of Chui through the ages.
When Hutton went to Chui in 1923 the people there were going around almost naked, as did one of the Ang's sons (JHH/MA/SPNH). Outside of the Ang's enormous house (unknown photographer/MA/SPNH) was placed his skull collection and an elephant's skull hidden underneath a bamboo mat (JPM/MA/SPNH). Although the present Ang, Mangkau, lives in a bungalow-style house and recently saw himself forced by missionaries to bury all the head trophies (picture taken in the mid 1990s/HS), the elephant skull is still used by him when he speaks on matters of justice (GG). His son's outlook on maintaining his father's power is uncertain (AS/SVH).

269

The Angs were always free to choose any woman as secondary wife. Only the first wife had to come from the Ang class. In 1921 Mills photographed two of the daughters of the Ang of Wakching (above – JPM/GH) Costly beads and ornaments were common dowry items for women from the Ang class to bring into their marriage, thus enriching the property and wealth already existing in the Ang's family (right: girdle of one of the Ang's wives, Mon). Only the first wives of the Angs were entitled to refrain from any labour. All others faced the same physical hardship, especially on the fields, as all Naga women, which clearly shows in their faces (opposite).

shade the soul, and a fire lit on the burial place as was traditionally done under the burial platform to guide the soul to *Yimpu*, the realm of the dead.

Finally, we arrive at Longsha's large house, Peter being visibly excited to see his old, cranky acquaintance again. Toongnam, who has accompanied us, shouts and Ngapshom, Longsha's equally old wife, answers, buzzing with excitement. She opens the door, we step inside and are led towards the terrace at the back where Longsha sits in the sun. Peter's eyes moisten – clearly he has become fond of the old fellow – but the joy of being reunited is tempered by seeing the state the old headhunter is in. The poor chap, who had taken four heads prior to 1948 and whose exact age is unknown to anybody, is almost totally deaf and his back has become so crooked in the last two years that he has trouble moving. We show him the photographs, which he looks at happily, and make the most of every minute we may still be together in this world as it seems unlikely we will be meeting Longsha again.

All the people present are photographed once again and pose in their finery. Then it is time to say goodbye for good. Peter holds Longsha's hand for a long time, his head directly opposite the monkey skull attached to the hat of the old headhunter. Two worlds meet at this moment, all differences in origin and culture transcended by the power of sheer humanity. We drive back to Mon in silence. Peter stares out of the window, not wanting to let go of the fields and mountain jungles. The treasure to be drawn from travelling with one's heart and mind open to new experiences is unfathomable. Being torn between two worlds is the price one pays.

In 2002, this dignified warrior was the first person Peter met in Mon. He appeared in full festive attire coming from the fields below the village. When in 2005 we tried to present him the photographs taken of him, we were only able to meet his widow who could not hold back a tear receiving them.

Views of Longsha, the sympathetic and cranky character from Mon village.
Top: Longsha seeing himself on a Polaroid for the very first time. (PN)
Left: Longsha wearing a hat adorned with a monkey skull and chewing betel in 2002.
Above: Longsha and Ngapshom, his wife, receiving our photographs along with the explanations by Toongnam in 2005.
Opposite: Longsha bidding farewell.

THE NAGA PEOPLES AND THEIR LAND

To one living and working in the Naga Hills in daily contact with various tribes from all parts of the district, as I was roughly from 1913 to 1930, the differences in language, custom, dress and psychology, seemed so marked that the inherent unity of the Naga tribes tended to be obscured by their differences ... All this meant that one could not see the forest for the trees. Now, after thirty years or so it is possible to look back and take a wider view and see the Naga as a people rather than an assortment of tribes or even villages, though what I have to say now must be read subject to the proviso that I am writing of the Nagas as I knew them over thirty years ago.[112]

This is how, in 1965, J. H. Hutton prefaced an article dealing with the mixed culture of the Naga. Now, more than forty years later, this unity has been further reinforced by the emergence of a movement that seeks to bind all those peoples recognised as Naga under a single political union and to consolidate that union in a homogenous homeland. In fact, Hutton went on to demonstrate the various differences that he found so marked in his years in the hills and to categorise these by area and ethnic grouping, while comparing them with similar practices occurring elsewhere in the Eastern world. The term 'Naga' has moved from a vague term used as a loose reference to peoples inhabiting the mountainous regions between India and Burma to a political label defining those same peoples, of whom, regardless of cultural and linguistic diversity, it is said that they now feel a sense of oneness with each other and wish to be regarded as a single nation. This development contains a lot of ground for political debate and how far this corresponds with the reality is beyond the scope, possibilities and interest of this book.

Geo-cultural Setting

Geographically, the Naga homeland region is bordered by the hills and mountains running in a generally north-south direction on the northeastern border of India and the northwestern border of Burma. The Naga live in four states of the Indian Union – Arunachal Pradesh, Nagaland, Manipur and Assam – and in the hills of the northwestern part of Burma's administrative district of Sagaing. The Naga cultural realm in Arunachal Pradesh is confined to the state's southernmost extension in its Tirap and Changlang Districts. The state of Nagaland is adjacent to this fingertip-shaped area and is the centre proper of Naga culture, its population consisting almost exclusively of Naga and, with sixteen groups, comprising the largest number of Naga groups in any one state. To the south is the Indian state of Manipur, which in its northern areas also accommodates Naga groups. The western extremities of these Naga territories extend to the southern tip of the Indian state of Assam. The Burmese territory in which Naga groups are found lies in the hills of Sagaing. This skirts the entire eastern border of the Indian Naga realm.

Several mountain ranges cross Naga territory. The Himalayas stretch in a continuous curve around the easternmost corner of Arunachal Pradesh to form the Patkoi and Naga Hills and the broader Manipur Plateau, which extends to the Cachar Hills of Assam. This part, the Barail Range, reaches up to Kohima, the capital of Nagaland and its highest peak, Japfu, attains a height of 3,048m/10,000ft. Here it is met by the Arakan Yoma range, which from this point runs in a northeasterly direction and marks the eastern frontier of Nagaland. It is a watershed between the rivers of India and Myanmar, though it is traversed by the Tizu river draining eastward into the Chindwin. The Naga Range has several peaks over 3,000m/9,800ft, Saramati (3,926m/12,800ft) on the international border with Burma being the highest. Consistent with the ranges and spurs, the courses of streams are also generally in a north-south direction. The river valleys, such as Dikhu, Tizu and Doyang, being generally narrow, they cut the hills almost at right angles, resulting in a criss-cross pattern.

Land, flora and fauna in the Naga areas show an altitudinal division into sections ranging from foothills to sub-alpine. A narrow band of tropical semi-evergreen forest forms the northern and

Top: Nagaland consists of mountainous terrain which used to be almost entirely covered with forest (Wokha district).

Above: Only in Southern Nagaland is rice cultivated on a large scale in terraces (Phek district).

Opposite top: Most of the Naga groups undertake slash-and-burn cultivation (jhum) (Mon).

Bottom: Terracing certainly is ecologically more advantageous (Khonoma).

112. Hutton 1965.
113. Krishna 1997.
114. Biswas 1988.
115. Barua 1991.
116. Jacobs et al 1990.

southern boundaries in the foothills and along the river banks to 600m/1,970ft. The tallest trees are deciduous; evergreens form the lower canopy, with a dense undergrowth of shrubs and climbers. Rich in tree-species, the tropical evergreen forests of the foothills have been heavily exploited for timber. Sub-tropical evergreen forest with trees growing to 25-40m/82-130ft occurs between 800 and 1,900m/2,600 and 6,320ft and is rich in orchid species. Bamboo occurs as a secondary succession on slash-and-burn cultivated lands (*jhum*) and in evergreen forest to 2,000m/6,500ft. This zone is also rich in fern species, which vary in different sites from west to east. In the rain-shadow areas of the temperate and sub-tropical belt are pockets of pine, growing in association with different trees, including birch (*Betula*) and *Lyonia*, depending on location. Next there is a wide band of wet temperate forest at 2,800-3,500m/9,000-11,500ft, predominantly conifer but also *Quercus*, *Michelia*, *Magnolia*, *Prunus*, *Schima*, *Alnus* and *Betula*, and broad-leaved forest at 1,800-2,800m/5,900-9,000ft. Temperate bamboos form a shrubby undergrowth in many places. The temperate broad-leaved forest includes *Magnolia*, *Quercus*, *Rhododendron*, *Populus* and chestnut species.[113] Differences in elevation and vegetation patterns cause considerable climatic variations in Naga areas, ranging from humid and hot to moderate, cool, or even cold in places like Saramati, where snow lies all year round. The entire Naga area, however, is exposed in varying degrees to the southwest monsoon from May to September.

Compared to other northeast Indian states, botanic diversity in Naga areas is relatively low, possibly as a result of extensive slash-and-burn cultivation.[114] Generally speaking, the Naga depend more on this form of cultivation than on gathered forest produce. They cultivate a diversity of food crops – paddy (rice), maize, millet and Job's tears, some pulses and certain varieties of mustard for oil; also sugarcane, tubers such as potato and sweet potato, several vegetables including gourds, leafy greens, and many herbs and spices. They also grow the tall toko palm (*Livistona jenkinsiana*), mainly for its betel-like fruit and for its leaves, which are used as thatch.

Abundant wildlife was once to be found in these areas, including tigers, leopards, Asian black bears, hoolock gibbons and even drills (a rare baboon species normally found only in Africa),[115] wild mithun and gayals, wild boars and wild mountain goats, the great Indian hornbill and pied hornbill, rare pheasant species such as the monal and the tragopan, and drongos (King's crow). However, all these species are under constant threat of extinction due to population growth, deforestation and hunting.

Geo-culturally and historically the hill ranges inhabited by Naga groups formed a barrier between the kingdoms of south China and Burma, and those of India – especially Assam and Manipur. They were places of refuge for peoples who were forced for whatever reasons to migrate from their own territories. Within this territory, the Naga groups traditionally built their villages on hill-tops – putting them out of reach of their enemies – while the hill climate was also more congenial to them, since winter's coolness reduces malaria, and springs are uncontaminated.

The Northern and Central Naga Groups

From linguistic and cultural studies[116] we are able to identify at least three or four different main groups that have settled in the Naga area over the aeons, having migrated there most probably from what is now central and southwest China, and that now make up approximately thirty Naga groups, including the Konyak- and the Ao/Yimchungrü-speaking peoples dealt with in this book. The former settle in the north of Nagaland in the districts of Mon and Tuensang (plus adjacent regions of Arunachal Pradesh and Myanmar) and the latter in the west and southeast of Nagaland (plus adjacent regions of Myanmar).

Konyak-speaking groups
Lower Konyak

Divided into two groups, Thendu and Thenkoh, the Lower Konyak live in the northern parts of Mon district. The main villages of the approximately 90,000 Thendu are Mon, Tang and Chui. Among the elder generation (successful headhunters) the typical distinguishing marks are the facial ('spectacle') tattoos and the artistic neck and chest tattoos. The name 'Konyak' derives from *khau* 'head' and *nyak* 'black', referring to the Konyak customs of tattooing their faces and blackening their teeth with soot. The *Angs*, the Konyak chiefs, still hold a king-like position in society and are entitled to numerous

Northern and Central Naga groups.
Above (top to bottom): Lower Konyak, Mon and Longwa (TF); Phom, Pongo.
Opposite top row: Khiamniungan, Noklak and Nokyan.
Middle row: Ao, Changtongnya; Sangtam, Tuensang.
Bottom row: Yimchungrü, Sangpurre and Tuensang.

117. Hutton *Tour diaries* 1935, n.p.

wives (the present *Ang* of Chui has ten) as well as to levy taxes in kind from allied villages; they are endogamous, i.e. they take wives from their own clan to perpetuate the royal line. The *Angs* also head the traditional village councils (*Wang Hamyen*), made up of representatives from all the *morungs* of the village. Among the Thendu an especially rich jewellery culture has developed, especially the glass bead necklaces of the women.

The approximately 35,000 Thenkoh are culturally close to the neighbouring Phom. Among them the *Angs* do not have the same amount of power as among the Thendu. Their main villages, Wakching and Wanching, have long been in contact with administration. Their tattoos are similar to those of the other groups.

Phom

The approximately 34,000 Phom form an early stratum of inhabitants of the western hills, with traditions of having predated the later waves of Ao and Upper Konyak. *Phom* means 'cloud'. The name was given to them by their neighbours because their territory – hilly terrain in the Longleng district – supposedly always remained in cloud. Thirty-six villages located at heights between 650 and 2,000m/2,100 and 6,500ft can be counted today. In Hutton's time, the Phom were thought to consist of only four or five villages grouped around Orangkong. A closer acquaintance with the villages towards the end of the colonial era increased the number of villages considerably, and later linguistic studies confirmed the increase. The villages are administered by senior headmen assisted by councils made up of village elders.

Upper Konyak

To the east of the Phom are the villages Hutton termed Chagyik, but which are now known as Upper Konyak. In architecture, dress and appearance the 35,000 Upper Konyak fill a gap between the Northern group and the rest of the main groups. Thus, face tattoos are common but not as distinct as among the Lower Konyak. Hereditary chieftainship is known to them but in its function of power almost meaningless. Villages are run by village councils. Impressive monumental carvings adorn the *morungs* of the often gigantic villages, many of which are located above 2,500m/8,200ft.

Chang

The 31,000 people who live south of the Upper Konyak in the latest formation of thirty-six villages are known as the Chang. The Chang were established from Upper Konyak, Yimchungrü and Khiamniungan groups who formed the mother villages of Tuensang and Hakchang, later expanding and taking land from the Upper Konyak, Phom, Sangtam, Yimchungrü and even Ao in the process. Customary law is especially strong among the Chang. A speciality is their unique poker-work drinking mugs and the rich carvings on their *morungs*.

Khiamniungan

To the east of the Upper Konyak and Chang are a series of groups all of whom include the village of Thang in Nagaland in their tales of origin. The Khiamniungan ('People from the water source') are divided into four sub-groups. Hutton knew these people as the Kalyo-Kengyu - 'slate house dwellers', because they roofed their houses with slate. Although he never actually visited any of their villages, which stretch far into Myanmar, he did meet some of the villagers while on tour. The Khiamniungan are noted among the Naga as manufacturers and distributors of especially fine weapons. Old forms of customary law with interesting modes of dispute settlement by oath-taking are still practised by the Khiamniungan. Due to the remote location of their territory, headhunting and slavery continued among them the longest.

Ao/Yimchungru-speaking groups

Ao

With 141,000 people, the Ao represent one of the main groups in Nagaland. Their name means 'those who came'. The Ao are divided into three linguistic sub-groups, all of whom settled in Mokokchung district. At the end of the 19th century they were targeted by American Baptist missionaries and were the first group to be converted, henceforth sending out missionaries of their own to other groups. Their dress differs considerably from the other groups. Specialities are head rings from bear's fur, body cloths in red and black with painted middle stripes, rock-crystal earrings and carnelian necklaces with trumpet-like brass beads for women. The Ao were the first to adopt a currency made of iron sticks (*chabili*) to replace the barter system.

Sangtam

The Sangtam consist of 39,000 people living east of the Ao and south of the Chang in Tuensang district. Due to the aggressive expansion of the Sumi (Sema) from the south, their territory is divided into two parts. Their name signifies 'one who is self-contained and lives in peace'. In outward appearance the Northern Sangtam are similar to the Ao, whereas the Southern Sangtam are culturally influenced by the Yimchungrü. Their society is divided into several sub-groups. Village chiefs and priests are selected from the population, the dominant position generally being held by the village founder's clan.

Yimchungrü

The Yimchungrü proper lies in Kiphire district, south of the Chang. The 86,000 people whose name means as much as 'the ones who have reached their place of choice' are divided into several linguistic sub-groups, the Langha group probably taking the core position. The first of these sub-groups are the Tikhir, who centre around Shamatore village. Closely linked are the Makuri, a group whose prime village in Nagaland is Chomi and who have a considerable number of their villages across the border in Myanmar. South of the Makuri are the Chirr, one of whose villages, Salumi, Hutton was to visit in 1935.[117] Finally there are the Longpfuri or Mimi, whose main village in Nagaland, Mimi, was visited a couple of times by Hutton. All in all there are seventy-six Yimchungrü villages in Nagaland. The villages are governed by hereditary village chiefs. Moreover, a special position is held by the *limpuru* or *mahtsaru*, a kind of peacemaker/ambassador, who was exempted from all headhunting raids by unwritten law. Uniquely, the Yimchungrü of the Mimi sub-group used to smoke the corpses of their dead and preserve them in caves with the aid of salt.

Cultural Affiliations and Differences

Konyak-speaking groups

All the Konyak-speaking groups settle on hill tops and practise slash-and-burn cultivation. All were headhunters and understood this as central to their culture. Most groups practised platform exposure of the dead, followed by the removal of the head at a later date and separate disposal of the skull. For the sacrifice of mithun and buffalo, forked sacrificial posts were erected. A strong *morung* tradition was maintained with regional differences, depending on whether the *morung* was used merely as a cultural focus or as a dormitory for the bachelors. Log drums were in use at one time by all groups, generally placed inside the *morungs*, but also in separate sheds or outside. Tattoo was used by both sexes among all Konyak speakers in varying forms and designs.

There are, however, considerable differences in political system and architecture among the groups. In political terms the Thendu Konyak are ruled by autocratic chiefs known as *Ang*, whose word is absolute law. These chiefs and their kinsmen are part of a class of nobles who rule over the commoner class, and retain strict rules of marriage within their own class. This is in contrast to the other Konyak-speaking groups who, where they have any form of hereditary chief, are generally ruled in a more democratic manner through councils of elders, the degree of control determined by the strength of character of the leaders. In architectural terms, the groups differ considerably. The houses of the Phom and Upper Konyak are a mixture of earth floor and suspended floor, the latter being located in the rear third of the house where the ground falls away and leads to a high platform. Lower Konyak houses have earth floors, left exactly as they were found, lumps and all, while Khiamniungan and related groups vary between plain earth floors and woven bamboo floors raised just above ground level at the entrance to the main living area and leading off an earth-floored porch.

Ao/Yimchungrü-speaking groups

All Ao/Yimchungrü-speaking groups settle on hilltops and practise slash-and-burn cultivation. All were headhunters and understood this as the core of their culture. Adolescents slept in the *morung*, tattoos were practised and Y-posts built for mithun and buffalo sacrifice. Log drums were in use. However, most of those of the Ao, Sangtam, and Yimchungrü are kept in drum sheds and utilise a pair of suspended beaters. Apart from the Ao, the members of this linguistic group used to bury their dead, usually under the floor of the house. In contrast to the rest of the group, Ao houses have raised floors and are built on stilts. Villages are generally run by councils of elders with hereditary headmen having no real importance.

The Colonial Period and its Agents in the Naga Hills

During an eight years' acquaintance with them [the Naga] I have learnt to speak the language fairly fluently and have been brought into contact with the life of the individual, the family, and the community more or less continuously and from many angles. For there is hardly any point of tribal custom which is not sooner or later somehow drawn into one of the innumerable disputes which the local officer in the Naga Hills is called upon to settle, and it is my experiences in this way which constitute my credentials in writing this volume.[118]

Rulers and their Views

History, as we are well aware, is written from the point of view current at the time and the historical accounts of the Naga presented here reflect colonial thinking. The reports were compiled according to how it was considered best to deal with the Naga within the framework of British colonial mores. For example, it was thought that inclusion within the Empire would ultimately benefit those future participants and therefore exclusion would be to their detriment. However, the expansion of the British Empire was often accompanied by serious clashes of cultural perceptions. In the Naga Hills these were especially the practices of headhunting and slavery, and at a later date the prevailing concepts of animal slaughter, which the British did not tolerate within their Imperial borders. As rulers they felt provoked and threatened if groups did not obey their orders and then felt duty bound to enforce their rules and laws.

The paternalistic viewpoint, whereby people were treated as somewhat naughty children in need of discipline when they paid no heed to foreign rules, was strictly adhered to. Therefore, when a village or villages disobeyed the rules, like children, the people were punished – usually by having fines imposed or their entire village burned and stock being taken away. At the same time punitive expeditions, especially if they had to penetrate regions which lay outside the Imperial boundaries (as described in this book), were costly affairs one certainly would have renounced on (and sometimes also did). However, these expeditions also served the purpose to gain new information for a possible later expansion of the Empire, which was kept in mind at all times.

Annexation versus Non-Interference

Apart from heeding the two, later three, core rules – no headhunting, no slavery, no 'inhumane' animal slaughter – the British more or less left the Naga groups to their own devices. Although the district administrators many a time were consulted by the villages regarding a certain problem, such as theft, the principal rule was non-interference or solving a problem according to customary law. Earlier the British had introduced a so-called 'Inner Line System', which prohibited lowlanders from moving into the mountains and highlanders from travelling to the plains. The financial disadvantages for the highlanders, who had gone down frequently to the plains, not only to get an occasional head but also to barter, were compensated by the British, by means of taxes levied within the administered zone of both the high- as well as the lowlands. Thus, a kind of redistribution took place. The raids of the highlanders that took place during the beginning of British infiltration into Assam were the main reason for introducing the 'Inner Line System', as their continuation would have meant financial losses for the developing tea industry.

Annexation of the regions described in this book took place in stages. The first concerned only the Ao region and a few adjacent Phom and Konyak villages. Forty-five years passed between the first exploratory tour in 1844 and the annexation in 1889. The next annexation, of northern regions of the Konyak and other Phom settlements, happened twenty years later, in 1909. By the end of colonial times British fiefdom had expanded as far as Tuensang. The rest of the northeastern regions, however, never came under British rule. Only the territories directly adjacent to the administered zone were called 'controlled areas' and this designation simply meant that villages in these regions were committed to provide porters for expeditions and to clear village paths before planned visits.

118. Hutton 1921, vii.
119. Stirn and van Ham 2003, 106-131.

Impacts of the Border on the Naga

The random demarcation and distinction between administered and unadministered territory nevertheless brought enormous consequences to the Naga. Instantly, the essential practice of headhunting was prohibited within the administered zone. But headhunting was not merely a war practice for the Naga but also motivation for all of their cultural traits and social development/change. The age-old principle 'Increase of life-force for the clan by getting an enemy's head' all of a sudden could no longer be fulfilled. This was a heavy blow to Naga culture as the entire social system had been built around this cultural practice. The most important insignia reserved for successful headhunters became unreachable, social prestige unattainable. Men were no longer perceived as fully fledged members of society since they had not taken a head and, thus, did not have a surplus of fertility at their disposal, which they could use to beget offspring. An entire religious way of thinking, which was built around the assumption that the life-force could be personally added to and directed to one's will (by headhunting) and so made it possible to change death into life (for the clan), was obsolete in an instant. This principle, however, had been fulfilled very seldom and only on very special occasions, when, for example, a new log drum was to be installed, a chief's house was to be inaugurated, or clan members wanted to get married. The ideal was never to take as many heads as possible: one head was enough for an entire clan if that would satisfy the worldview. This sudden and dramatic cultural change did not happen easily and even today is not complete. Tendencies to reactivate the old customs, as they currently take place in Naga society, are strong indicators of this.

Repercussions on the British

The immense change was felt by the colonial British. By forcing their policies on to the Naga within their Imperial borders, but excluding those outside their region of influence, they had not only a profound psychological and cultural effect on the people but also created a fundamental change in power in the entire Naga Hills. Headhunting never took place at random but was always orientated to benefit the clan. In a sense it was a 'cultivated practice' with many taboos and laws,[119] the proof of which may be gained from the stone monuments still to be found in many villages. Many of these are hundreds of years old but consist of relatively few stones. As it was customary to erect one stone for each head taken, it would seem that the stone settings should be enormous if the Naga had taken as many heads as possible during a raid. But this is not the case. In addition, it is logical to assume that had wanton killing taken place among the Naga groups there would have been a dramatic decrease in the population, if not extinction. Age-old clan feuds that mostly concerned land had been settled through alliances, peace treaties and differences in status and power of certain settlements, so that a kind of balance between clans, villages and groups had developed over the centuries. This is recognised by Hutton even when travelling through the unadministered zone when he remarks how old the heads in certain *morungs* are and how long it must have been since a raid had taken place in such-and-such village (Chare, for example).

By imposing their 'Inner Line System', the British changed the delicate balance of power between certain villages and their subordinates and, as a result, were confronted with a lot more headhunts than before, involving a much higher loss of lives than had previously been the case. For example, when villages were no longer allowed to wield power to keep others in check, the threat of possible raids increased. It is known that Naga at times undertook week-long marches to take a head from an enemy village because, although there were many villages in their vicinity, they were not hostile. The subordinate villages often lay in the unadministered zone and, consequently, villages that had been weak now formed alliances among themselves and set out, united in hatred, to fight a powerful village located within the administered zone. Then the long-established rage was often unleashed in bitter killing of sometimes hundreds of victims. Since, however, it was British policy to guard its 'citizens of the Empire', the colonial forces on their part were compelled to set out on a punitive expedition in order to avenge the raid against its citizens – expeditions that presumably could have been waived if the random border hadn't been drawn in the first place.

The British administrators' policy towards the Naga continued unchanged as long as they ruled India, as did the evaluation of the impact their

Some early Western perceptions of the Naga Hills. *Opposite top: Political Agent Capt. John Butler in ruling pose, discussing with an Angami chief (The Graphic 3/1876). Bottom: Derogative and exaggerated depiction of Angami at their "skull tree" (The Graphic 11/1879).*
Top: Heavy panji stockade on frontier police post at Mongsenyimti in 1914.
Above: Naga recruited by the British for frontier operations (Illustrated London News 11/1911). (All: VH)

headhunting ban had on Naga society. As stated before, this to a large extent had undermined the fundamental tenets of Naga culture. Depriving people so deeply rooted in magical-mythical principles inevitably led to a strong need to fill it with something else. This was Christianity in the form of American schismatic sects, an extreme fundamentalism. The British administrators were sceptical of the Christian mission movement in the Naga Hills, detecting its often perfidious machinations and the techniques of fear and guilt used in converting people. They also were aware of the possible identity crises that could result from the missionaries' impact on the Naga, which, they feared, could lead to even more violence. However, they did not stop the missionary activities – presumably due to uncertainties concerning colonial thinking, such as the possible benefits of Western civilisation, freedom of religion, possible advantages to be gained from developmental aid, and so on. Indeed, anthropologically-orientated administrators, such as Hutton and Mills, greatly appreciated the culture of the Naga, were fascinated by them and perceived them as unique and logical in their context. But by depriving the Naga of the core aspect of their culture, even such men as Hutton and Mills destroyed their desire to preserve Naga culture the way they had found it when they first arrived in the Naga Hills.

The three great researchers

That Hutton's view was so traditionally orientated was probably due to the fact that when he came to the Naga Hills in 1912 he was confronted by people that had had no previous contact with Western culture, and an entirely new field of research. He became acquainted with the Naga when Western cultural influence was only just beginning. For him, the losses these cultures had to bear from outside contact seemed to weigh heavier than the 'doubtful profits' gained. Though former administrators and soldiers had shown more than a swift interest in the Naga and had written a number of interesting accounts and articles, on which Hutton could rely at least to some extent, to his amazement, he found that there was no systematic account of any of the peoples he was expected to govern, and, despite his lack of formal training in anthropology, immediately set about putting this to rights, first with his classic analysis of Angami society and then with his equally important work on the Sema.

John Henry Hutton was born in 1885 in Yorkshire and was educated in Essex and at Worcester College, Oxford, where he gained a third class degree in modern history in 1907. In 1909 he joined the Indian Civil Service and came to East Bengal. Three years later he was posted to Assam and from there to the Naga Hills District, where he served first as Political Officer and then as Deputy Commissioner. In 1920 he was appointed honorary Director for Ethnography of Assam. Although he had no formal training in anthropology, Hutton himself acknowledged how his professional career as an Indian civil servant fed his anthropological work, a view shared by the University of Oxford, as it bestowed the Doctor of Social Sciences on him in 1921. In addition Hutton published a prodigious number of articles in scientific and other journals and periodicals. In 1929 he was appointed Census Commissioner for India. Eight years later he resigned and the following year was appointed to the William Wyse Chair of Social Anthropology at Cambridge University, a position he held until his retirement in 1950 at the age of 65. He was awarded numerous fellowships and medals before he died in 1968 at the age of 78. Not only did Hutton share his knowledge and experience with generations of students, and inspire many of members of his staff, he was also highly respected among the Naga, whom he loved, not the least for his legendary sense of humour. Thus, a Chang once characterised Hutton in front of W.G. Archer: 'You and Hutton Sahib come from the same village. Hutton Sahib was a thorough Naga. He was always fooling about.'[170]

Hutton inspired especially one of his staff members: *James Philip Mills*. Born in 1890, J. P. Mills was educated at Winchester School and Corpus Christi College, Oxford. In 1913 he joined the Indian Civil Service and came to the Naga Hills in 1916, where he served as Sub-divisional Officer in Mokokchung till 1924. He took over the position as Deputy Commissioner in Kohima when Hutton was transferred, and like Hutton became honorary Director of Ethnography in Assam. Between 1922 and 1937 Mills published similarly remarkable monographs about the Lhota, Ao and Rengma. In 1930 he married Pamela Vesey-Fitzgerald, the woman to whom he had written the *'Pangsha Letters'*

cited in this book. In 1943 he was appointed as Advisor to the Governor for Tribal Areas and States, with overall responsibility for tribal matters in Northeast India. This appointment enabled him to travel among and study for the first time tribal people living north of the Brahmaputra towards the Tibetan frontier. Back in England, Mills was elected to the Council of the Royal Anthropological Institute in 1948 and served as its President from 1951 to 1953. At the same time he became Reader in Language and Culture with special reference to Southeast Asia at the School of Oriental and African Studies (SOAS) in London and together with his good friend Christoph von Fürer-Haimendorf built up the Department of Cultural Anthropology, until ill health forced his retirement in 1954. He died in 1960.

The third great researcher of the Naga, Mills' friend, the Austrian anthropologist *Christoph von Fürer-Haimendorf*, was one of the people who profited from British partial rule over the Naga Hills. He was born on 22 June 1909 in Vienna. In 1927 he entered the Theresianische Akademie of the University of Vienna, where he studied anthropology and archaeology. Fürer-Haimendorf received his DPhil in 1931, based on a doctoral thesis comparing the social organisation of the hill tribes of Assam and Northwest Burma. The opportunity for fieldwork came when Fürer-Haimendorf was awarded the Rockefeller Foundation Fellowship for 1935-1937. With this backing, he first undertook a period of post-doctoral studies in London, where he met Mills who guaranteed his support while in India, and set out for the Naga Hills in 1936. Haimendorf took residence at the already administered Konyak village of Wakching and worked for thirteen months on his studies. Thus, he was the first to undertake fieldwork among a Naga group in the true sense of the word – he lived among the people, learnt their language and meticulously recorded their customs, social structures and clan relationships. His findings were published in numerous scientific and popular scientific books and journals.

Back in London, Fürer-Haimendorf married Elizabeth Barnardo (Betty) in 1938, who became his co-worker, organiser of his expeditions, and a notable ethnographer in her own right. He was en route to the Naga Hills for a second period of research when the Second World War broke out. Holding a German passport, Fürer-Haimendorf was arrested and interned as an enemy alien (although his internment was carried out with great courtesy, due to his excellent connections in the British colonial administration). He was subsequently confined to Hyderabad State for the duration of the War. During this time he was able to undertake important fieldwork amongst the tribal groups of this state. From 1944 to 1945 he was appointed Special Officer and Assistant Political Officer to the North East Frontier Agency (NEFA, present Arunachal Pradesh), where on behalf of the Government he made the first unarmed contact with various peoples of the eastern Himalayas and lived among them. From 1945 to 1949, Fürer-Haimendorf was appointed Adviser for Tribes and Backward Classes at Hyderabad State and taught as Professor of Anthropology at the local university. The following year he accepted a lectureship at SOAS in London. Shortly after his initial appointment, he was made Reader, and then Chair of Asian Anthropology in 1951. He was founding Head of the Department of Cultural Anthropology (later Anthropology and Sociology) from 1950 until 1975. By the time of his retirement from SOAS in 1976, Fürer-Haimendorf had built up the largest department of anthropology in the country.

In the course of his lifetime, Christoph von Fürer-Haimendorf, who had received numerous academic honours and medals, carried out a great number of groundbreaking studies among a great number of peoples, especially in India and Nepal and published comprehensively on them. In the 1960s and 1970s he also returned to the Naga. On 11 June 1995 he died at the age of 85.

Opposite: Stone setting and carvings of warriors with erect penises at Shangnyu – symbols for what headhunting used to stand for among the Naga – gaining a surplus of fertility and life-force. (Both: GG)

Top: J.H. Hutton (right) on tour in Lower Konyak country in 1927, photographed by Suydam Cutting. (VH)

Above from left to right: Cartoon of J.H. Hutton 1931; J.P. Mills with a returned slave at Chingmei in 1936; C.v. Fürer-Haimendorf with a Konyak girl at Longkhai in 1937. (All: MA/SPNH)

120. Archer 1947, n.p.

Acknowledgements

This work would not have been possible without the support and input of a great number of friends and well-wishers, to all of whom we are deeply grateful. First of all sincere gratitude goes to Thangi Mannen, Secretary of the Government of Nagaland, and her husband T.N. Mannen, Additional Chief Secretary and State Election Commissioner of the Government of Nagaland, for making our expeditions possible. All the administrators in the respective districts, such as Deputy Commissioners, Additional Deputy Commissioners, Extra Assistant Commissioners and Cultural Officers, who extended their valuable help and support to the project, we thank wholeheartedly. Ashish Phookan and his staff of 'Jungle Travels India' supplied transport, help and guidance throughout all the expeditions. Toshi Wungtung was a wonderful and knowledgeable team member, friend, guide and interpreter all along the obstacle-ridden paths in the districts of Tuensang, Mon and Kiphire. Through him we received insights which would not have been possible otherwise. Shayung Phom gave expert guidance, interpretation and warm hospitality in the Longleng district. All the inhabitants of the villages we visited and their honourable village councils extended amicable support and hospitality to us. Unfortunately, there are too many for them all to be mentioned by name but we hope that our humble efforts will find their appreciation and may be taken the way we intended them to be: as a sign of deep respect for, and appreciation of, their culture and an effort to promote and preserve their fascinating cultural heritage for generations to come. In this regard sincere gratitude is extended also to the members of the Society for the Preservation and Promotion of Naga Heritage (SPNH) for their wholehearted financial and moral support of this project.

Hearty thanks are also due to Alan Macfarlane and Sarah Harrison for their tremendous efforts of making the colonial sources to the Naga available on the Internet, which also made our work possible. Through Alan Macfarlane's Foreword our work has gained recognition beyond words. Transferring their comprehensive picture and text archives to the SPNH has been the climax of their support and has brought this book to life in an unbureaucratic manner. The inspiration for this project came in the early 1990s, when George Breguet supplied the original edition of Hutton's Diaries to us – many thanks for this too.

Heartfelt gratitude is due also to Jean Saul and the members of her family for transferring Jamie's substantial archives to the SPNH and hence supporting this project comprehensively (I, Peter, wish it had not happened this way).

Many thanks also to the various friends for their generous supply of additional photographs, help and information (in alphabetical order): Bea Bartusek and Günter Gessinger, Veyielo Doulo, Thierry Falise, Nick Haimendorf, Geraldine Hobson, Helga and Carl-Uwe Höger, Shota Kanazawa, Richard Kunz, Maike Langkau, Thangi Mannen, Pan Nalin, Christa Neuenhofer, Hemen Sanghvi and Aglaja Stirn.

Gratitude is also extended to our travel companions – especially Aglaja Stirn and Jean Saul, as well as Richard Kunz, Toshi Wungtung, Shayung Phom, Manfred Praxl and Tom Hornig, all of whom not only made the often tedious journeys lighter and happier, but also were actively involved in the process of making this dream become reality.

Without our publishers this book would have not turned out as magnificently as it has. For establishing the initial contact to the ACC we thank Kenneth Cox, and for believing in the project and giving it all their skills we extend our wholehearted thanks to Diana Steel, Mark Eastment, Erica Hunningher, Louisa Yorke, James Smith, Tom Conway, Stephen MacKinlay, and especially Craig Holden as well as all the staff members of the ACC.

Finally, an extra special thank you goes to Sidonia Kolster for her support and care during the production process.

Photographers

All photographs © by Peter van Ham except for the following:

AA/VH – Alemchiba Ao / van Ham Collection, Frankfurt/Main / Germany
VD – Veyielo Doulo, Kohima / Nagaland / India
VE/MA/SPNH – Verrier Elwin / Macfarlane Archives / Society for the Preservation and Promotion of Naga Heritage, Frankfurt/Main / Germany
TF – Thierry Falise, Bangkok / Thailand
CFH/MA/SPNH – Christoph von Fürer-Haimendorf / Macfarlane Archives / Society for the Preservation and Promotion of Naga Heritage, Frankfurt/Main / Germany (used by permission of Nick Haimendorf, legal heir of Christoph von Fürer-Haimendorf)
GG – Günter Gessinger, Mainz / Germany
MG/VH – Milada Ganguli / van Ham Collection, Frankfurt/Main / Germany
HH – Helga Höger, Stuttgart / Germany
JHH/MA/SPNH – J.H. Hutton / Macfarlane Archives / Society for the Preservation and Promotion of Naga Heritage, Frankfurt/Main / Germany
SK – Shota Kanazawa, Yangon / Myanmar
RK/MKB – Richard Kunz / Museum der Kulturen, Basle / Switzerland

ML – Maike Langkau, Witzenhausen / Germany
TM – Thangi Mannen, Kohima / Nagaland / India
JPM/GH – James Philip Mills / Geraldine Hobson Collection, Sturminster Newton, England (used by permission of Geraldine Hobson, legal heir of J.P. Mills)
PN – Pan Nalin, Paris / France
CN – Christa Neuenhofer, Bocholt / Germany
HS – Hemen Sanghvi, New Delhi / India
JS/SPNH – Jamie Saul / Society for the Preservation and Promotion of Naga Heritage, Frankfurt/Main / Germany
AS/SVH – Aglaja Stirn / The Stirn-van Ham Archives, Frankfurt / Main / Germany

Collections
CUMAA – Cambridge University Museum of Archaeology and Anthropology / England
MKB – Museum der Kulturen, Basle / Switzerland
PRM – Pitt Rivers Museum, Oxford / England
VH – van Ham Collection, Frankfurt/Main / Germany
VUZ – Völkerkundemuseum der Universität, Zurich / Switzerland

Bibliography

Ao, M.A., *The Arts and Crafts of Nagaland* (Kohima, 1968).

Archer, W.G., Manuscript notes between 1946 and 1948, and miscellaneous papers and letters. Available at: http://www.alanmacfarlane.com/bamboo_naga_front/T34.htm (5.11.06)

Barua, S.N., *Tribes of the Indo-Burma Border: A Socio-Cultural History of the Inhabitants of the Patkai Range* (New Delhi, 1991).

Biswas, S., 'Studies on Bamboo Distribution in North-Eastern Region of India', *The Indian Forester* 114/9 (1988), 524–31.

Elwin, V., *The Art of the North-East Frontier of India* (Shillong, 1958).

Elwin, V., *Nagaland* (Shillong, 1961).

Elwin, V. (ed.), *The Nagas in the Nineteenth Century* (London, 1969).

Fürer-Haimendorf, C.V., *Naga Notebook 4 – Notes from Mr Lambert's survey tour of 1935*. Available at: http://www.alanmacfarlane.com/bamboo_naga_front/T36.htm

Fürer-Haimendorf, C.V., Tour diaries 1936/37, Available at: http://www.alanmacfarlane.com/bamboo_naga_front/T36.htm

Fürer-Haimendorf, C.V., 'Through the Unexplored Mountains of the Assam-Burma Border', *The Geographical Journal* 91/3 (1938), 203–19.

Fürer-Haimendorf, C.V., *Die Nackten Nagas* (Leipzig, 1939).

Fürer-Haimendorf, C.V., *Das Gemeinschaftsleben der Konyak-Naga von Assam: Aus den Ergebnissen einer Forschungsreise in den Jahren 1936 und 1937* (Vienna, n.d.).

Fürer-Haimendorf, C.V., *The Naked Nagas* (London, 1955).

Fürer-Haimendorf, C.V., *The Konyak Nagas: An Indian frontier tribe. Cases in Cultural Anthropology* (New York 1969).

Fürer-Haimendorf, C.V., *Return to the Naked Nagas: An Anthropologist's View of Nagaland 1936–1970* (London, 1976).

Ganguli, M., *Reise zu den Naga* (Leipzig, 1978).

Ganguli, M., *A Pilgrimage to the Nagas* (New Delhi, 1984).

Ganguli, M., *Naga Art* (New York, 1993).

Ham, P. van, *In den Bergen der Kopfjäger. Indiens wilder Nordosten* (Munich 2006).

Hutton, J.H., 'Tour diary November 1920'. Available at: http://www.alanmacfarlane.com/bamboo_naga_front/T37.htm (5.11.06)

Hutton, J.H., *The Sema Nagas* (London, 1921).

Hutton, J.H., *The Angami Nagas. With some notes on neighbouring tribes* (London 1921).

Hutton, J.H., 'Diaries of Two Tours in the Unadministered Area East of the Naga Hills', *Memoirs of the Asiatic Society of Bengal* 11/1 (1924). 1st re-print: Report on Naga Hills (Delhi 1986). 2nd re-print: Naga Manners and Customs (Gurgaon 1990).

Hutton, J.H., 'Tour diaries 1926'. Available at: http://www.alanmacfarlane.com/bamboo_naga_front/T37.htm (5.11.06)

Hutton, J.H., 'Tour diaries 1935'. Available at: http://www.alanmacfarlane.com/bamboo_naga_front/T37.htm (5.11.06)

Hutton, J.H., 'The Mixed Culture of the Naga Tribes', *Journal of the Royal Anthropological Institute* 95/1 (1965), 16–43.

Impongsoted, T., and Chang, B. / Changun Cultural Society, 'Brief Glance of Chang Culture (History)'; manuscript (2002) in the possession of the authors through the courtesy of the GB's Chief Federation, Tuensang.

Jacobs, J., Macfarlane, A., Harrison, S., Herle, A., *The Nagas. Hillpeoples of Northeast India* (London, 1990).

Krishna, S., 'Gender Dimensions in Biodiversity Management: India'; report submitted to FAO Regional Office for Asia and the Pacific (Bangkok, 1997).

Kumar, B.B., *Society and Culture in a Corner of Nagaland* (Meerut, 1998).

LAMBERT, E.T.D., 'From the Brahmaputra to the Chindwin', *The Geographical Journal* 89/4 (1937), 309–26.

LOTAN YIMCHUNGRU, K., 'Brief History of Yimchungrü (Naga) Tradition and Culture'; manuscript (2002) in the possession of the authors through the courtesy of K. Lotan Yimchungrü.

MACFARLANE, A., Interview with Christoph von Fürer-Haimendorf, July 1983. Available at: https://www.dspace.cam.ac.uk/handle/1810/449 (5.11.06)

MILLS, J.P., 'Certain Aspects of Naga Culture', *Journal of the Royal Anthropological Institute of Great Britain and Ireland* 56, 27-35 (1926).

MILLS, J.P., 'Tour Diary, November to December 1936'. Available at: http://www.alanmacfarlane.com/bamboo_naga_front/T38.htm (5.11.06)

MILLS, J.P., *The Pangsha Letters. An Expedition to Rescue Slaves in the Naga Hills.* (Oxford 1995). Edited by GERALDINE HOBSON for the Pitt Rivers Museum, Oxford. Available at: http://www.alanmacfarlane.com/bamboo_naga_front/T38.htm (5.11.06)

NALIN, P., *The Nagas.* Documentary (Paris, 1995).

PHAMJONG MORUNG, 'History of Phamjong Morung Yongnyah Village: History of our Forefathers'; manuscript (2002) in the possession of the authors through the courtesy of the Phamjong *khel*, Yongnyah.

PHOM, B. & M., 'Shemci Moobu, Hetu Kean Apbu'; manuscript (2004) in the possession of the authors through the courtesy of the Yongnyah Village Council.

PHOM, C., PHOM, L., PHOM, D., PHOM, B., PHOM, P., 'Pung Vaum Moo'; manuscript (2004) in the possession of the authors through the courtesy of the Yongnyah Village Council.

PHOM, C. / OFFICE OF THE YONGNYAH VILLAGE COUNCIL, 'The History of Yongnyah'; manuscript (2002) in the possession of the authors through the courtesy of the Yongnyah Village Council.

PHOM, P. / PHOM PEOPLE'S COUNCIL, 'People of Phom–Significance of Phom Monyü'; manuscript (2002) in the possession of the authors through the courtesy of the Phom People's Council, Longleng.

SARDESHPANDE, S.C., *The Patkoi Nagas* (Delhi, 1987).

SAUL, J.D., 'Nagas of the Patkoi & East, North of the Nantaleik'; manuscript (1977).

SAUL, J.D., 'The Chang-Warriors of Nagaland'; unpublished manuscript (2002).

SAUL, J.D., 'The Naga Home'; unpublished manuscript (2002).

SAUL, J.D. & VIALLARD, D., *The Naga of Burma. Their Festivals, Customs and Way of Life.* (Bangkok 2005).

SINGH, K.S. (ed.), *People of India*, Vol. 34: Nagaland (Calcutta, 1994).

SINGH, P., *Nagaland*, 3rd revised edition (New Delhi, 1981).

SPNH, 'Obituary for Jamie Saul – 1943-2006'. Available at: http://www.spnh.com/Pages/English/Obituary_Jamie_Saul.html (5.11.06)

STIRN, A. and HAM, P. VAN, *The Seven Sisters of India: Tribal Worlds Between Tibet and Burma* (Munich/London/New York/Ahmedabad, 2000).

STIRN, A., and HAM, P. VAN, 'Ohne Tätowierung bin ich nackt!' Haut, Identität und Kopfjagd in Nordost-Indien'; available at: http://parapluie.de/archiv/haut/kopfjagd/. (Accessed 1 Dec. 2001.)

STIRN, A., and HAM, P. VAN, *The Hidden World of the Naga. Living Traditions in Northeast India and Burma* (Munich/Berlin/London/NewYork/Delhi, 2003).

STIRN-VAN HAM ARCHIVES & SPNH, *NAGA – Songs from the Mist. A Celebration of music from the Naga Hills in Northeast India and Burma.* Audio CD (Frankfurt 2004).

TUENSANG VILLAGE CITIZEN UNION, 'Short Description of Morung'; manuscript (2002) in the possession of the authors through the courtesy of the Tuensang Village Citizen Union.

WADIA, D.N., *The Geology of India*, 3rd ed. (London, 1966).

WONGTU CHANG, C., and MULLONG CHANG, W.M., 'Dance of the Warriors and Wealthy'; manuscript (2002) in the possession of the authors through the courtesy of the Cultural Board Committee, Chongpho Citizen, Tuensang Village.

YAONGYIMCHEN VILLAGE COUNCIL MEMBERS, 'The Significance and Meaning of the Performances by the Elders of Yaongyimchen Village, District Longleng, Nagaland'; manuscript (2004) in the possession of the authors through the courtesy of the Yaongyimchen V.C.M.

INDEX

For the reader's convenience, this index incorporates a glossary, with those explanations given in brackets.
*Page numbers in **bold** refer to images and/or captions.*

Aboi township, Mon, **213**; 197, 198, 200, 252
Additional Deputy Commissioner, 284
aeroplane, depictions of, **38**
agriculture, **35**, **128-129**, **212**, **214**, **270**, **276**; 13, 35, 56, 83, 88, 102, 112, 144, 149, 156, 167, 168, 172, 181, 221, 222, 262, 277, 279
 jhum, **277**; 35, 65, 168, 221, 277
 terraced, **145**, **212**, **276**; 221
Aiha Okshok [*Monyü* spring festival, Phom], 76
alcohol, **50**, **51**, **131**; 57, 75, 112, 131, 146, 179, 187, 191, 255, 265
Amguri town, Assam, 29
ammoniac, 76
Anaki village, Longleng, **197**
Anangba village, Tuensang, **122**; 144
Ang, [a chief of the Lower Konyak, Mon], **18**, **73**, **81**, **89**, **131**, **140-141**, **167**, **173**, **184**, **200**, **203**, **206**, **250**, **254**, **259-266**, **268**, **270**; 203, 206, 213, 252, 255, 259, 261, 262-264, 278, 279
 sub *Ang*, **203**; 203
 deputy *Ang*, 262
Angami group, Kohima, **67**, **158**, **280**; 7, 8, 29, 282
Angphang village, Mon, **182**, **193**
animal sacrifice, **96-105**, **161**, **170**, **193**; 9, 11, 70, 76, 97-102, 152, 160, 210, 279
 buffalo, **161**; 152, 160, 279
 chicken, **96-105**, **193**; 97-102
 mithun, **193**; 41, 152, 160, 279
 pig, **170**
Anjangyang, Mon, 198
annexation [British colony], 280-281
Ao group, Mokokchung, **6**, **20**, **30-33**, **118**, **119**, **209**, **233**, **241-243**, **249**, **279**; 29, 32, 35, 63, 66, 118, 129, 277, 278-279, 280, 282
Aopao village, Mon, 198, 256
Aoyangyong Kang, ['flood stone', Yonghong], **249**; 211
Arakan Yoma mountain chain, 276
Arunachal West, 111, 200, 211, 241-7, 197, 282
Arunachal Pradesh State, India, **143**, **181**; 6, 276, 277, 283
Asian black bear, 277

fur, **237**; 235, 236, 278
stuffed, **255**; 255
Assam, Governor of, 55
Assam Rifles, the, **121**; 119, 168, 170, 192
Assam State, India, **67**, **109**, **110**; 6, 7, 20, 27, 28, 29, 55, 110, 111, 112, 244, 276, 277, 280, 282, 283
Awman clan, Yongnyah, 49

baboon, 277
Balfour, Henry, **67**, **141**, **151**, **209**; 7, 8
balls [bamboo, basketry and canework - signifying enemy heads], **68**; 41, 49, 50, 85-86, 88, 134, 142, 153, 252
bamboo (*see also:* balls), **34**, **68-69**, **78**, **89**, **129**, **131**, **142**, **149**, **268**; 41, 45, 50, 55, 60, 66, 76, 77, 99, 112, 134, 138, 142, 149, 152, 177, 203, 213, 222, 231, 244, 252, 255, 277, 279
banana leaf, 49, 70, 94, 99, 230, 231
bandeaux, 76, 93
Baptist Church, *see:* church
Barail mountain range, 276
bark loincloths, *see:* loincloth
Barnardo, Elizabeth [Betty, wife of Christoph von Fürer-Haimendorf], 203
basketry (*see also:* balls; cane), **78**, **87**, **194**, **276**, **244**, **264**; 49, 76, 82, 88, 112, 152, 153, 172, 230, 235, 236, 244, 252, 255
beehive, 138
 protective magic, 138
beer, *see:* alcohol; rice
Benares, *see:* Varanasi
betel nut (*see also: paan*), **274**; 14, 50, 251
Bhanjong clan, Nian, **97**; 85, 97
Bhumnyu, *see:* Mongnyu village
Bilaeshi clan, Tuensang, **133**, **134**, **144**, **146**; 134, 138, 144
bison, *see:* gayal
blacksmith, *see:* metalwork
boar, wild, 277
 tusks, 39, 41, 51, 77, 92, 235
body cloth, **114**, **135**, **148**, **181**, **226**; 88, 153, 168, 231, 233, 278

Bower, Ursula Graham, 7, 8, 20
Brahmaputra River, India, 110, 283
brass, **108**, **175**, **237**; 50, 77, 93, 138, 177, 195, 235, 236, 278
British Empire, 14, 278-283
buffalo, **48**, **49**, **85**, **161**, **170**, **177**, **188**, **194**; 49, 144, 152, 153, 160, 177, 179, 263, 279
burial (*see also:* death; stone, urn), **176**, **180-185**, **262**; 129, 144, 247, 262, 265, 270, 279
Burma (Myanmar), **11**, **16**, **75**, **120**, **143**, **150**, **237**; 6, 7, 10, 11, 14, 20, 22, 154, 176, 202, 276, 277, 283
Burmese Government, **120**
Butler, John, **281**

Cacha [unmetalled side road], **120**; 23, 36, 61, 83, 252
Cachar Hills, Assam, 276
Calcutta [Kolkata], India, 27, 109-110, 191
Cambridge University, **173**; 7-9, 10, 22, 282
Camp Chentang, 172
Camp Kuthurr, 170
cane (*see also:* balls; basketry), **34**, **68-69**, **70**, **178**, **204**, **225**, **226**, **255**; 39, 41, 50-51, 70, 76, 85, 88, 92, 99, 134, 144, 153, 205, 222, 231, 235, 236, 252
Careofligna JJ, **255**, 60, 64, 153, 252, 255
carving, **7**, **16**, **56**, **57**, **66**, **70**, **73**, **81**, **86**, **87**, **100**, **119**, **122**, **135**, **142**, **150**, **155**, **160**, **161**, **163**, **167**, **169**, **170-171**, **173**, **178**, **182**, **188**, **192**, **193**, **194**, **196**, **197**, **199**, **204**, **241**, **242**, **252**, **264**, **282**; 13, 22, 39, 44, 49, 50, 57, 58, 65, 66, 81, 85, 88, 127, 134, 138, 142, 144, 149, 152, 153, 160, 163, 168-169, 172, 177, 178, 181, 205, 206, 251, 264, 278
 animals, **56**, **70**, **85**, **87**, **100**, **160**, **163**, **169**, **170-171**, **178**, **188**, **189**, **192**, **194**, **196**, **197**, **199**, **204**; 41, 49, 50, 66, 85, 88, 153, 160, 168, 178, 205
 echpae, **59**, 170
 erotic/phallic, **100**, **154-155**, **173**, **282**; 163
 figures, **7**, **57**, **66**, **67**, **81**, **85**, **87**, **182**, **188**, **196**, **197**, **199**, **282**; 41, 81, 85, 177-178

grotesque, **87**, **198**; 85
heads, **122**, **167**; 39, 41, 85, 138, 168
low relief, **161**, **252**; 160, 168, 205
cemetery, *see:* burial
Census Commissioner, India, (*see also:* Hutton), 9, 282
Chabili [iron sticks used as currency, Ao], 278
Chahlim, [Toongnam's 'commoner' wife], 262
Chakhesang group, Phek, 200
chalk, **80**, **85**, **90**; 39, 44, 85, 92
Chang, Sangam, **142**
Chang group, Tuensang, **16**, **63**, **68-69**, **122-123**, **130**, **133**, **135**, **137**, **140**, **142**, **149**, **178**, **181**, **195**, **208**, **241**; 13, 63, 73, 130, 133, 134, 144, 146, 149, 150, 153, 156, 164, 278, 279, 282
Changkeangyeang clan, Tobu, 153
Changlang village, Mon, 197, 198, 252, 276
Changlangshu village, Mon, **166**, **172**, **240**; 167, 168, 169, 172, 175, 192, 217
Changnhe clan, Yinghong, **218**, 217
Changsang, 150
Changtongnya village, Mokokchung, **209**, **242**, **243**, **279**; 29
Changwei, **176**
Chank, *see:* shells
Chare village, Tuensang, **121**, **129**; 117, 129, 281
Checklon [central ancestor stone, Lungtrok], 70
Chen village, Mon, **18**, **200**, **201**, **202**, **206**, **208**, **209**, **212**, **215**; 197, 198, 200, 203, 206, 213, 252
Chen Loisho village, Mon, **200**
Chen Moho village, Mon, **213**, **241**; 213
Chen Wetnyu village, Mon, **203**, **206**, **241**, **252**; 197, 200, 203
Chenhoo, **203**, **204**; 203, 205, 206
Chentang Saddle mountain ridge, Tuensang, **120**, **121**; 172
Chenyak stream, Yongnyah, 36
Chief Commissioner, *see:* Mannen, T.N.
chiefs, **13**, **51**, **53**, **88**, **94**, **98**, **181**, **182**, **184**, **195**, **214**, **238**, **281**; 33, 36, 52, 57, 78, 172, 197, 218, 244, 259, 277, 278, 279, 281
Chimongchi River, Yongnyah, 36
Chindwin River, Burmese Naga Hills, 76
Chingda clan, Nian, **84**; 85
Ching-i-Okshok [part of *Monyü* spring festival, Phom], 76
Chinglong village, Mon, 87
Chingong clan, Yongnyah, 49
Chingmak, Chief, **122**; 175
Chingmei village, Tuensang, **121**, **122**, **125**, **155**, **283**; 119, 150

Chirongchi, Chief, Anangba, **122**
Chirr sub-group, Yimchungrü, **122**; 279
Chomi village, Makuri/Yimchungrü, 279
Chongpho clan, Tuensang, **141**, 134
Chongtore village, Tuensang, 146
Chongwe village, Mon, 256
Christianity (*see also:* church), **116**, **125**, **155**, **160**, **185**, **201**; 29, 160, 206, 233, 262, 278, 282
Chui village, Mon, **131**, **264**, **268**; 257, 261, 277, 278
church (*see also:* Christianity), **118**; 52, 63, 65, 84, 118, 130, 146, 200, 233, 257, 261
Baptist, **118**; 117, 118, 278
hall, 163, 168, 175, 177, 200
clan feuds, **113**; 12, 54-61, 119, 130, 138, 153, 281
colonial power, *see:* British Empire
Constitution, the, 130
coolie [porter], 57, 73, 119, 130
corrugated iron/tin (*see also:* roofs), **20**, **32**, **158**; 27, 129, 153, 175, 177
council, *see:* village
council hall, **130**, **135**; 134, 144
cowrie, *see:* shells
crafts, **174**; 88, 149, 168
Cutting, Suydam, **283**; 8

dance, **44**, **52**, **71**, **74**, **78**, **93**, **102**, **104**, **114**, **125**, **137**, **143**, **162**, **207**, **226**; 49, 51, 60, 65, 66, 76, 77, 92, 102, 112, 160, 163, 212, 236
dao and *dao* sheath, [multi-purpose tool/machete-like weapon], **44**, **45**, **65**, **174**, **177**, **235**, **264**; 8, 20, 41, 44, 51, 60, 65, 77, 90, 92, 102, 112, 151, 163, 168, 175, 177, 187, 192, 198, 212, 218, 221, 222, 231, 235, 236, 244, 247, 263, 264
death (*see also:* burial; stone, urn), **108**; 20, 22, 48, 49, 126, 133, 138, 142, 181, 198, 262, 263, 270, 279, 281
Delhi, India, 27, 179, 215
Deputy *Ang*, *see:* Ang
Deputy Commissioner, **48**, **111**, **114**; 6, 9, 20, 111, 282, 284
Dibrugarh airstrip, 27
Dikhu river, 35, 64, 276
Director for Ethnography of Assam, 282
Doyang river, **113**; 276
drill, *see:* baboon
drongo [King's crow], 277
drum, *see:* log drum
dye, 32, 39, 41, 66, 130, 235

ears, **30**, **261**; 261
earlobes, **31**, **261**; 76, 93

jewellery, **22**, **30**, **31**, **38**, **72**, **74**, **208-211**, **263**, **265**, **270-273**; 177, 278
East Bengal, 282
education (*see also:* schools), **69**, **160**; 9, 11, 32, 88, 179, 200
effigies, *see:* cane
electricity, 13, 172
elephant (*see also:* carving)
skulls, **268**, **269**; 259
tusks, 37, 235
Elwin, Verrier, **85**, **96**; 7, 20, 81, 83, 85, 197
Empire, *see:* British Empire
endogamy, 278
Euphorbia [tree, symbolic for headhunting], **57**; 259
Extra Assistant Commissioner, 150, 198, 284

facial markings, **19**, **85**, **90-91**, **94-95**, **96**, **98**, **99**, **101**, **102**, **134**, **141**, **148**, **196**, **201**, **206**, **207**, **208-209**, **210-211**, **230**, **246**, **257**, **261**, **265**, **269**, **273**, **274**, **275**; 76, 92, 138, 163, 200, 206, 255, 277, 278
Feast of Merit, **177**, **188**; 222
Feastgiver, **177**; 252
feather, *see:* hornbill
fertility, **40**, **46-47**, **49** **56-57**, **68-69**, **84**, **97-100**, **154-155**, **173**, **176**, **181**, **188**, **193**, **247**, **282**; 20, 22, 41, 45, 49, 51, 75, 77, 83, 93, 99, 138, 163, 205, 218, 244, 281
fire, **89**, **98**, **147**, **265**; 50, 57, 73, 81, 88, 97, 99, 102, 153, 155, 170, 172, 178, 206, 264, 270
firestick [traditional method of making fire], 50, 88, 99
food, 60, 65, 112, 118, 131, 133, 146, 230-231, 244, 277, 172
cereals and grains (maize, millet, rice, taro), **72**, **244**; 94, 130, 138, 146, 155, 163, 172, 206, 212, 221, 230, 244, 264, 277
dall [dhal, lentil paste or soup], 146
exotic (hornets, snake, worms), **114**; 109, 112, 170, 206
fruit (bananas, tangerines, toko palm fruit), 118, 129, 277
herbs and spices, 277
meat (chicken, goat, mutton, pork), **223**, **244**; 33, 66, 73, 94, 112, 131, 146, 155, 163, 170, 221, 230, 231, 244
pulses, 277
seeds (Job's tears seeds), **244**, **247**; 221, 231, 244, 277
vegetables (gourds, jungle leaves, leafy vegetables, potatoes, sweet potatoes, yam roots), **244**; 88, 94, 163, 230, 231, 277

sweets (biscuits, honey, toffee), 146, 192, 200, 204, 215
forest, **contents pages**, **64**, **89**, **216**, **276**; 8, 35, 63, 65, 70, 192, 218, 222, 277
 deciduous, 277
 evergreen, 276, 277
 sub-tropical, 277
 temperate, 277
 tropical, **216**; 276, 277
 wet temperate, 277
Fortes, Meyer, 8
fortification, 134, 152, 156
Fürer-Haimendorf, Christoph von, **10**, **13**, **14**, **18**, **22**, **44**, **45**, **57**, **88-89**, **90**, **104-105**, **118**, **121**, **127**, **131**, **133**, **158**, **173**, **184**, **197**, **228**, **260**, **283**; 6, 7, 8, 9, 10, 20, 33, 94, 109, 117, 119, 129, 131, 144, 170, 175, 262, 283

gable roof, *see:* roofs
Ganguli, Milada, **66**; 65, 66, 175, 177
gaonbura [middle-man between village and administration], **94**, **142**; 85, 144, 160, 163, 179, 194
gayal [wild Indian bison] (*see also:* mithun), 275
genna [taboo period], **182**; 63, 156, 247
goat (*see also: goral*), **160**; 32, 39, 66, 85, 149, 163, 170, 277
 goat hair, 32, 39, 66
gong [donation to *Ang*, symbol of *Ang's* power], **75**, **264**; 49, 77, 112, 150, 262
goral [mountain goat], **160**, **171**; 149, 160
Government, *see:* Nagaland – Government
grain, *see:* food
grave, *see:* burial
gravel, upper, 144
grave-house, 129
guesthouse, 111, 112, 117, 131, 257
gunpowder, **76**; 76
Gurkha soldiers, 28

hair, **50**, **143**, **210-211**; 22, 55, 77, 88, 112, 194, 262
Hakchang village, Tuensang, **150**; 133, 150-151, 153, 278
 clan origin, **210-211**
 fertility, 68
headgear, **85**, **114**, **181**, **184**, **203**, **237**; 50, 113, 231, 236, 270, 274
 headdress, **195**, 90
 helmet, **2**, **143**; 39, 41, 112, 235
 Russian cap, **237**; 205
headhunting, **13**, **14**, **18**, **34-53**, **56-57**, **58**, **63**, **65**, **68-69**, **77**, **78**, **84**, **85**, **90-91**, **109**, **120**, **122**, **127**, **129**, **138-139**, **142**, **143**, **153**, **154-155**, **180-181**, **182**, **188**, **193**, **204**, **207**, **236**, **252**, **264**, **268**, **281**; 6, 9, 13, 14, 20, 22, 32, 33, 35-52, 55, 57, 65, 75, 77, 85, 88, 92, 93, 119, 129, 130, 131, 133, 138-140, 152, 153, 156, 163, 164, 170, 175, 177, 181, 192, 194, 197, 200, 206, 212, 235, 236, 256, 259, 265, 270, 277, 278, 279, 280, 281-282
Helipong village, Tuensang, **121**, **122**; 170
hero, *see:* village
Hilary (driver), 110, 134, 168, 213, 215, 231, 233, 255
Hobson, Geraldine, **113**; 10
Hongkhong ridge, **168**, **196**; 192
hoolock gibbon, 277
Hootton's *morung*, *see:* Hutton's *morung*
hornbill, 40, 218, 277
 beak, **6**, **135**, **182**, **264**; 40, 144
 carving, **58**, **85**, **135**, **151**, **179**, **182**, **188**, **264**; 49, 50, 84, 144, 152, 160, 179, 206, 264
 depiction of, **68**; 134
 feather, **58**; 39, 92, 93, 112, 235
 symbolic meaning, **58**, **264**
hornets, *see:* food
horns, 48, 152
 brass, 50
 buffalo, **48**, **49**, **161**, **188**, **252**; 49, 144, 153
 mithun, **48**, **143**; 41, 45, 49, 144, 153
 serow, 49
 wooden, 49
Hoyang clan, Chen Wetnyu, 206
Hukpang village, Longleng, 63, 75
Hungkai, chief's wife, Yonghong, 194
Hutton, John Henry, **6**, **7**, **8**, **10**, **17**, **18**, **23**, **49**, **60**, **64**, **81**, **87**, **111**, **117**, **147**, **150**, **152**, **161**, **182**, **194**, **204**, **210**, **211**, **217**, **218**, **252**, **255**, **259**, **260**, **268**, **283**; 6-9, 10, 20, 22, 28, 32-33, 36, 48, 52, 56, 57, 63, 64, 66, 73, 85, 88, 92, 94, 109, 111, 129-130, 134, 138, 142, 144-146, 150, 153, 156, 160, 164, 175, 194, 203, 217, 231, 251, 252, 255, 264, 276, 278, 279, 281, 282
Hutton's *morung*, **218**, **252**; 217

Independence, *see:* Naga Independence Movement
Indian Government, **120**
Inner Line, 20, 280-281
Inspection bungalow, 32-33
ironwork, *see:* metalwork

Jaiching clan, Nian, **84**, **87**; 85, 87

jail, Chare, **129**; 129
Japfu mountain, 276
Jhum [to slash and burn ground] (*see also:* agriculture), **277**; 35, 65, 168, 221, 277
Job's tears [*Coix lacryma-jobi*] (*see also:* food, seeds), **244**, **247**; 138, 221, 231, 244, 277
Jorhat town, Assam, **109**, **110**; 110, 200
jungle leaves, *see:* food

Kali [Indian Hindu goddess], 109
Kalyo-Kengyu [slate house dwellers], *see:* Khiamniungan
Kamahu, *see:* Yongshe
Kangsho clan, Tuensang, 134
Kenchenshu village, Mon, **253**; 252
kham [log drum] (*see also:* log drum), 218
Khamba, **164**; 163
Khao Pa, *Ang* of Sheangha Chingnyu, **18**
khel [clan, quarter], **127**, **133**, **134**, **135**, **142**, **144**, **146**, **159**; 134, 138, 144, 153, 175
Khiamniungan group, Tuensang, **88**, **108**, **117**, **120**, **122**, **123**, **125**, **140**, **209**, **279**; 32, 130, 149, 278, 279
Kiphire district, Nagaland, 277
Kohima, [capital of Nagaland], **11**, **48**, **114**; 20, 26, 119, 276, 282
Kolkata, *see:* Calcutta
Konyak, **frontispiece**, **7**, **13**, **14**, **44**, **45**, **57**, **72**, **81**, **87**, **89**, **100**, **127**, **151**, **182**, **185**, **193**, **197**, **199**, **210**, **214**, **237**, **262**, **283**; 6, 9, 13, 14, 32, 94, 130, 131, 144, 146, 149, 151, 163, 164, 167, 172, 205, 236, 247, 252, 259, 263, 277-278, 279, 280, 283
 Lower Konyak group, Mon, **18**, **81**, **87**, **89**, **141**, **173**, **182**, **197**, **208**, **209**, **241**, **242**, **278**, **283**; 198, 200, 203, 206, 256, 257, 277-278, 279
 Upper Konyak group, Mon, **16**, **100**, **141**, **148**, **178**, **208**, **209**, **226**, **240**, **241**, **246**; 66, 192, 205, 233, 278-279
Konyak, Shamlu, 218
Konyak, Sheiya, 200, 203
Konyak, Wennyei, **222**, **223**; 221
Kudeh village, Tuensang, 36

Lambert, F.D.T., 197, 206
Lamphong, **248**; 247, 251
Lamsong, 89
Langchong clan, Nian, 84, 94
Langha linguistic group, Yimchungru, 279
Laningpu village, Mon, **81**, **263**
Lekhang village, Mon, 256
Lemwang, *Ang* of Tang, **267**
Lenba, Hongpe, **169**, **170**, **172**; 168, 172

leopard, **108**, **206**; 206, 277
Lhota group, Wokha, 130, 282
Lijaba [fertility spirit], 99
lime, 92, 99
lime wood (*see also:* firestick), 50
Limpuru [ambassador/peacemaker, Yimchungrü], *279*
lizard, **177**, 204
log drum, **44**, **80**, **94**, **117**, **168**, **193**, **220**, **222**, **233**, **240-241**, **242**, **243**, **251**, **257**; 8, 39, 41, 43, 60, 66, 70, 75, 81, 85, 88, 93, 134, 152, 153, 168, 169, 194, 197, 206, 218, 221, 222, 251, 255, 256, 279, 281
 abandoned, **168**; 168
 beaters, **75**, **94**, **257**; 41, 152, 236, 256, 279
 house/shelter, **32**, **125**, **158**; 279
 pulling, **218**, **221**, **220-231**, **232**, **236**, **244-246**; 6, 8, 194, 218, 222-231, 236, 244
 ritual, **94**, **232-244**; 60, 194, 221, 235-236
 symbol of clan unity, **94**, **193**; 60, 230
loincloth, **34**, **39**, **53**, **176**; 22, 39, 50, 52, 77, 92, 112, 235
Lomao clan, Tuensang, 134, 138
London University, 8, 282
Longching village, Mon, **176**, **196**, **198**, **209**, **241**; 197-198
Longkhai village, Mon, **13**, **22**, **73**, **88**, **89**, **131**
Longkhum village, Mokokchung, **20**, **32**; 29
Longkhumer, Temjen, 29
Longleng district, Nagaland, **14**, **24-25**, **64**, **93**, **140-141**, **208-209**, **210**; 60, 61, 63, 75, 76, 278, 284
Longmein [Longmien] village, Mon, **214**, **250-251**, **254-255**, **256-257**; 94, 198, 251-257
Longpfuri [Mimi] village, Kiphire, 279
Longsha, **274-275**; 259, 265, 270
Longwa border village, Mon, **201**, **278**; 172
loom, 262
 double loom, **135**
Lower Konyak, *see:* Konyak
Luchaipani border village, Assam, 28

Macfarlane, Alan, 6-9, 10, 22
maize, *see:* food
Maksha village, Tuensang, **150**; 133, 150-151
Makuri sub-group, Yimchungrü, **2**; 279
malaria, 131, 277
Mangthong clan, Yongshe, 61, 58, 60
Manipur Plateau, 276
Manipur State, India, 66, 261, 276, 277
Mannen, Mr T.N., **114**, **118**; 111, 112, 117, 118
Mannen, Mrs Thangi, 27, 28, 76, 111

Matong ridge, 36
Mauwang, *Ang of* Longkhai, **13**, **131**, **167**, **184**
menstruation, 231
Menyakshu village, Mon, **174-179**, **180**, **188-189**, **190**, **215**, **241**; 167, 170, 175-179, 191, 192, 217
metalwork (blacksmiths, ironwork), **48**; 76, 88, 177, 187
migration, 129
millet, *see:* food
Mills, James Philip, **6**, **16**, **28**, **32**, **33**, **49**, **55**, **64**, **111**, **114**, **120**, **122**, **125**, **127**, **131**, **143**, **156**, **170**, **266**, **270**, **283**; 6, 7, 8, 10, 20, 28, 32, 109, 119, 129, 131, 175, 282, 283
Mimi, *see:* Longpfuri village
Min, *see:* Mom
missionaries, **93**, **268**; 6, 14, 29, 57, 11, 144, 278, 282
Mithun [*Bos frontalis*, semi-domesticated crossbread of cow and *gayal*] (*see also:* animal sacrifice), **193**; 41, 73, 90, 247, 259, 263, 277, 279
 carving, **58**; 41, 50, 129
 hide, **80**; 39, 60, 163, 218, 235
 horns, **48**, **143**; 41, 45, 49, 144, 153
 shield, **80**; 39, 44, 60, 163, 218, 235
 skull, **153**; 152, 160
Mokokchung district, Nagaland, **8**, **110**, **111**, **112**, **120-121**; 20, 39, 58, 108, 110-111, 117, 119, 131, 197, 278, 282
Mom [Min] village, Mon, 175
Mon district, Nagaland, **8**, **14**, **73**, **106-107**, **108**, **141**, **184**, **208-209**, **210**, **215**, **241**, **258-259**, **266-267**, **270**, **272**, **274-275**, **277**, **278**; 11, 13, 20, 112, 150, 197, 198, 244, 251, 252, 257, 259-265, 270, 277
Mongnyu [Bhumnyu] village, Longleng, 48, 75
Mongsen, Chief, Pangsha, **127**
Mongsenyimti village, Mokokchung, **281**; 118
monkey, **61**, **67**, **78**, **170**, **171**, **188**, **189**, **192**, **236**, **265**, **274**; 41, 49, 55, 58, 66, 179, 218, 235, 236, 270
monsoon, **28**, **106-107**; 97, 277
Monyü [spring festival, Phom], **74**, **78-79**; 51, 75, 76
Mopungchukit village, Mokokchung, **33**, **241**, **243**; 29
morung [bachelors' dormitory, traditional place of education] (*see also:* Hutton's *morung*), **35**, **42**, **44**, **46**, **50**, **54**, **66-67**, **80**, **83**, **84**, **96**, **97**, **98**, **119**, **130**, **143**, **150**, **151**, **152**, **158**, **160**, **170-171**, **175**,

176, **178**, **186**, **190**, **193**, **196**, **198**, **207**, **219**, **253**, **256**; 8, 22, 30, 39, 41, 49-51, 57, 58, 65, 66-70, 76, 82, 85, 88, 93, 94, 97, 99, 102, 131, 138, 152, 153, 160, 163, 168 169, 172, 175, 177, 179, 194, 198, 200, 203, 206, 217, 218, 251, 252, 255, 256, 259, 265, 278, 279, 281
 decoration, **58-59**, **66**, **68-69**, **70**, **85-87**, **100**, **134**, **152**, **154-155**, **163**, **170**, **171**, **173**, **178**, **179**, **186**, **188-189**, **192**, **196**, **252**; 22, 41, 44, 49, 50, 57, 65, 66, 82, 85, 88, 134, 152, 153, 160, 163, 168-169, 177
 function, **130**; 46, 76, 85, 88, 168, 169, 177, 198
 girls', 90
 inauguration, 56, 60
 storming, **42-43**, **44**, **61**; 43-44, 51, 60
mugs, **16**, **78**, **142**, **149**; 41, 50, 142, 149, 255, 278
Mungo, Pobang [tigerman, 'were-tiger'], Tuensang, **144**; 144
Myanmar *see:* Burma

Naga Hills, *passim*
Naga Independence Movement, 10, 14, 20
Naga Range, 276
Nagaland, *passim*
 Government, 10, 14, 27, 28, 84, 110, 111, 131
Namsang village, Longleng, 33
Nazira town, Assam, 28
necklace, **31**, **85**, **108**, **114**, **181**, **208**, **210**, **226**, **228**, **238**, **244**, **246**; 39, 51, 77, 138, 230, 233, 261, 262, 263, 278
NEFA, North East Frontier Agency (*see also:* Arunachal Pradesh), 283
Ngapnun [wife of the *Ang* of Longkhai], 22
Ngapshom [Longsha's wife], **274**; 270
Nian village, Longleng, **82-95**, **96-105**; 39, 83-94, 97-102
Ninyam village, Tuensang, 138
Noklak village, Tuensang, **121**, **124-125**, **141**, **279**
Nokyan village, Tuensang, **88**, **140**, **209**, **279**
nudity, **31**, **94**, **52**, **55**, **103-105**, **158**, **228**, **268**; 39, 93, 94, 129, 252

opium, **266**; 206, 262, 263
Orangkong [Urangkong] village, Longleng, 278
orchids, 277
Oting village, Mon, **40**, **75**, **104-105**
Oxford University, 282

Pa [clan/*morung*], 206

paan, [betel nut, lightly stimulating] (*see also:* betel nut), 99
palm (*see also:* thatch), **68-69**; 97, 252, 277
 palm wood, 32
Panglem, Chief, Yonghong, **195**; 194, 203
Pangsha expedition, **16**, **113**, **120-127**; 10, 20
Pangsha letters, **113**; 10, 130, 282
Pangsha village, Tuensang, **16**, **44**, **57**, **120-127**; 10, 120
Panji [bamboo spike], **125**, **153**, **164**, **165**, **281**; 55, 64, 73, 152, 153, 156, 164
Patkoi [Patkai] mountains, 167, 276
Pawsey, Charles, **111**; 129, 146
Peace treaties
 British and Pangsha, **127**
 Sheangha Chingnyu and Chen, **200**
permits, 65, 110, 149
Pesao village, Mon, 155, 167, 170
phallic symbols, **154-155**, **282**; 163
Phamjong clan, Yongnyah, **44-47**, **50-52**; 44, 51, 163
pheasant (Monal and Tragopan species), 277
Phom, **14**, **24-25**, **26-27**, **35**, **49**, **50**, **60**, **65**, **68**, **80**, **85**, **90**, **93**, **140-141**, **151**, **185**, **195**, **199**, **208-209**, **210**, **214**, **278**; 32, 35, 36, 39, 41, 51, 52, 60, 66, 70, 75, 76, 169, 278, 279, 280
Phom, Shayung, 57, 63-65, 85, 88, 90
Phomching [Pongching] village, Longleng, **80**; 36, 39
pigs (*see also:* animal sacrifice; food), **170**; 73, 83, 85, 94, 133, 134, 146, 170, 203, 221, 244
Pitt Rivers Museum, Oxford, **48**, **126-127**, **143**, **182-183**, **255**; 7, 8, 10
Poangba, S., **14**, **151**, **152**, **153**, **155**, **156**, **167**, 179, 192
poker work, **16**, **119**, **278**
poles, **35**, **225**; 41, 50, 99, 134, 153, 160, 205, 230
police, **121**, **281**; 41, 111, 133, 149, 152, 257
Pongching *see:* Phomching village
Pongo [Pongu] village, Longleng, **68-69**, **74-81**, **85**, **140**, **184-185**, **208**, **278**; 75-81, 74-81
Ponyo village, Burma, 120-121
porcupine quill, 261
pork, *see:* food
porter, *see:* coolie
potato, *see:* food
pottery, **76**, **204**; 39, 44, 50, 76, 88, 204, 264, 265,
pounding table, **72-73**; 255, 264
prediction of future, **95-107**; 96-107

Reid, Sir Robert, Governor of Assam, **60**; 55, 58
Rengma group, Wokha, *282*
rice (*see also:* agriculture; alcohol; food), **50**, **51**, **70**, **72**, **131**, **212**, **276**; 29, 41, 44, 49, 50, 52, 56, 70, 75, 94, 110, 130, 138, 146, 149, 155, 163, 179, 187, 191, 206, 212, 230, 242, 255, 264, 265, 277
 beer, **50**, **51**, **131**; 41, 44, 49, 50, 52, 57, 75, 146, 179, 187, 191, 255, 265
rifles, 41, 218
roofs, **84**, **125**, **132-133**, **154-155**, **159**; 39, 129, 204, 252, 278
 corrugated iron/tin, **21**, **32**, **158-159**; 32, 52, 57, 66, 117, 129, 153, 177, 179, 186, 262
 forms, **58-59**, **68-69**, **83**, **84**, **119**, **125**, **132-133**, **139**, **150**, **152**, **176**, **190**, **202**, **204**, **214-215**, **218-219**, **253**, **260**; 66, 85, 153, 168-169, 177, 200, 205, 252, 255
 gable, **42**, **58-59**, **69**, **83**, **84**, **86**, **125**, **132**, **139**, **150**, **151**, **214-215**, **219**, **253**; 66, 85, 134, 138, 153, 158, 159, 176, 177, 190, 193, 200, 207
 slate, **125**; 278
 thatch, 20, 26, **32**, **84**, **152**, **158-159**, **169**, **177**, **219**, **253**; 27, 39, 41, 57, 76, 77, 85, 134, 153, 163, 172, 175, 205, 217, 252, 261, 277
rope, **48**, **225**, **226**; 213, 222, 230, 231, 234, 236
Royal Anthropological Institute, 283

Sagaing Administrative District, Burma, 276
Sakchi village, Longleng, **85**, **141**, **210**
Salumi village, Kiphire, 279
Sangpurre village, Kiphire, **12**, **140**, **150**, **279**
Sangnyu border village, Tuensang/Mon, 150
Sangtam group, Tuensang, Kiphire, **122**, **279**; 129, 144, 146, 278, 279
Saochu village, Tuensang, 119
Saramati peak, **contents pages**; 276, 277
Sardeshpande, S.C., 22, 198, 247
schools, 52
Sema, *see:* Sumi group
serow [*Capricornis sumatrensis rubidus*], 49
Shakespear, Captain W.B., 28
shaman, **46**, **51**, **62**, **71**, **96-97**, **98**, **99**, **100**, **102-103**; 49, 66, 70, 99, 102, 144, 194
Shamatore village, Kiphire, 279
Shamnyu [Wangnu] village, Mon, **154-165**, 155-164, 167
Shamong Mt., near Yongshe, **56**; 56
Shamthun [part of *Monyü* spring festival, Phom], 75

Shangnyu village, Mon, **282**; 261
Sheangha Chingnyu village, Mon, **18-19**; 131, 200
shells, **226**, **230**, **246**; 39, 77, 112, 177, 230, 233, 235
shields, **44**, **45**, **80**, **235**; 39, 41, 44, 51, 60, 64, 92, 163, 218, 221, 235, 236
singing/songs, **72**, **78**, **92**, **206**, **227**, **231**; 29, 32, 60, 66, 70, 77, 81, 92, 93, 97, 102, 12, 160, 163, 212, 222, 230, 231, 233, 236, 249
skulls
 buffalo, **161**, **188**; 152, 160
 elephant, **268-269**; 259
 fertility, **46-47**, **49**, **57**; 20, 45, 51
 human, **9**, **18-19**, **27**, **46-47**, **48**, **49**, **50**, **51**, **57**, **84**, **122**, **127**, **129**, **138**, **143**, **146**, **178**, **181**, **184**, **251**, **256**, **268**, **278**, **281**; 22, 39, 45-49, 51, 88, 142, 144, 170, 255, 256, 279
 mithun, **153**; 152, 160
 monkey, **60**, **78**, **236**, **264**, **274**; 49, 55-58, 235, 236, 270
 pig, 170
 skull place, **146**; 144
slash and burn, *see: jhum*
slavery, **120**, **126-127**, **283**; 20, 119, 278, 280
snakes, **58**, **84**, **198**; 50, 85, 160, 206, 218, 222
SOAS [School of Oriental and African Studies], 8, 283
soothsaying, *see:* predicting the future
spears, **30**, **127**, **200**; 8, 32, 39, 41, 49, 77, 218, 222, 256, 263
spiders, 117, 215
SPNH [Society for the Preservation and Promotion of Naga Heritage], 7, 11
Spring Villa Museum, Mokokchung, 110, 117
stamping boards, **38**, **109**, **206**
stilts, huts on, **219**; 110, 217, 279
Stirn, Aglaja, 6, 27
stone, **84**, **138**; 44, 66, 84, 163, 218, 247, 259, 261
 ancestral, **70**; 70
 dolmen, menhir, **84**; 252
 drum beaters, **75**, **257**; 257
 flood, **248-249**; 244
 of Lungtrok, **70**; 70
 memorial, **18**, **150**; 65, 150
 paths, 35, 179, 247, 252, 255
 sacred, **97**, **98**, **179**, **260**; 66, 99, 170, 179, 247, 261
 settings, **176**, **258-259**, **260-261**, **283**
 tables, 255, 259
 urns/cists, **181**, **184**
sub *Ang*, *see: Ang*

Sumi [Sema] group, Zunheboto, **28**, **122**; 6, 7, 279, 282
sword-bean [*Entada scandens*], 49

Tamkhong village, Mon, 155, 163, 167
Tamlu village, Longleng, 32
Tang village, Mon, 32-33, 55
Tangha [Tangsa] clan, Yongnyah, **40-41**; 32-33, 39, 41, 51, 55, 56, 64
Tanhai village, Mon, **14**
tattoo, 55, 150, 177, 198, 256, 278
 female, **133**, **134**, **208-209**, **210**, **230**, **246**; 76, 129, 138, 163, 206, 278
 headhunting status, **18**, **76**, **84**, **125**, **163**, **176**, **201**, **207**; 77, 93, 155-156, 163, 200, 206, 256, 261, 277
 male, **18**, **19**, **77**, **84**, **124**, **125**, **140-141**, **148**, **163**, **176**, **196**, **201**, **206**, **207**, **257**, **261**, **265**, **269**, **273**, **274**, **275**, **278**; 138, 155-156, 163, 200, 204, 206, 256, 261, 277, 278
 relationship to animals, **207**; 206
tea, 20, 29, 109, 110, 163, 168, 175, 192, 200, 206, 215, 280
teacher, 200
Tesophenyu village, Kohima, **32**
Tezpur, Assam, 110
Thamji clan, Yongnyah, **40-46**; 41, 51
thatch, *see:* roofs
Thendu [distinction among the Konyak], 277-278, 279
Thenkoh [distinction among the Konyak], 277, 278
Theresianische Akademie, 283
thrones, *Ang*, **264**; 264
tigers, **108**, **134**; 7, 52, 61, 138, 153, 277
 depictions of, **58**, **65**, **85**, **87**, **163**, **171**, **178**, **192**, **197**, **207**; 41, 50, 66, 85, 88, 160, 168, 179, 206
 teeth, **1**, **108**, **114**; 39, 41, 262
 tiger-man, *see:* Mungo, Pobang
Tikhir sub-group, Yimchungrü, 279
Tirap district, Arunachal Pradesh, 6, 276
Tizu river, 276
Tobu village, Mon, **16**, **106-107**, **141**, **148**, **151**, **152**, **153**, **178**, **196**, **208-209**; 13, 22, 133, 138, 149-153, 155, 163, 167, 169, 175, 192, 198
Toko palm [*Livistona jenkinsiana*] (*see also:* fruit), 97, 277
Tolei, Ang, **206-207**; 206
Toongnam, **260**, **262**, **274**; 262-264, 270
Totok Chingnyu village, Mon, **182**; 256-257, 261
Tsawlaw village, Burma, **120**

Tuensang district, Nagaland, **14**, **16**, **106-107**, **18**, **117**, **123**, **140-141**, **208-209**, **210**, **241**, **278**; 11, 20 117, 130, 277, 279
Tuensang town, **68**, **114**, **128**, **130**, **149**; 112, 119, 129, 130-136, 144, 146
Tuensang village, **136**, **143-146**, **151**; 130, 144, 146, 150, 278
turtles, **58**; 252
tusks
 boar, 39, 41, 51, 77, 92, 235
 elephant, 37, 235

Ukha village, Mon, **168**, **182**, **192**, **193**; 85, 167, 192
Ukhrul village, Manipur, 167
Ungma village, Mokokchung, **30-31**, **33**; 27, 29, 32
Upper Konyak, *see:* Konyak
Urangkong, *see:* Orangkong village
urine, human, **76**; 76

Varanasi [Benares], India, 203, 213-215
vegetables, *see:* food
Vesey-Fitzgerald, Pamela, [wife of J.P. Mills], **113**; 10, 282
Vienna University, 283
village
 council, **135**; 134, 144, 156, 160, 187, 192, 206, 247, 255, 278, 279
 gate, **164-165**; 129, 156, 261
 hero, **142**, **162**, **176**, **232**; 142, 163, 194, 217-218, 219, 235, 236
 quarter, *see: khel*
violin, single-stringed, **92**; 93

Wakching village, Mon, **2**, **14**, **57**, **89**, **90**, **100**, **198**, **228**, **242**, **266**, **270**; 198, 261-263, 278, 283
Wakka village, Arunachal Pradesh, 167
Wanching village, Mon, **20**, **44**, **184**, **208**, **241**; 94, 278
Wang Hamyen [traditional village council] (*see also:* village council), 278
Wangkau, *Ang* of Chui, **131**, **269**; 278
Wangsu, *see:* Shamnyu village
Wangti village, Mon, **174**; 177
warriors, **35**, **36**, **40**, **42**, **46-47**, **59**, **74**, **85**, **127**, **143**, **182**, **188**, **201**, **220**, **221**, **226**, **234-235**, **236**, **257**, **272**, **282**; 27, 36, 39, 41-43, 50-51, 83, 85, 88, 92-93, 99, 110, 112, 140, 144, 153, 160, 194, 218, 230-231, 235, 236, 255-256
water, drinking, **89**, **141**; 39, 112, 146
weaving, **114**, **135**, **226**; 13, 76, 262

Webster, Mr. 252
were-tiger, *see:* Mungo, Pobang
William Wyse Professorship, Cambridge University, 7, 8, 282
Williams, Major, **121**, **127**; 119, 172
woodcarving, *see:* carving
Woodthorpe, R.G., **141**, **185**; 85, 197
worms, *see:* food
Wungtung, Toshi, **134**, **223**; 14, 22, 110-112, 119, 131, 133, 144, 149, 155, 163, 167-168, 172, 179, 187, 191, 213, 215, 218, 231, 232, 234, 249, 257

Yachem [Yacham] village, Longleng, **63**, **66**, **68**, **69**; 36-39, 48, 57, 63-66, 73, 90
Yakshu village, Mon, **152**, **161**, **194**; 167, 192
Yam root, *see:* food
Yangam [Yongam] village, Longleng, **49**; 36
Yangang, **220**, **225**, **226**, **232**, **238**; 194, 217, 218, 235, 236, 251
Yangbong, *Ang* of Mon, **258**, **261**
Yangching village, Longleng, **209**
Yangkayla [sacred stone, Changlangshu], 170
Yaong [Yong] village, Longleng, **62**, **67**, **68**, **70-71**, **72**; 63-70
Yei village, Mon, 231, 233, 247
Yenthü [part of *Monyü* spring festival, Phom], 76
Yimchungrü [Yimtsungr] group, Kiphire, Tuensang, **12**, **108**, **117**, **123**, **140**, **150**, **279**; 14, 32, 112, 130, 144, 146, 217, 248, 277-279
Yimpang village, Tuensang, **121**, **127**
Yimpu [realm of the dead], **181**; 270
Yimtsungr, *see:* Yimchungrü
Yüüjep [part of *Monyü* spring festival, Phom], 75
Yong, *see:* Yaong village
Yongam, *see:* Yangam village
Yonghong village, Mon, **23**, **73**, **87**, **161**, **166**, **182**, **193-195**, **204**, **209**, **214**, **216-231**, **232-249**, **252**; 160, 167, 191-194, 197, 203, 211, 215, 217, 231, 233-249, 251
Yongjong clan, Yongnyah, **53**; 50
Yongkai clan, Menyakshu, **188**, **190**
Yongkhoang clan, Menyakshu, 177
Yongnyah [Yungya] village, Longleng, **14**, **25-26**, **34-53**, **54**, **195**, **209**, **214**; 28, 32-33, 35-52, 55, 57, 60, 83, 252
Yongshe [Kamahu] village, **54-61**, **209**; 32-33, 48, 55-61, 64, 73
Y-post, **188**; 279
Yungya, *see:* Yongnyah village

Zeliangrong group, Peren, Manipur, Assam, **67**

EXPEDITION NAGA – THE DVD

Contents:

Expedition Naga

107 minutes

Return to the Naked Nagas

32 minutes

The Longleng Diaries

1) From Longleng to Nian
2) One night in Nian
 a) Warriors' dance
 b) Elders' song
 c) Log drumming
3) Foretelling the future
4) Yongnyah – A quiet day in the realm of the clouds
5) Conversations with head hunters I –
 An interview with the chief of Yongjong clan, Yongnyah, 20 October 2004
6) Inauguration of a morung
7) Findings and surprises – Exploring Yangching village
8) Conversations with head hunters II –
 Two old warriors from Yangching
9) Calling the lost shadow – Spiritual healing at Yaong
10) A pounding trance

The Tuensang-Mon Diaries

11) Skulls and substitutes at Tuensang
12) Conversations with head hunters III –
 An interview with Sangam Chang, head gaonbura of the Chongpho clan
13) Skulls in a cave
14) Celebrating the strangers
15) Footsteps in the fog – Crafts at Menyakshu
16) Days of the drum I –
 The log drum pulling at Yonghong
17) Days of the drum II – The ritual
18) Credits

1) Return to the Naked Nagas
 Christoph von Fürer-Haimendorf.
 Scenes from the Naga Hills 1969-70 (silent)
2) Dried heads are better than no heads – Christoph von Fürer-Haimendorf in the Naga Hills.
 An interview by Alan Macfarlane, July 1983.
3) J.P. Mills and the British
4) Why the Konyak Naga?
5) Monoliths and heads
6) Missionary influences
7) The Pangsha Expedition I
8) The Pangsha Expedition II
9) The Pangsha Expedition III
10) The virtues of headhunting

Total running time: 139 minutes

Credits:

All cinematography – Manfred Praxl
Sound – Tom Hornig
© Trias TV Productions, Frankfurt / Germany

Except:

"Footsteps in the fog", "Days of the drum I" and
"Days of the drum II" – cinematography and sound: Jamie Saul
© SPNH, Frankfurt / Germany;

"Return to the Naked Nagas" – cinematography: Christoph von Fürer-Haimendorf
© The Macfarlane Archives at SPNH,
Frankfurt / Germany;

"Dried Heads are better than no heads" and all successive interview sequences with C. v. Fürer-Haimendorf – cinematography and sound: Tristram Riley-Smith, directed by Alan Macfarlane
© The Macfarlane Archives at SPNH, Frankfurt / Germany.

Editing: Peter van Ham
Media transfer: ecg media transfer GmbH, Frankfurt / Germany

Opening sound file "Lemwang, the Ang of Tang, singing with friends on the occasion of Aoling" courtesy of Bea Bartusek

DVD produced and directed by Peter van Ham for the Society for the Preservation and Promotion of Naga Heritage (SPNH)

Thanks to: The people and the government of Nagaland, Jungle Travels India, Alan Macfarlane, Jean Saul, Manfred Praxl, ecg media transfer, the members of the SPNH, Bernhard van Ham, Sidonia Kolster.

This DVD © SPNH, Frankfurt / Germany 2007.
www.spnh.com

All rights reserved.

The copyright owner has licensed the picture in this DVD for private home use only and prohibits any other use, copying, reproduction, or performance in public, in whole or part.

Note: The contents of this DVD are conceived as an accompaniment of the book's chapters and the respective incidents described therein. Thus, no extra explanatory commentary was added.

First published 2008
© 2008 Peter van Ham
World copyright reserved

ISBN: 978-1-85149-560-3

The right of Peter van Ham to be identified as author of this work has been asserted by him in accordance with the Copyright, Designs and Patents Act 1988

All rights reserved. No part of this publication may be reproduced, stored in a retrieval system, or transmitted in any form or by any means electronic, mechanical, or photocopying, recording or otherwise, without the prior permission of the publisher

British Library Cataloguing-in-Publication Data:
A catalogue record for this book is available from the British Library

Printed in China for The Antique Collectors' Club Ltd.,
Woodbridge, Suffolk IP12 4SD